Disability Aesthetics

Corporealities: Discourses of Disability

David T. Mitchell and Sharon L. Snyder, editors

Books available in the series:

Disability Aesthetics

Tobin Siebers

The University of Michigan Press

Ann Arbor

Copyright © by the University of Michigan 2010
All rights reserved
Published in the United States of America by
The University of Michigan Press
Printed and bound by CPI Group (UK) Ltd, Croydon, CR0 4YY

2013 2012 2011 2010 4 3 2 1

*A CIP catalog record for this book is available from the
British Library.*

Library of Congress Cataloging-in-Publication Data

Siebers, Tobin.
 Disability aesthetics / Tobin Siebers.
 p. cm. — (Corporealities)
 Includes bibliographical references and index.
 ISBN 978-0-472-07100-5 (cloth : alk. paper) — ISBN
978-0-472-05100-7 (pbk. : alk. paper)
 1. Disability studies. 2. Aesthetics. 3. Artists with
disabilities. I. Title.
HV1568.2.S535 2010
704.9'42--dc22 2009038404

Contents

Contents

Chapter 1

Introducing Disability Aesthetics

Aesthetics tracks the sensations that some bodies feel in the presence of other bodies. This notion of aesthetics, first conceived by Alexander Baumgarten, posits the human body and its affective relation to other bodies as foundational to the appearance of the beautiful—and to such a powerful extent that aesthetics suppresses its underlying corporeality only with difficulty. The human body is both the subject and object of aesthetic production: the body creates other bodies prized for their ability to change the emotions of their maker and endowed with a semblance of vitality usually ascribed only to human beings. But all bodies are not created equal when it comes to aesthetic response. Taste and disgust are volatile reactions that reveal the ease or disease with which one body might incorporate another. The senses revolt against some bodies, while other bodies please them. These responses represent the corporeal substrata on which aesthetic effects are based. Nevertheless, there is a long tradition of trying to replace the underlying corporeality of aesthetics with idealist and disembodied conceptions of art. For example, the notion of "disinterestedness," an ideal invented in the eighteenth century but very much alive today, separates the pleasures of art from those of the body, while the twentieth-century notion of "opticality" denies the bodily character of visual perception. The result is a nonmaterialist aesthetics that devalues the role of the body and limits the definition of art.

There are some recent trends in art, however, that move beyond idealism to invoke powerful emotional responses to the corporeality of aesthetic objects. Andy Warhol's car crashes and other disaster paintings represent the fragility of the human body with an explicitness rarely found in the history of art. Nam June Paik, Carolee Schneemann, Mary Duffy, Marc Quinn, and Chris Burden turn their own bodies into instruments or works of art, painting with their face or hair, having themselves shot with guns, sculpting their frozen blood, and exhibiting themselves in situations both ordinary and extraordinary. Paul McCarthy, Tyree Guyton, and Damien Hirst employ substances thought to be beyond the bounds of art: foodstuff, wreckage, refuse, debris, body parts. Curiously, the presence of these materials makes the work of art seem more real, even though all aesthetic objects have, because of their material existence, an equal claim to being real. Nevertheless, such works of art are significant neither because they make art appear more realistic nor because they discover a new terrain for aesthetics. They are significant because they return aesthetics forcefully to its originary subject matter: the body and its affective sphere.

Works of art engaged explicitly with the body serve to critique the assumptions of idealist aesthetics, but they also have an unanticipated effect that will be the topic of my investigation here. Whether or not we interpret these works as aesthetic, they summon images of disability. Most frequently, they register as wounded or disabled bodies, representations of irrationality or cognitive disability, or effects of warfare, disease, or accidents. How is disability related to artistic mimesis—or what Erich Auerbach called "the representation of reality"? Why do we see representations of disability as having a greater material existence than other aesthetic representations? Since aesthetic feelings of pleasure and disgust are difficult to separate from political feelings of acceptance and rejection, what do objects representing disability tell us about the ideals of political community underlying works of art?

Disability Aesthetics is meant to be a first attempt to theorize the representation of disability in modern art. What I am calling "disability aesthetics" names a critical concept that seeks to emphasize the presence of disability in the tradition of aesthetic representation. My argument here conceives of the disabled body and mind as playing significant roles in the evolution of modern aesthetics, theorizing disability as a unique resource discovered by modern art and then embraced by it as one of its defining

concepts. Disability aesthetics refuses to recognize the representation of the healthy body–and its definition of harmony, integrity, and beauty— as the sole determination of the aesthetic. Rather, disability aesthetics embraces beauty that seems by traditional standards to be broken, and yet it is not less beautiful, but more so, as a result. Note that it is not a matter of representing the exclusion of disability from aesthetic history, since no such exclusion has taken place, but of making the influence of disability obvious. This goal may take two forms: (1) to establish disability as a critical framework that questions the presuppositions underlying definitions of aesthetic production and appreciation; (2) to elaborate disability as an aesthetic value in itself worthy of future development.

My claim is that the acceptance of disability enriches and complicates notions of the aesthetic, while the rejection of disability limits definitions of artistic ideas and objects. In the modern period, disability acquires aesthetic value because it represents for makers of art a critical resource for thinking about what a human being is. Aesthetics is the human activity most identifiable with the human because it defines the process by which human beings attempt to modify themselves, by which they imagine their feelings, forms, and futures in radically different ways, and by which they bestow upon these new feelings, forms, and futures real appearances in the world. Disability does not express defect, degeneration, or deviancy in modern art. Rather, disability enlarges our vision of human variation and difference, and puts forward perspectives that test presuppositions dear to the history of aesthetics. Neither disabled artists nor disabled subjects are central to my argument, it will soon be evident, although interpretations of both appear in these pages. What is central is how specific artists and works force us to reconsider fundamental aesthetic assumptions and to embrace another aesthetics—what I call disability aesthetics. Disability aesthetics names the emergence of disability in modern art as a significant presence, one that shapes modern art in new ways and creates a space for the development of disabled artists and subjects. The many examples of disability aesthetics mustered here are arranged strategically to span time periods, cross national boundaries, and mix genres with the specific goal of revealing the aesthetic arguments by which disability contributes to the imagination of the human condition. Each chapter targets a particular set of arguments. Chapters 1 and 4 challenge the presuppositions about intelligence and cognitive ability underlying aesthetic notions of "vision,"

"intention," "originality," and "genius." Chapter 2 questions standards of aesthetic beauty that rely on ideals of human beauty, in particular, those that disqualify human beings with reference to mental health, strength, and physical attractiveness. Chapter 3 focuses on the American culture wars as a way to think about how the defense mechanisms used to stave off the fear of individual disabled bodies jump to the symbolic and social level, creating disputes over the shape of the ideal body politic. Chapter 4 considers art vandalism as a new mode of representing disability that throws off the daunting burden of enfreakment troubling the traditional mimesis of disability. Chapter 5 presents a theoretical approach to disability that casts light on the aesthetic images of trauma, injury, wounding, and violence increasingly generated by the global world and transmitted by the media from nation to nation. Finally, chapter 6 explains the aesthetic prejudice against the image and in favor of words as the product of the image's symbolic association with disability. These are but a few of the new questions that arise when traditional aesthetic arguments are addressed from the perspective of disability studies.

To argue that disability has a rich but hidden role in the history of art is not to say that disability has been excluded. It is rather the case that disability is rarely recognized as such, even though it often serves as the very factor that establishes works as superior examples of aesthetic beauty. To what concept, other than the idea of disability, might be referred modern art's love affair with misshapen and twisted bodies, stunning variety of human forms, intense representation of traumatic injury and psychological alienation, and unyielding preoccupation with wounds and tormented flesh? Disability intercedes in the modern period to make the difference between good and bad art—and not as one would initially expect. That is, good art incorporates disability. Distinctions between good and bad art may seem troublesome, but only if one assumes that critical judgments are never applied in the art world—an untenable assumption. My point is only that works of art for which the argument of superiority is made tend to claim disability. This is hardly an absolute formula, although some have argued it, notably Francis Bacon and Edgar Allan Poe who found that "There is no exquisite beauty, without some strangeness in the proportion" (Poe 2:311–12) or André Breton who exclaimed that "Beauty will be *convulsive* or it will not be at all" (160).

Significantly, it could be argued that beauty always maintains an

underlying sense of disability and that increasing this sense over time may actually renew works of art that risk to fall out of fashion because of changing standards of taste. It is often the presence of disability that allows the beauty of an artwork to endure over time. Would the Venus de Milo still be considered one of the great examples of both aesthetic and human beauty if she had both her arms (fig. 1)? Perhaps it is an exaggeration to consider the Venus disabled, but René Magritte did not think so. He painted his version of the Venus, *Les Menottes de cuivre,* in flesh tones and colorful drapery but splashed blood-red pigment on her famous armstumps, giving the impression of a recent and painful amputation (color pl. 1).[1] Magritte's Venus exemplifies a discovery articulated repeatedly in modern art: the discovery of disability as a unique resource, recouped from the past and re-created in the present, for aesthetic creation and appreciation. The Venus de Milo is one of many works of art called beautiful by the tradition of modern aesthetic response, and yet it eschews the uniformity of perfect bodies to embrace the variety of disability.

To argue from the flip side, would Nazi art be considered kitsch if it had not pursued so relentlessly a bombastic perfection of the body? Sculpture and painting cherished by the Nazis exhibit a stultifying perfection of the human figure. Favored male statuary such as Arno Breker's *Readiness* displays bulked-up and gigantesque bodies that intimidate rather than appeal (fig. 2). The perfection of the bodies is the very mark of their unreality and lack of taste. Nazi representations of women, as in Ivo Saliger's *Diana's Rest,* portray women as reproductive bodies having little variation among them (color pl. 2). They may be healthy, but they are emotionally empty. When faced by less kitschy representations of the body, the Nazis were repulsed, and they launched their own version of a culture war: their campaign against modern art stemmed from the inability to tolerate any human forms except the most familiar, monochromatic, and regular. Specifically, the Nazis rejected the modern in art as degenerate and ugly because they viewed it as representing physical and mental disability. Hitler saw in paintings by Modigliani, Klee, and Chagall images of "misshapen cripples," "cretins," and racial inferiors (figs. 3 and 4) when the rest of the world saw masterpieces of modern art (cited by Mosse 29; see also Siebers 2000a). Hitler was wrong, of course—not about the place of disability in modern aesthetics but about its beauty. Modern art continues to move us because of its refusal of harmony, bodily integrity, and

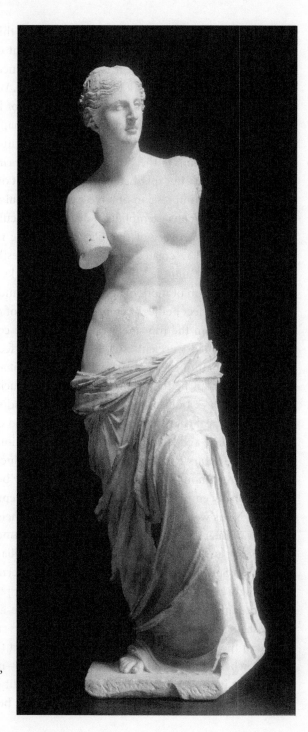

Figure 1. Venus de
Milo, 100 BCE, Paris,
Louvre

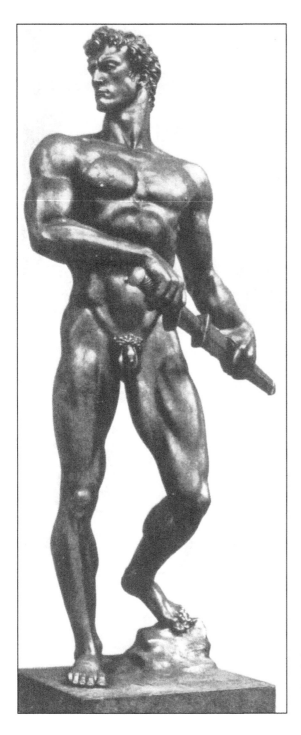

Figure 2. Arno Breker,
Readiness, 1937,
Great German Art
Exhibition, 1937

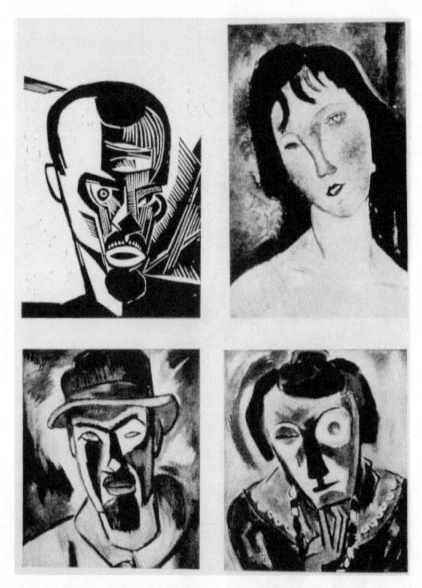

Figure 3. "Degenerate" art by Karl Schmidt-Rottluff and Amedeo Modigliani, from Paul Schultze-Naumburg, *Kunst und Rasse*, 1928

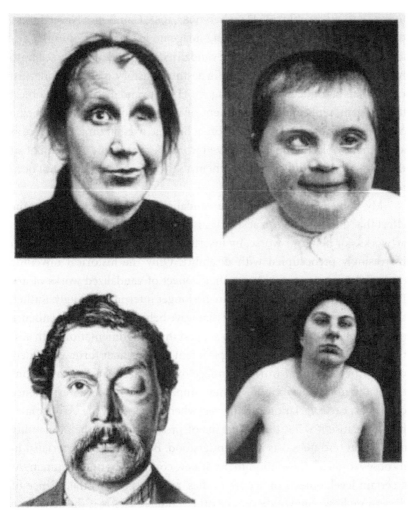

Figure 4. Facial deformities, from Paul Schultze-Naumburg, *Kunst und Rasse*, 1928

perfect health. If modern art has been so successful, I argue, it is because of its embrace of disability as a distinct version of the beautiful.

What is the impact of damage on classic works of art from the past? It is true that we strive to preserve and repair them, but perhaps the accidents of history have the effect of renewing rather than destroying artworks. Vandalized works seem strangely modern. In 1977 a vandal attacked a Rembrandt self-portrait with sulfuric acid, transforming the masterpiece

forever and regrettably (see Dornberg 1987, 1988; Gamboni). Nevertheless, the problem is not that the resulting image no longer belongs in the history of art. Rather, the riddle of the vandalized work is that it now seems to have moved to a more recent stage in aesthetic history, giving a modernist rather than baroque impression (fig. 5). The art vandal puts the art object to use again, replicating the moment of its inception when it was being composed of raw material and before it became fixed in time and space as an aesthetic object. Would vandalized works become more emblematic of the aesthetic, if we did not restore them, as the Venus de Milo has not been restored?

My point is not to encourage vandalism but to use it to query the effect that disability has on aesthetic appreciation. Vandalism modernizes artworks, for better or worse, by inserting them in an aesthetic tradition increasingly preoccupied with disability. Only the historical unveiling of disability accounts for the aesthetic effect of vandalized works of art. Damaged art and broken beauty are no longer interpreted as ugly. Rather, they disclose new forms of beauty that leave behind a kitschy dependence on perfect bodily forms. They also suggest that experimentation with aesthetic form reflects a desire to experiment with human form. Beholders discover in vandalized works an image of disability that asks to be contemplated not as a symbol of human imperfection but as an experience of the corporeal variation found everywhere in modern life. Art is materialist because it relies on the means of production and the availability of material resources—as Marx understood. But art is also materialist in its obsession with the embodiment of new conceptions of the human. At a certain level, objects of art are bodies, and aesthetics is the science of discerning how some bodies make other bodies feel. Art is the active site designed to explore and expand the spectrum of humanity that we will accept among us.

Since human feeling is central to aesthetic history, it is to be expected that disability will crop up everywhere because the disabled body and mind always elicit powerful emotions. I am making a stronger claim: that disability is integral to modern aesthetics and that the influence of disability on art has grown, not dwindled, over the course of time. If this is the case, we may expect disability to exert even greater power over art in the future. We need to consider, then, how art is changed when we conceive of disability as an aesthetic value in itself. In particular, it is worth asking

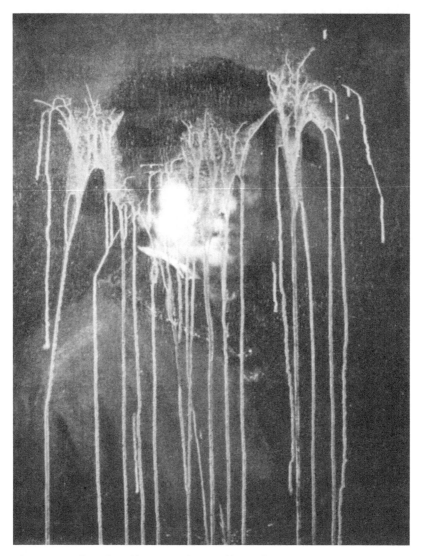

Figure 5. Rembrandt, *Self-Portrait,* damaged by acid in 1977

how the presence of disability requires us to revise traditional conceptions of aesthetic production and appreciation, and here the examples of two remarkable artists, Paul McCarthy and Judith Scott, make a good beginning because they are especially illuminating and suggestive.

Paul McCarthy is well known in avant-garde circles for his chaotic,

almost feral, bodily performances as well as his tendency to make art from food and condiments. One of the most significant fictions of disembodiment in the history of art is, of course, the doctrine of disinterestedness, which defines the power of an artwork in direct proportion to the urgency of the desires and appetites overcome in the beholder. Hunger, sexual desire, and greed have no place in the appreciation of artworks, despite the fact that these appetites are constant themes in art. McCarthy challenges the classic doctrine of disinterestedness in aesthetic appreciation by revealing that it censors not only the body but also the disabled body. He refuses to prettify the human body, reproducing the logic of the nineteenth-century freak show in the museum space with exhibits that stress bodily deformation. He also makes art out of foodstuff, forcing beholders to experience his work with all their senses, not merely with their eyes. In short, his is a different embodiment of art, one expert in the presentation of differently abled bodies. For example, *Hollywood Halloween* (figs. 6 and 7) pictures the artist tearing a Halloween mask from his head, but because the mask has been stuffed with hamburger meat and ketchup in addition to the artist's head, the effect is a kind of self-defacement. The transformation of the artist from eerie able-bodiedness to the defacement of disability is the work's essential movement. The work reverses the apparently natural tendency to consider any form of corporeal transformation as driven by the desire for improvement or cure. In *Death Ship* (color pl. 3), a crazed ship captain hands out sailor hats to the audience, inviting them on a voyage in which the boundaries between body, food, and filth dissolve, as the captain smears his body with ketchup and food and installs a feeding tube for himself running from his anus to his mouth. *Mother Pig* (color pl. 4) similarly plays out a self-sculpture using processed meats and condiments in which McCarthy, masked as a pig, wraps strings of frankfurters smeared with ketchup around his penis. In these typical works, the smell of raw meat and pungent condiments permeate the air of the performance space, making it difficult for the audience to avoid reactions to foodstuff and flesh from its everyday life.

In addition to the challenge to disinterestedness perpetrated on the audience by McCarthy's stimulation of the appetite or gag reflex, as well as the assault on human beauty and form, is the representation of the mental condition of the artist. As the performances grow more intense and irrational, the audience begins to react to McCarthy as if he were mentally

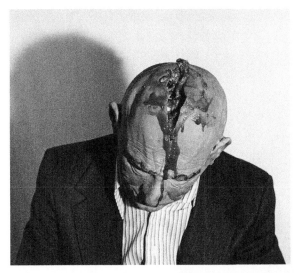

Figure 6. Paul McCarthy, *Hollywood Halloween*, 1977, performance

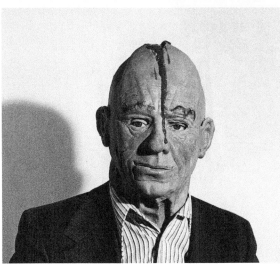

Figure 7. Paul McCarthy, *Hollywood Halloween*, 1977, performance

disabled. The video of *Class Fool* (1976), for example, shows the audience's reaction to his performance, moving from amusement, to hesitation, to aversion. At some level, McCarthy's commitment to elemental behavior—smearing himself with food, repeating meaningless actions until they are ritualized, fondling himself in public—asks to be seen as idiocy, as if the core values of intelligence and genius were being systematically removed from the aesthetic in preference to stupidity and cognitive disorder. *Plaster*

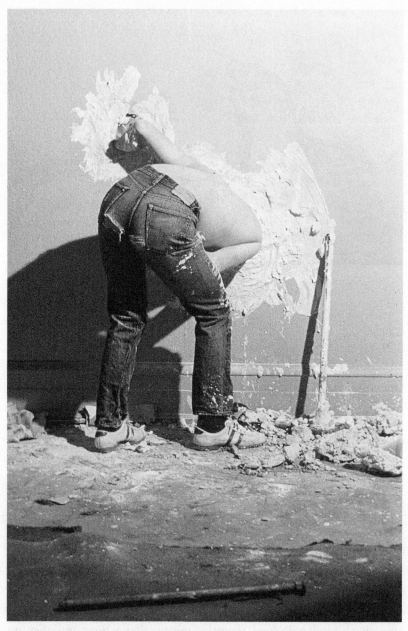

Figure 8. Paul McCarthy, *Plaster Your Head and One Arm into a Wall*, 1973, performance

Your Head and One Arm into a Wall (fig. 8), in which McCarthy inserts his head and left arm into wall cavities and then uses his right hand to close the holes with plaster, provides a more obvious example of these values. McCarthy changes how art is appreciated by overstimulating his audience with a different conception of art's corporeality. He takes the analogy between artwork and body to its limit, challenging ideas about how the human should be transformed and imagined. Moreover, the link between aesthetic appreciation and taste faces a redoubtable attack in his works because of their single-minded evocation of things that disgust.

The appreciation of the work of art is a topic well rehearsed in the history of aesthetics, but rarely is it considered from the vantage point of the disabled mind—no doubt because the spectacle of the mentally disabled person, rising with emotion before the shining work of art, disrupts the long-standing belief that pronouncements of taste depend on a form of human intelligence as autonomous and imaginative as the art object itself. Artistic production also seems to reflect a limited and well-defined range of mental actions. Traditionally, we understand that art originates in genius, but genius is really at a minimum only the name for an intelligence large enough to plan and execute works of art—an intelligence that usually goes by the name of "intention." Defective or impaired intelligence cannot make art according to this rule. Mental disability represents an absolute rupture with the work of art. It marks the constitutive moment of abolition, according to Michel Foucault, that dissolves the essence of what art is (286).

The work of Judith Scott challenges the absolute rupture between mental disability and the work of art and applies more critical pressure on intention as a standard for identifying artists. It is an extremely rare case, but it raises complex questions about aesthetics of great value to people with disabilities. A remarkably gifted fiber artist emerged in the late 1980s in California named Judith Scott. Her work is breathtaking in its originality and possesses disturbing power as sculptural form (color pl. 5). The sculptures invite comparisons with major artists of the twentieth century and allude to a striking variety of mundane and historical forms, from maps to the works of Alberto Giacometti, from Etruscan art and classical sculpture in its fragmentary state, to children's toys (color pl. 6). What makes the fiber sculptures even more staggering as works of art is the fact that Scott has no conception of the associations sparked by her

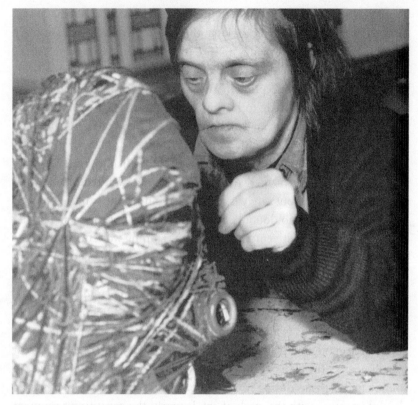

Figure 9. Judith Scott in action, no date, Creative Growth Center

objects and no knowledge of the history of art. In fact, she never visited
a museum or read an art book, she did not know she was an "artist," and
never intended to make "art" when she set to work, at least not in the con-
ventional understanding of these words. This is because Scott had Down
syndrome (fig. 9). She was also deaf, unable to speak, extremely uncom-
municative, isolated. She was warehoused at age seven in the Ohio Asylum
for the Education of Idiotic and Imbecilic Youth and spent the next thirty-
five years of her life as a ward of the state, until her twin sister rescued her
and enrolled her in the Creative Growth Center, a California program in
Oakland designed to involve intellectually disabled people with the visual
arts. Almost immediately, she began to make fiber sculptures six hours a
day, and she maintained this relentless pace for over ten years.

Although materials were made available to her, Scott behaved as if

she were pilfering them, and each one of her sculptures takes the form of a cocoon at the center of which is secreted some acquired object (color pl. 7). The first hidden objects were sticks and cardboard spools used to store yarn and thread. Then she began to wrap other objects, an electric fan, for instance. Commentators have made the habit of associating her methods with acts of theft and a kind of criminal sensibility, acquired during thirty-five years in a mental institution. The association between Scott's aesthetic method and criminal sensibility, however, takes it for granted that she was unable to distinguish between the Ohio Asylum for the Education of Idiotic and Imbecilic Youth and the Creative Growth Center in Oakland, between thirty-five years spent in inactivity and neglect and her years involved intensively in the making of objects of beauty. The fact is that Scott's relation to her primary materials mimics modern art's dependence on found art—a dependence that has never been described as a criminal sensibility, to my knowledge. Her method demonstrates the freedom both to make art from what she wants and to change the meaning of objects by inserting them into different contexts. One incident in particular illuminates her attitude toward her primary materials. During a period of construction in the art center, Scott was left unobserved one day for longer than usual. She emptied every paper-towel dispenser in the building and fabricated a beautiful monochromatic sculpture made entirely of knotted white paper towels (fig. 10).

Scott's method always combines binding, knotting, sewing, and weaving different fiber materials around a solid core whose visibility is entirely occluded by the finished work of art. She builds the works patiently and carefully, as if in a process of concealment and discovery that destroys one object and gives birth to another mysterious thing (fig. 11). A number of aesthetic principles are clearly at work in her method, even though she never articulated them. She strives to ensure the solidity and stability of each piece, and individual parts are bound tightly to a central core. Since she had no view to exhibit her work, no audience in mind, her sculptures do not distinguish between front and back. Consequently, her work projects a sense of independence and autonomy almost unparalleled in the sculptural medium (color pl. 8). Despite the variety of their shape, construction, and parts, then, Scott's sculptures consolidate all of their elements to give the impression of a single, unique body.

John MacGregor, who has done the most extensive study to date on

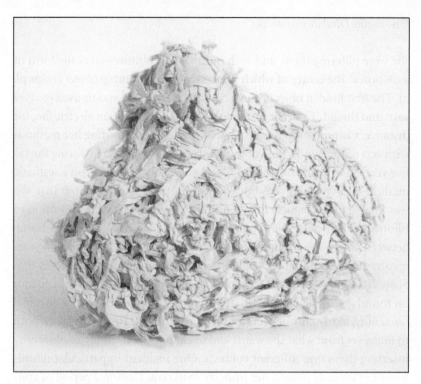

Figure 10. Judith Scott, untitled, no date, Creative Growth Center

Figure 11. Judith Scott in action, no date, Creative Growth Center

Scott, poses succinctly the obvious critical questions raised by her work. "Does serious mental retardation," he asks, "invariably preclude the creation of true works of art? . . . Can art, in the fullest sense of the word, emerge when intellectual development is massively impaired from birth, and when normal intellectual and emotional maturation has failed to be attained?" (3). The problem, of course, is that Scott did not possess the intelligence associated with true artists by the tradition of art history. What kind of changes in the conception of art would be necessary to include her in this history?

Despite the many attacks launched by modern artists, genius remains the unspecified platform on which almost every judgment in art criticism is based, whether about artistic technique, invention, or subversiveness. In fact, Thomas Crow claims that the campaign against autonomy and creativity in modern art gives rise to a cult of the genius more robust than any conceived during the Romantic period. The growth, rather than decline, of heroic biography supporting the value of art is a constant theme in his work (1996a). We still assume that creativity is an expression of inspiration and autonomy, just as we assume that aesthetic technique is a form of brilliance always at the artist's disposal. Intelligence, however, is fraught with difficulties as a measure of aesthetic quality, and intention in particular has long been condemned as an obsolete tool for interpreting works of art.[2] Artists do not control—nor should they—the meaning of their works, and intentions are doubtful as a standard of interpretation because they are variable, often forgotten, improperly executed, inscrutable to other people, and marred by accidents in aesthetic production. If intention has uncertain value for interpretation, why should it be used to determine whether an action or object is a work of art?

Disability aesthetics prizes physical and mental difference as a significant value in itself. It does not embrace an aesthetic taste that defines harmony, bodily integrity, and health as standards of beauty. Nor does it support the aversion to disability required by traditional conceptions of human or social perfection. Rather, it drives forward the appreciation of disability found throughout modern art by raising an objection to aesthetic standards and tastes that exclude people with disabilities. Modern art comes over time to be identified with disability, and to the point where the appearance of the disabled or wounded body signals the presence of the aesthetic itself. No object beyond the figure of disability has a greater

capacity to be accepted at the present moment as an aesthetic representation. Disability is not, therefore, one subject of art among others. It is not merely a theme. It is not only a personal or autobiographical response embedded in an artwork. It is not solely a political act. It is all of these things, but it is more. It is more because disability is properly speaking an aesthetic value, which is to say, it participates in a system of knowledge that provides materials for and increases critical consciousness about the way that some bodies make other bodies feel. The idea of disability aesthetics affirms that disability operates both as a critical framework for questioning aesthetic presuppositions in the history of art and as a value in its own right important to future conceptions of what art is. It is only right, then, that we refer, when we acknowledge the role played by disability in modern art, to the idea of disability aesthetics.

Chapter 2

The Aesthetics of Human Disqualification

Smile Train, an international organization devoted to children with cleft palette, seems in many ways to be a model charity. It trains and uses local doctors. It claims to put 100 percent of contributions toward surgeries. But Smile Train is a model charity in more than one way. It promotes itself by giving a familiar and typical appearance to disability, following an aesthetic model long established for the purpose of qualifying some people and disqualifying others. The "world's leading cleft charity" uses in-your-face, close-up portraits of disabled children, largely of color and non-Western, to encourage donations to the "modern-day medical miracle" designed "to give a desperate child not just a new smile, but a new life" (fig. 12).[1] Smile Train equates disability with loss of life, isolating the children from everyday existence and exhibiting them in a series of medical mug shots. Individuality is downplayed, and the children appear first and foremost as medical specimens of nature gone awry, displayed to elicit feelings of pity, disgust, and charity. The children's color, non-Western origin, and disabled state stand in sharp contrast to the white, smiling, celebrity friends, such as Candice Bergen, who urge donors to be generous.[2] Smile Train "enfreaks" the children, to use David Hevey's term, only to promise to whisk away their freakish nature through the magic of modern medical technology.[3]

Let me note from the outset that I am not opposing the sharing of

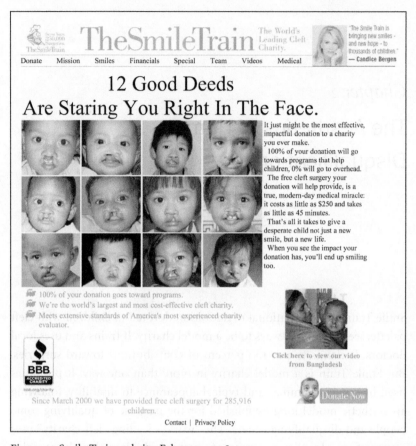

Figure 12. Smile Train website, February 2008

medical technology across the globe, the assistance of poor nations by wealthy nations, or the creation of charities and nongovernmental organizations devoted to particular world problems. These are desperate times, and many people in the world need help. Rather, what concerns me is the symbolism by which populations and individuals are established as needing help, as being inferior, and the role played by disability in that symbolism, because it has a long history of being placed in the service of discrimination, inequality, and violence. What I am calling the aesthetics of human disqualification focuses on how ideas about appearance contribute to these and other forms of oppression. My claim is that this symbolism depends on aesthetic representations that require further clarification

and critique, especially with respect to how individuals are disqualified, that is, how they are found lacking, inept, incompetent, inferior, in need, incapable, degenerate, uneducated, weak, ugly, underdeveloped, diseased, immature, unskilled, frail, uncivilized, defective, and so on. My intention is less to provide a theoretical description of this problem than to review a series of analytic examples from the historical record, but I will begin by defining my theoretical vocabulary and presuppositions.

Three Definitions

Disqualification as a symbolic process removes individuals from the ranks of quality human beings, putting them at risk of unequal treatment, bodily harm, and death. That people may be subjected to violence if they do not achieve a prescribed level of quality is an injustice rarely questioned. In fact, even though we may redefine what we mean by quality people, for example as historical minorities are allowed to move into their ranks, we have not yet ceased to believe that nonquality human beings do exist and that they should be treated differently from people of quality. Harriet McBryde Johnson's debate with Peter Singer provides a recent example of the widespread belief in the existence of nonquality human beings (Johnson). Johnson, a disability activist, argues that all disabled people qualify as persons who have the same rights as everyone else. Singer, a moral philosopher at Princeton University, claims to the contrary that people with certain disabilities should be euthanized, especially if they are thought to be in pain, because they do not qualify as persons. Similarly, Martha Nussbaum, the University of Chicago moral philosopher, establishes a threshold below which "a fully human life, a life worthy of human dignity," is not possible (181). In particular, she notes that the onset of certain disabilities may reduce a person to the status of former human being: "we may say of some conditions of a being, let us say a permanent vegetative state of a (former) human being, that this just is not a human life at all" (181).

 Surprisingly little thought and energy have been given to disputing the belief that nonquality human beings do exist. This belief is so robust that it supports the most serious and characteristic injustices of our day. Disqualification at this moment in time justifies discrimination, servi-

tude, imprisonment, involuntary institutionalization, euthanasia, human and civil rights violations, military intervention, compulsory sterilization, police actions, assisted suicide, capital punishment, and murder. It is my contention that disqualification finds support in the way that bodies appear and in their specific appearances—that is, disqualification is justified through the accusation of mental or physical inferiority based on aesthetic principles.

Disqualification is produced by naturalizing inferiority as the justification for unequal treatment, violence, and oppression. According to Snyder and Mitchell, disability serves in the modern period as "the master trope of human disqualification."[4] They argue that disability represents a marker of otherness that establishes differences between human beings not as acceptable or valuable variations but as dangerous deviations. Douglas Baynton provides compelling examples from the modern era, explaining that during the late nineteenth and early twentieth centuries in the United States disability identity disqualified other identities defined by gender, race, class, and nationality. Women were deemed inferior because they were said to have mental and physical disabilities. People of color had fewer rights than other persons based on accusations of biological inferiority. Immigrants were excluded from entry into the United States when they were poor, sick, or failed standardized tests, even though the populations already living there were poor, sick, and failed standardized tests. In every case, disability identity served to justify oppression by amplifying ideas about inferiority already attached to other minority identities. Disability is the trope by which the assumed inferiority of these other minority identities achieved expression.

The appearance of lesser mental and physical abilities disqualifies people as inferior and justifies their oppression. Thanks to the work of Baynton and others, it is now possible to recognize disability as a trope used to posit the inferiority of certain minority populations, but it remains extremely difficult to understand that mental and physical markers of inferiority are also tropes placed in the service of disability oppression. Before disability can be used as a disqualifier, disability, too, has to be disqualified. Beneath the troping of blackness as inbuilt inferiority, for example, lies the troping of disability as inferior. Beneath the troping of femininity as biological deficiency lies the troping of disability as deficiency. The mental and physical properties of bodies become the natural symbols of inferiority via a

process of disqualification that seems biological, not cultural—which is why disability discrimination seems to be a medical rather than a social problem. If we consider how difficult it is at this moment to disqualify people as inferior on the basis of their racial, sexual, gender, or class characteristics, we may come to recognize the ground that we must cover in the future before we experience the same difficulty disqualifying people as inferior on the basis of disability. We might also recognize the work that disability performs at present in situations where race, sexuality, gender, and class are used to disqualify people as physically or mentally inferior. At the current time we prefer to fix, cure, or eradicate the disabled body rather than the discriminatory attitudes of society. Medicine and charity, not social justice, are the answers to the problems of the disabled body, because the disabled body is thought to be the real cause of the problems. Disability is a personal misfortune or tragedy that puts people at risk of a nonquality existence—or so most people falsely believe.

Aesthetics studies the way that some bodies make other bodies feel. Bodies, minimally defined, are what appear in the world. They involve manifestations of physical appearance, whether this appearance is defined as the physical manifestation itself or as the particular appearance of a given physical manifestation. Bodies include in my definition human bodies, paintings, sculpture, buildings, the entire range of human artifacts as well as animals and objects in the natural world. Aesthetics, moreover, has always stressed that feelings produced in bodies by other bodies are involuntary, as if they represented a form of unconscious communication between bodies, a contagious possession of one body by another. Aesthetics is the domain in which the sensation of otherness is felt at its most powerful, strange, and frightening. Whether the effect is beauty and pleasure, ugliness and pain, or sublimity and terror, the emotional impact of one body on another is experienced as an assault on autonomy and a testament to the power of otherness. Aesthetics is the human science most concerned with invitations to think and feel otherwise about our own influence, interests, and imagination.

Of course, when bodies produce feelings of pleasure or pain, they also invite judgments about whether they should be accepted or rejected in the human community. People thought to experience more pleasure or pain than others or to produce unusual levels of pleasure and pain in other bodies are among the bodies most discriminated against, actively

excluded, and violated on the current scene, be they disabled, sexed, gendered, or racialized bodies. Disabled people, but also sex workers, gay, lesbian, bisexual, and transgendered people, and people of color, are tortured and killed because of beliefs about their relationship to pain and pleasure (Siebers 2009). This is why aesthetic disqualification is not merely a matter for art critics or museum directors but a political process of concern to us all. An understanding of aesthetics is crucial because it reveals the operative principles of disqualification used in minority oppression.

Oppression is the systematic victimization of one group by another. It is a form of intergroup violence. That oppression involves "groups," and not "individuals," means that it concerns identities, and this means, furthermore, that oppression always focuses on how the body appears, both on how it appears as a public and physical presence and on its specific and various appearances. Oppression is justified most often by the attribution of natural inferiority—what some call "in-built" or "biological" inferiority. Natural inferiority is always somatic, focusing on the mental and physical features of the group, and it figures as disability. The prototype of biological inferiority is disability. The representation of inferiority always comes back to the appearance of the body and the way the body makes other bodies feel. This is why the study of oppression requires an understanding of aesthetics—not only because oppression uses aesthetic judgments for its violence but also because the signposts of how oppression works are visible in the history of art, where aesthetic judgments about the creation and appreciation of bodies are openly discussed.

Two additional thoughts must be noted before I treat some analytic examples from the historical record. First, despite my statement that disability now serves as the master trope of human disqualification, it is not a matter of reducing other minority identities to disability identity. Rather, it is a matter of understanding the work done by disability in oppressive systems. In disability oppression, the physical and mental properties of the body are socially constructed as disqualifying defects, but this specific type of social construction happens to be integral at the present moment to the symbolic requirements of oppression in general. In every oppressive system of our day, I want to claim, the oppressed identity is represented in some way as disabled, and although it is hard to understand, the same process obtains when disability is the oppressed identity. "Racism" disqualifies on the basis of race, providing justification for the inferiority of

certain skin colors, bloodlines, and physical features. "Sexism" disqualifies on the basis of sex/gender as a direct representation of mental and physical inferiority. "Classism" disqualifies on the basis of family lineage and socioeconomic power as proof of inferior genealogical status. "Ableism" disqualifies on the basis of mental and physical differences, first selecting and then stigmatizing them as disabilities. The oppressive system occults in each case the fact that the disqualified identity is socially constructed, a mere convention, representing signs of incompetence, weakness, or inferiority as undeniable facts of nature.

Second, it is crucial to remember the lessons of intersectional theory. This theory rightly focuses on how oppressive systems affect the identity of the oppressed individual, explaining that because individuality is complex, containing many overlapping identities, the individual is vulnerable to oppressive systems that would reduce the individual to one or two identities for the purpose of maintaining power and control (Collins 208).[5] Intersectional theorists restore a complex view of the individual and fight against creating hierarchies between different identities. For example, the debate whether it is worse to be black or female is viewed as divisive and unproductive. My tactic here is similar. I want to look at identity not from the point of view of the oppressed individual but from the point of view—limited as it may seem and significant because limited—of oppressive systems. Disability is the master trope of human disqualification, not because disability theory is superior to race, class, or sex/gender theory, but because all oppressive systems function by reducing human variation to deviancy and inferiority defined on the mental and physical plane.

Intersectional analysis shows that disability identity provides a foundation for disqualification in cases where other minority identities fail because they are known to be socially constructed for the purposes of domination. It is not clear why disability has proven so useful a trope for maintaining oppression, but one reason may be that it has been extraordinarily difficult to separate disability from the naturalist fallacy that conceives of it as a biological defect more or less resistant to social or cultural intervention. In the modern era, of course, eugenics embodies this fallacy. Eugenics has been of signal importance to oppression because eugenics weds medical science to a disgust with mental and physical variation, but eugenics is not a new trend, only an exacerbation of old trends that invoke disease, inferiority, impairment, and deformity to disqualify one group in

the service of another's rise to power. As racism, sexism, and classism fall away slowly as justifications for human inferiority—and the critiques of these prejudices prove powerful examples of how to fight oppression— the prejudice against disability remains in full force, providing seemingly credible reasons for the belief in human inferiority and the oppressive systems built upon it. This usage will continue, I expect, until we reach a historical moment when we know as much about the social construction of disability as we now know about the social construction of race, class, gender, and sexuality. Disability represents at this moment in time the final frontier of justifiable human inferiority.

Three Analytic Examples

The aesthetics of human disqualification presents in almost every sphere of human influence, but because the art world thrives on aesthetic judgments, art-making practices and debates about them provide a unique window into disqualifying and qualifying statements about human appearance, made almost always, of course, in the guise of judgments of taste. Oddly, although the source of disqualification is not the aesthetic itself, the devices of disqualification are often worked through in the aesthetic context—at museums, art shows, in literary works, music, art catalogs, magazines, and by entertainments of various kinds. My itinerary begins with a focus on the Nazi era because of its definitive and violent interpretation of modern art as part of a medical and eugenic project that disqualifies certain populations as defective. Then I jump forward in time to the controversial display in 2005 of Marc Quinn's sculpture of Alison Lapper in London's Trafalgar Square. Here I address the debate about whether disabled bodies should be subjects of art and displayed in public spaces. Finally, I conclude by looking at a 2008 essay in *Newsweek* magazine that reproduces medical photographs from the Mütter Museum in Philadelphia in a gesture embracing the tradition of the freak show. Each analytic example demonstrates the shuttling back and forth of aesthetic judgments between the art world and the political world, providing the occasion to map the operative principles obtaining between aesthetics, disqualification, and oppression.

 Degenerate Art and Defective People. Although the Nazis were not shy

about using disability to disqualify human beings, these attitudes acquired even greater transparency in statements about the art world. Hitler's love of art and conception of himself as an artist—as preposterous as they may seem—meant that art was the preferred vehicle for the development of Nazi ideas and philosophy. It was also the domain where we see played out Nazi ideas about nonquality human beings. The competition in 1937 between the Grosse Deutsche Kunstausstellung (Great German Art Exhibition) and the exhibit of Entartete Kunst (Degenerate Art) makes the use of aesthetic disqualification by the Nazis' crystal clear by setting in opposition their positive and negative conceptions of human types. The Degenerate Art exhibition represented the Nazis' attack on modern art because of its portrayal of "defective" people, while the Great German Art Exhibition, with which Hitler inaugurated the House of German Art, was supposed to demonstrate the superiority of German bloodlines and aesthetic taste. The purposes of the two exhibitions could not have been more different, but their occurrence in the same year provides the occasion to construct from their negative and positive views of human appearance a clear conception of the Nazi system of aesthetic disqualification.[6]

The works included in the Great German Art Exhibition avoid representing physical imperfection and racial diversity at all costs. The Nazis staked their claim to superiority on the representation of beautiful and healthy German bodies, although the works are now indistinguishable from kitsch. The controlling design of the exhibition came directly from Hitler's ideas about art, as revealed by many public statements. Hitler embraced health and racial homogeneity as the measures of quality human beings. Disease and disability were his principal disqualifiers. "The German people," Hitler exclaimed, "with their newly awakened affirmation of life are seized with admiration for strength and beauty and therefore for what is healthy and vigorous" (Adam 76). "We only want the celebration of the healthy body in art" (Adam 149). The House of German Art was to open its doors only to ability, not disability.

In contrast, Hitler accused the modern works shown in the Entartete Kunst exhibit of reveling in "deformed cripples and cretins, women who inspire only disgust, men who are more like wild beasts, children who, if they were alive, would be regarded as God's curse!" (Sax and Kuntz 230). As evidence for Nazi claims about the biological inferiority of the subjects pictured in modern art, the catalog designed to accompany Entartete

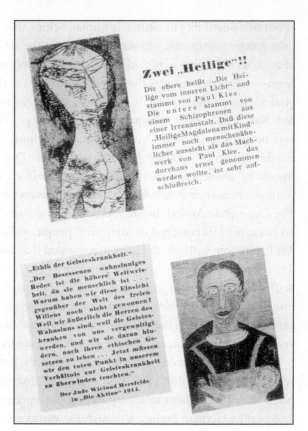

Figure 13. Paul Klee and "Schizophrenic," Germany, Entartete Kunst exhibition catalog, 1937

Kunst juxtaposed modernist works and examples of facial deformities as well as works by modern artists and mental patients. The catalog claims, for example, that a painting by a "schizophrenic from a lunatic asylum" "looks more human than Paul Klee's botched effort" (Barron 383) (fig. 13). Entartete Kunst asks beholders not only to cast the psychological sources of modern art as mentally incompetent but also to confuse modernist experiments with form with realistic depictions of disabled human beings. Paul Schultze-Naumburg, author in 1928 of *Kunst und Rasse,* provides an early example of the strategy used by Entartete Kunst to denigrate modern art; the book compares portraits by Modigliani, Schmidt-Rottluff, and others to medical photographs of physically disabled and diseased patients (figs. 3 and 4).[7] Similarly, Entartete Kunst either interpreted artworks as medical specimens or juxtaposed artworks with medical photographs

and other artifacts. The exhibition sought to tutor the public in the Nazi vision of aesthetics by suggesting the negative medical impact that disabled and racially diverse people might have on the German population. In effect, beholders were supposed to see the so-called degenerate works through Nazi eyes as picturing examples of in-built inferiority, providing an experience of disability preliminary to the extermination of more than 200,000 human beings with similar characteristics.[8]

Degeneration was principally a medical term before Max Nordau applied it to art. It referred throughout the last half of the nineteenth century to individuals who departed from norms of human health because of genetic difference, sexual habits deemed excessive, or shattered nerves. The Nazis applied these distinctions as standards of aesthetic beauty. Degenerate art deserved its name in their view because it included bodily deformities, bloodshot eyes, feebleness, and signs of nervous exhaustion— all disabling conditions supposedly brought about by racial impurity or the stress of modern life. Jews, homosexuals, and criminals were automatically assumed to be biologically inferior, and the Nazis found evidence for their assumptions in the physical traits given to people in works of modern art.

The works banned as degenerate by the Nazis are more familiar in their form and content than those approved by them. Consequently, it makes sense to focus first on the so-called Great German Art, so that we may let the full power of defamiliarization strike us when we turn to the better-known works and artists. The point of the comparison, I remind, is to gain an understanding of the aesthetics of human disqualification, not to make judgments about which objects are better works of art. This goal requires attention to the contribution of aesthetics to oppression, that is, to the choice of appearance placed in the service of intergroup or political violence.

The Great German Art works to achieve qualification for the German people by designing a specific though imaginary human type based on the healthy and able body. This type was proposed as the norm, and deviation from it tended to justify disqualification and oppression. One of the oddities revealed by a disability studies perspective on aesthetics, however, is how truly unreal and imaginary are nondisabled conceptions of the human body. Remove imperfection from the body, and one discovers the perfect recipe for what does not exist for the most part in the human uni-

verse. Disability theorists are fond of noting that nondisabled bodies are all alike, while disability takes a thousand unique and different forms. If the strength of human nature lies in its evolutionary compact with variation, then the Nazi drive toward perfection based on uniformity produces results contrary to the laws of evolution. The Great German Art refuses variation by embracing an idea of human form characterized by exaggerated perfection and striking regularity. Arno Breker's *Readiness* represents the perfect picture of health and ability, but it is deeply unreal and stumbles into pure kitsch: its pumped-up body, thought classical by the Nazis, actually swerves away from its Greek models to present a profile and shape outside the bounds of human form (fig. 2). Famously called Hitler's Michelangelo, Breker preferred to model his sculptures on the bodies of athletes, but his works seem more frequently to represent bodybuilders—shapes contoured by steroids rather than sport and dubious as examples of male beauty.

"There is no exquisite beauty," Francis Bacon claimed, "without some strangeness in the proportion." By these lights, the only thing beautiful about Ivo Saliger's *Diana's Rest* is the peculiar fact that the three women are all exactly the same (color pl. 2). It is a convention of painting to base multiple figures on the same model, but in this example the convention springs from the ideological imperative to achieve human perfection by suppressing individual variation. *Diana's Rest* provides an example of the eerie world, sought by the Nazis, in which the desire for perfection quashes individuality and variety. Josef Thorak's *Comradeship* demonstrates the masculine version of this overcharged regularity (fig. 14). Matched muscle for muscle, the gigantic figures twin each other, while striving to embody an impossible ideal of human health. According to Hitler's address at the opening of the Great German Art Exhibition, the Nazi eugenic project required an emphasis on beauty and health as the first step in achieving the goal of creating a new human type. "The new age of today is at work on a new human type," Hitler remarks: "Tremendous efforts are being made in countless spheres of life in order to elevate our people, to make our men, boys, lads, girls, and women more healthy and thereby stronger and more beautiful. From this strength and beauty streams forth a new feeling of life, and a new joy in life. Never before was humanity in its external appearance and perceptions closer to the ancient world than it is today" (Sax and Kuntz 230).[9] Strangeness in proportion in either indi

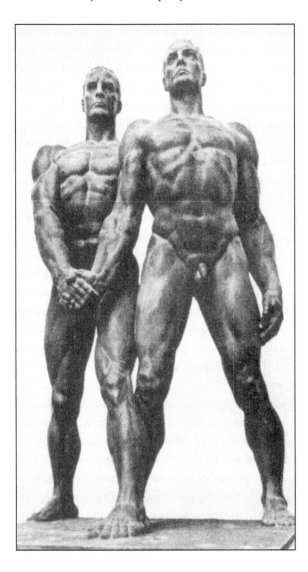

Figure 14. Josef Thorak, *Comradeship*, 1937, Germany, Great German Art Exhibition, 1937

vidual human figures or among them is deliberately eschewed in Nazi art because its goal is to portray a new human being whose embodiment of beauty and health results in an almost obscene regularity of features and body parts.

The image of nature in the Great German Art mirrors its treatment of the human body in the emphasis on banal, unvarying, and exaggerated perfection. If German blood issues supposedly from the soil, the picture

of meadow, pasture, and forest in Nazi art seeks an image of nature that supposedly proves the superiority and durability of the German people. Nature in Nazi art is all abundance, but the ripeness is so artificial that it seems—and there is no irony intended—to bulge with decay. It has often been noted that Nazi artists take their image of nature from the tradition of German Romantic art, especially the paintings of Caspar David Friedrich. The influence, however, is vastly overstated. Friedrich's nature scenes possess an aura of desolation, focusing often on a lone marker in the landscape such as a cross, a solitary figure, a crumbling church, a dead tree, or a broken grave marker. There are no dead trees, ruins, or broken graves in Nazi landscapes—no hint of the weight of time or the inevitability of death blemishing nature's bounty. Rather, nature exists as an eternal plenitude resistant to decay and death. For example, Oskar Martin-Amorbach's *The Sower* displays a blond peasant, marching across a field and smiling at the good earth in satisfaction, against a backdrop of vast blue sky and other fields being prepared for planting—all of the elements united by a rainbow as if to testify to a Nazi covenant with nature (color pl. 9). There is not a single dead tree in view, no plant that is not ready to burst into full bloom. Gisbert Palmié's *Rewards of Work* represents the same vision of nature (color pl. 10). The figures in the foreground, all surrounded by friendly animals and involved in expressions of antiquated labor (weaving on a spinning wheel, gathering fruit in a basket, harvesting wheat in sheaves), focus their attention on a nude blond goddess, apparently work's reward personified, from whom flows an almost infinite trail of golden cloth. In the background blossoms a spectacle of unspoiled nature: a bright sky, flowing river, abundant trees, and grassy meadows. No one aware of the earth's seasons could find in Nazi art the smallest semblance of nature's passage from birth and fullness to death and rebirth. Rather, nature seems fixed in an unending summer, never displaying the slightest hint of autumn, let alone the death of winter—a testimony to the Nazi hope that the Third Reich might endure without change for a thousand years.

Compared to the Great German Art, the art labeled degenerate by the Nazis presents a startling variety of human appearances. But more startling are the suggestions, first, that this variety is an effect of including disability and, second, that the Nazis were the first to recognize the aesthetic centrality of disability to modern art. It is not merely the case

that the Nazis preferred representational art to Dada or expressionism, that they disliked broken lines and unnaturalistic uses of color, that they wanted artists only and always to draw or paint or sculpt with the greatest technical skill. They preferred all these things because they interpreted their opposites as signposts of disability. The techniques of Dada and expressionism deform the bodies rendered by them, seeming to portray disabled people. The palette of modernism paints human faces in greens, yellows, and purples, embracing discoloration without rejecting attendant associations of disease. The modernist determination to flatten the canvas and to draw attention to the sculptural quality of paint often stunts figures, bending and twisting them into anagrams of disability. Moreover, the attention given by modern art to themes of alienation, violence, panic, terror, sensory overload, and distraction requires an openness to disability as a visible and potent symbolization of these themes. People quivering with anxiety, howling in fear, or cringing in silent terror populate modernist canvases, openly embracing situations and conditions thought abnormal and feared by the Nazis. The Nazis waged war against modern art because they interpreted the modern in art as disability, and they were essentially right in their interpretation, for modern art might indeed be named as the movement that finds its greatest aesthetic resource in bodies previously considered to be broken, diseased, wounded, or disabled.

If modern art has had such enormous success, it is because of its embrace of disability as a distinct version of the beautiful. The Nazis grasped the nature of this aesthetic, but they rejected it, misreading the future direction of art as they misread many other things about human culture. Instead, they attacked modern art for the very features that give it such remarkable imaginative and transformative power to represent the human condition—be it the capacity to claim through formal experiments and new content a vast array of human emotions, thoughts, and physical appearances or be it the confidence to leave behind the imitation of nature and to represent what nature might reject or fail to conceive.

Hitler's remarks on the modernist palette exemplify the tendency to associate invention in modern art with human impairment. Hitler disqualifies artists who apply imaginative uses of color by calling their vision defective:

From the pictures submitted for exhibition, I must assume that the

eye of some men shows them things different from the way they really are. They really are men who can see in the shapes of our people only decayed cretins, who feel the meadows as blue, the heavens green, clouds sulphur yellow. . . . I only want to prevent these pitiable unfortunates, who clearly suffer from defective vision, from attempting with their chatter to force on their contemporaries the results of their faulty observation, and indeed from presenting them as "art." (Sax and Kuntz 230)

More significant than blaming modernist techniques on disability, however, is the Nazi use of modern art to illustrate people, trends, and conditions called degenerate. This point cannot be overstated. For the Nazis, modern art provided evidence in support of the medical and eugenic rejection of disability. The modernist interest in deformation of the human body and in new techniques of representation combined to produce visions of human appearance that demonstrated to Nazi eyes the evils of miscegenation, the devastating effects of modern life on the human nervous system, and the danger of allowing disabled people and racial inferiors to reproduce themselves. The Nazi way of life, once established by total warfare against and extermination of everything not German, would presumably have existed in stark opposition to the world pictured by modern art.

Consider Emil Nolde's *Mulatto* and Ludwig Meidner's *Self-Portrait.* Although a Nazi sympathizer, Nolde found his works displayed at the Entartete Kunst exhibit because of his embrace of modernist themes and techniques. The title of *The Mulatto* serves as a red flag for Nazi disapproval, but it is finally Nolde's modernist aesthetic that marks the woman in the portrait as "degenerate" (color pl. 11). Her patchy coloration, overbite, frizzy hair, and narrow eyes suggest in-built inferiority to the Nazi medical gaze. She demonstrates for the Nazis what mixing races will produce and supplies evidence for the necessity of keeping German bloodlines pure. Ludwig Meidner, the Jewish expressionist painter who initially made a reputation for himself by producing horrific landscapes of life in the modern city, later became a prolific self-portraitist. The Nazis included his *Self-Portrait* in the "Jewish room" of Entartete Kunst as proof of the defective nature of the Jewish people, scratching above the painting the words, "Jewish, all too Jewish" and referring to the work in the catalog as one of "three specimens of Jewish sculpture and painting" (Barron 298). The curation for the Jewish room announced its purpose as the "Revelation of

the Jewish racial soul" (Barron 194). What the Nazis saw in the portrait, and wanted others to see, one can only imagine. A misshaped face, elfin ears, deformed hand, and twisted body—all rendered in unnaturalistic colors—seem to attest to the biological inferiority of Jews (color pl. 12).

Another category significant for the definition of degenerate art and its reliance on disability as a marker of disqualification touches on antiwar art. Beginning with Callot and Goya and increasing in importance with the rise of photography, images of wounded soldiers, victims of torture, maimed civilians, and devastated cities have played a crucial role in the critique of warmongering among nations. This tradition pictures disability as the measure of the evils of warfare, and although this usage stigmatizes the wounded person as an allegorical symbol of the horrors of war, it nevertheless makes an important contribution to the inclusion of disability, injury, and disease in the history of visual culture, one that endures to this day, most recently in the photographs of torture taken at Abu Ghraib. Hitler's war machine had every reason to resist this tradition, and artists critical of warfare soon found themselves labeled as degenerate. Like Hitler, Ernest Ludwig Kirchner went to war to defend Germany, but he was horrified by what he saw in the trenches of World War I. He had a nervous breakdown and represented the cost of war in the poignant and powerful *Self-Portrait as a Soldier*, included in the Entartete Kunst exhibit. The painting shows Kirchner in full dress uniform, exhibiting the bloody stump of his severed right hand against the background of a Baconesque meaty collage and a nude woman (color pl. 13). The attack against him as a degenerate artist threw Kirchner into despair, as more than 600 of his works were confiscated. He committed suicide on June 15, 1938. Otto Dix is another powerful critic of the war ethic. His series *War* was attacked as degenerate, both because it is antiwar and because it uses ghastly images of war victims to depict the horrors of war. *Transplant* pictures a man in a hospital bed, his face torn asunder, with brains exposed, patched up with chunks of flesh designed to stand in for his nose, cheek, and forehead (fig. 15). *Skull* represents a fleshless head, a scraggly crop of hair spouting from the head and the lip, mingled with worms busily devouring the residues of this former person's brain (fig. 16).

The aesthetic vocabulary used by the Nazis to attack their victims is the invention of modern art—stolen to support a perverse and violent cause. The casualties of war represented in modern art display fragilities

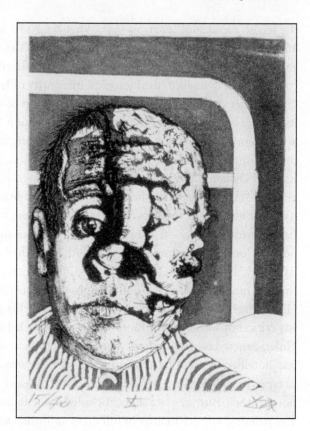

Figure 15. Otto Dix,
Transplant, from
War series, 1924

of the human mind and body that the Nazis used not to denounce war
but to condemn certain populations and races. The focus of modern art-
ists on the dangers of industrialization and crowded cities was made to
support the idea that human beings best inhabit the archaic landscape
of Nazi homelands. The images of diverse peoples from across the globe,
celebrated in modern art, represent an openness to human variation that
nevertheless struck Hitler's faithful as embracing degenerate, defective,
and racially inferior people. The Nazis reinterpreted what they saw in
modern art and put it in the service of an aesthetics of human disquali-
fication, setting images, shapes, and human forms to oppressive and vio-
lent ends never imagined by modern artists themselves. In no way did
the direction and inclination of modern art share in the prejudices and
hatreds of the Nazis, but with a brutal twist of interpretation, they turned
the expansiveness of human types found in modern art into a condemna-

Figure 16. Otto Dix, *Skull*, from *War* series, 1924

tion of everything not their own. They created once and for all a system of disqualification that justifies exclusion and genocide—a system whose aesthetic principles still rationalize oppression today.

Alison Lapper Pregnant: "Why Shouldn't My Body Be Considered Art?" The most significant aspects of Entartete Kunst, if we listen to the Nazis who toured it, were the feelings of revulsion that the artworks were supposed to excite in beholders. These works were revolting, of course, because they used disability to prove the degeneracy of modern existence. "All around us you see the monstrous offspring of insanity, impudence, ineptitude, and sheer degeneracy," explained the introduction to the Entartete Kunst catalog; "What this exhibition offers inspires horror and disgust in us all" ("Nazi Treasure Trove"). The aesthetic disqualification of disabled people has remained remarkably consistent over time, linking the emergence of eugenics in the late nineteenth century and its applications in Great Britain, the United States, and Nazi Germany to unproductive and inac-

curate stereotypes causally expressed today in discussions about health care, civil rights, neonatal testing, euthanasia, wrongful birth, reproductive care, assisted suicide, abortion, and quality of life. Although we seem to have moved to some degree beyond the idea that certain racial, ethnic, gendered, and sexed identities represent nonquality human beings, there continues to be widespread acceptance of the prejudice that individual human beings, of whatever race, ethnicity, gender, or sexuality, might be classified as inferior on the basis of injury, illness, disability, intelligence, or genetic traits.

When incorporated into works of art, however, the forms of aesthetic appearance that disqualify individual human beings as defective produce an entirely different set of meanings and emotions. Modern art claims disability as the virtuoso sign of the aesthetic, increasingly presenting disability as an aesthetic value in itself. Far from designing representations to mark human beings as inferior, modern art turns to disability, I have been arguing, as a new and powerful resource for promoting aesthetic variation, self-transformation, and beauty. Nevertheless, the radical gesture of rooting aesthetics in the representation of the disabled body produces an interpretive dilemma, one first discovered by the Nazis and still found almost everywhere in the art world today. As modern art increasingly defines its future direction in terms of disability, artists represent disabled bodies more and more explicitly as aesthetic objects, and the beholders of these objects must choose whether to embrace or to reject the strong feelings excited by disability. On the one hand, because modern art embraces disability as an aesthetic value in itself, there seem to be few objects with greater potential than disabled bodies to qualify as works of art. The modern in art manifests itself as disability, and disabled bodies possess an aura that seems to satisfy the artistic desire for new, varied, and beautiful forms of appearance. On the other hand, aesthetic objects symbolizing disability are sufficiently disruptive that some beholders are tempted to reject modern art as "sick" and "ugly" and to call for alternative forms of art that are "healthy" and "beautiful." The alliance between modern art and disability becomes the cause for disgust, complaints, and doubts, resulting in culture wars targeting the art world itself. Disability is mustered as evidence that art as a whole has succumbed to sickness and degeneracy.

In 2004, Marc Quinn began to exhibit a series of works that advances the modern preoccupation with disability as a key aesthetic concept as

well as probes the strong feelings of prejudice that disabled bodies excite in other bodies. *The Complete Marbles* revise the tradition of classical fragmentary sculpture for the modern day by representing likenesses of people who in real life have missing limbs, establishing a powerful resonance between artworks long considered beautiful because of their broken state and people whose disabilities would seem to exclude them from the category of aesthetic beauty. One marble won the competition of the Fourth Plinth Commissioning Group and was installed on Trafalgar Square in London, immediately sparking a heated debate about the kinds of bodies thought permissible to exhibit in public. *Alison Lapper Pregnant,* juxtaposed with a king, two generals, and the naval hero Admiral Nelson, depicts a nude woman, three and a half meters high, weighing thirteen tons, and carved from snow-white Carrara marble. She is also eight months pregnant and has foreshortened legs and no arms (color pl. 14).[10] Quinn explained that Nelson's Column, the focal point of Trafalgar Square, is "the epitome of a phallic male monument" and that "the square needed some femininity" (Reynolds). The sculpture repulsed some beholders, while exhilarating others. Some decried the display of a disabled person in a public square, but others celebrated it, pointing out that Admiral Nelson was also disabled. All beholders, however, had a difficult time not revealing their feelings about disability, and these feelings, negative for the most part, affected the sculpture's value and identity as a work of art, not to mention contributing to the ongoing stigmatization of disabled people.[11]

The negative responses by critics to Quinn's work are especially revealing because they fixate on disability as an unacceptable subject for art, while trying to justify by other means the revulsion stirring them. At the same time, the commentators often embrace illiterate positions on disability, praising or pitying the people depicted in the works merely because of their impairments. Robert Simon, editor of the *British Art Journal,* calls Lapper "very brave" but concludes that the sculpture is "just a repellant artifact" (Lyall). Theodore Dalrymple in *City Journal* praises Lapper's "admirable courage" only to mount a personal attack against her. He dismisses her as "a single mother sporting ironmongery in her nose," who "has shrewdly (and, in her circumstances, understandably) commodified her armlessness, turning it to an advantage." Dalrymple apparently accepts that disability may be represented in art—since he notes that "some of the greatest paintings by one of the greatest artists of all time,

Diego Velázquez, are of dwarfs"—but he concludes that Lapper's image, given over to "narcissism, self-pity, and self-obsession," falls well short of Velázquez's "statements of his deeply felt and completely sincere humanity." Apparently, neither Quinn nor Lapper is a good example of humanity. Hilton Kramer in the *New York Observer* calls Quinn's marbles "an amazing performance," "if you have the stomach for it," accusing the artist of turning beholders into "voyeurs of a succession of personal catastrophes— an experience that bears a distinct resemblance to involuntary encounters with pornography." Finally, in an opinion piece in the *Guardian,* illustrated by a photograph of pigeons swarming over the surface of the sculpture and hatefully captioned "Pigeon Toes," Brendan O'Neill confesses "to loathe the *Alison Lapper Pregnant* statue (not Alison Lapper herself, please note, who I'm sure has overcome great challenges to become both an artist and a mother)." For O'Neill, "the statue captures much of what is rotten in the heart of new Britain. . . . *Alison Lapper Pregnant* is about as challenging as old underwear. . . . It shows that we value people for what they are rather than what they achieve. . . . We prefer victims to heroes" (fig. 17).

As much as these commentators try to achieve the focus on the artwork apparently required by aesthetic judgment, they end by remarking not so much on the artistic properties of the statue as on the details of Lapper's disability. Lapper's physical features—and not necessarily those represented in the statue—become reasons for denying the status of the work as art. The commentators also attack Lapper's personality as psychopathological, although it is not clear what Lapper herself has to do with the artwork.[12] More important, the commentaries conclude in nearly every case that the alliance between modern art and disability provides evidence that the art world in general is in decline, rotten, inhuman, or sick. The appearance of disability somehow justifies the claim that the project of modern art is diseased.

But modern art permits no such condemnation of disability. I have been arguing that modern art makes of disability one of its defining aesthetic principles, rendering it impossible to attack disability without also rejecting modern art. The Nazis, of course, epitomize this last response. They attack the modern in art as disability and, consequently, reject all modern art as sick. The controversy over *Alison Lapper Pregnant* reinforces a similar dilemma, compelling beholders, whether friendly or not to modern art, to confront human disqualification as a facet of aesthetic

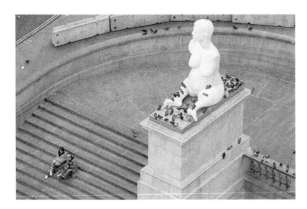

Figure 17. "Pigeon Toes," *Alison Lapper Pregnant* by Marc Quinn, "Statue of Limitations," *The Guardian,* May 17, 2007

judgment. Their choice is either to reject artworks that picture disabled people or to embrace disability as an aesthetic value in itself.

Many beholders choose to reject disability, but what would the other choice involve? "If the Venus de Milo had arms," Quinn observes, "it would most probably be a very boring statue" (4). Quinn's work trades in the bewildering idea that the same properties that strengthen works of art disqualify the actual people who possess them—the same bewildering idea on which modern art establishes itself. Modern art discovers in the eye drawn to the difference of disability one of its defining aesthetic principles. The interviews included in the catalog of *The Complete Marbles* insist again and again on this idea. Quinn repeatedly asks the subjects of his sculptures what they think about fragmentary classical statuary, whether it is beautiful and, if yes, whether their bodies are therefore beautiful as well. Lapper poses the same question: "Why shouldn't my body be considered art?" (Freeman). The crucial point here is to recognize that Lapper's body, once turned into an aesthetic representation, has a better chance of being accepted as art than a nondisabled body, despite the fact that disabled bodies, outside of aesthetic contexts, are still dismissed as repulsive and ugly. Disability is not merely unwanted content, political or otherwise, introduced into art but a mode of appearance that grows increasingly identifiable over time as the aesthetic itself.

Anita Silvers argues that modern art, because of its preoccupation with corporeal deformation, represents a moral resource for teaching people to accept disabled bodies as beautiful rather than rejecting them as ugly. She notices that people find beautiful Picasso's cubist portrait,

Maya with a Doll, while simultaneously being repulsed by a real child whose osteogenesis imperfecta produces the same features. The solution is, she argues, to embrace an aesthetic point of view in our everyday life, to tutor ourselves to look at disabled people as if they were works of art. I have no objection if modern art helps people to see disability as beautiful, although I am dubious about the possibility, but I am proposing a different dynamic between disability in art and reality. It is not a matter of being able to view disabled people as representing works of art; it is a matter of being able to view works of art as representing disability.[13] This fine distinction is important because it underscores that the difference ascribed to the artwork relies on the difference of disability, and as long as it remains unacknowledged, disability can be used to disqualify and oppress human beings. The distinction itself between disability in art and in reality is a function of the aesthetics of human disqualification.

Medical Photographs: The Art of Making Strange. The Mütter Museum of Philadelphia shows medical specimens, artifacts, and photographs to 80,000 people annually—exhibits called "disturbingly informative" on its website. The crowds streaming through the museum are not subjected to explicit captions and signs about degeneracy, as were the people who visited the Entartete Kunst exhibition, but the human subjects viewed by these crowds bear the weight nevertheless of an aesthetics of human disqualification that uses disability to represent some human beings as inferior to others. The Mütter Museum, conceived in 1849, ten years after the invention of the photograph, seems at first glance to be an archaic survival from a time before it became inappropriate to look at disabled people for education, fun, and profit. But in January 2008 *Newsweek* magazine published a visual essay that gives the lie to this theory. The essay reproduces ten sample images from the nearly 200 photographs published in the new catalog, *Mütter Museum: Historic Medical Photographs,* apparently for the distinct purpose of presenting disabled people as objects of visual pleasure. Unlike the catalog, which avoids the sensational language of medical marvels and monsters associated historically with the museum, *Newsweek* seems deliberately to mine the shock value of the medical photographs, calling its selection, in an apparent desire to rehabilitate the freak show for the modern moment, "A Century of Medical Oddities."

There may be no better example with which to think about the aesthetics of human disqualification than the medical photograph. The med-

ical photograph is its own aesthetic genre, an aesthetic genre determined not to be seen as one. It obeys a number of aesthetic rules, such as the use of full body profiles, changing postures, serial shots of the same subject, comparative anatomy between subjects, and close-ups, but its primary aesthetic imperative is the pretense of objectivity for the purpose of medical understanding and diagnosis. The images exist, after all, not to give pleasure but to instruct. Medical photographs cast disability as reality, not art, because their disabled subjects are exhibited first and foremost as medical specimens—examples of natural history gone bad and preserved for the advancement of science. No person in a medical photograph is a picture of health—all of which is to say that medical photographs represent medical subjects: the sick, the disabled, the injured, the deformed, those supposedly in need of a cure. The explicit ideology behind medical photographs is to promote a healthy world in which medical photography would no longer be necessary or possible as a genre, for once medical science prevails, a golden age will be upon us, and medical subjects will be gone forever.[14]

Until that glorious day arrives, however, people thought in need of medical rescue will be found among us. Who are they and what do they look like? What happens when doctors take their photographs and they are collected in museums, archives, and magazines? The *Newsweek* selection runs the gamut from giants and dwarfs, persons affected by polio, tuberculosis, facial deformities to parasitic insects, x-rays of objects stuck in throats, and a skeleton of conjoined twins, creating a collection, like most medical collections, in which it is not always clear why any given person might be classified as a human oddity. The problem, of course, is the instability of disability as an identity. All people, by virtue of being human, move in and out of disability identity, and people recognized as disabled in one context may not be thought disabled in another. In fact, the aesthetics of human disqualification works comparatively. Because the baseline in medicine is perfect health, medical photographs may enfreak any deviation from the baseline, however slight. Human disqualification viewed in isolation, based on individual appearance, has little meaning; its meaning emerges by association, placement in context, and aesthetic technique.

The Russian formalists define art itself as aesthetic technique, most notably as the technique of making strange. *Ostranenie* represents for

them a process of "defamiliarization" by which the familiar is cast as unfamiliar and surprising (Shklovsky). Picasso's cubist faces present superb examples, but making strange and disability are not so easily distinguished, especially because modern art relies with increasing frequency in its history on the semblance of disability to produce aesthetic effects.[15] The Russian formalists do not mention medical images as examples of defamiliarization, but the medical photograph offers, in fact, a remarkable vision of the art of making strange. The ability to represent a person as a medical oddity often relies on the technique of the photograph itself, on its ability to shift an appearance, create an association, or elicit a context that disqualifies the medical subject as inferior.

The art of making strange, annexed to the conventions of the freak show, is on vivid display in the *Newsweek* essay from its very first page. We also see on display the use of medical photographs to disqualify their subjects. The essay opens under the pall of a double death head, accentuating with a close-up view the malevolent associations of the two skulls of a pair of conjoined twins and juxtaposing them with the essay's title reference to medical oddities. The essay closes with the same image in smaller scale but describes the twins in medical terms as a case of "ectopagus" (fig. 18).[16] Beginning at least with Chang and Eng Bunker, some of whose remains are housed in the Mütter Museum, freak shows and carnivals have profited from the American love affair with conjoined twins (Wu). More than any other, this image makes it absolutely clear that the *Newsweek* essay conceives itself as a continuation of the freak-show tradition and its exhibition for fun and profit of people deemed inferior.

At least three other photographs send the same message about the freak show to *Newsweek* readers. The second image uses a sideshow convention to defamiliarize and enfreak its subjects, lining up in a row four men of varying statures from too small to too tall (fig. 19). The caption explains that Henry Mullins "was nearly seven feet seven inches tall, weighed 280 pounds, and performed on stage and in the movies," but *Newsweek* leaves unnamed the person of smallest stature and those in the middle ranges, although their names are written on the photograph. Another example reveals that captions invent contexts that make medical subjects seem strange. The fourth image shows a wax model of Madame Dimanche before she experienced "one of the most unusual surgeries in history." The Parisian "sprouted" from her forehead at age seventy-six a

XXXIII *Ectopagus*

Figure 18. Ectopagus (laterally conjoined) dicephalus dibrachius tripus twins. From Part IV of the collection of pictures of congenital abnormalities that form the basis of the four-volume atlas *Human Monstrosities*, by Barton Cooke Hirst (1861–1935) and George Arthur Piersol (1856–1924), published 1891–93. Photograph opaqued for reproduction. Donor: Dr. B. C. Hirst. Reproduced in "A Century of Medical Oddities," *Newsweek*, January 7, 2008.

Figure 19. Stanley Rosinski, Tommy Lowe, Dr. Charles D. Humberd, and Henry M. Mullins (1915–?), photographed December 30, 1939, from an album of photographs and newspaper clippings of giants and acromegalic cases compiled 1942 by Dr. Joseph McFarland. Henry M. Mullins measured 7′6 3/4″ and weighed 280 pounds. Humberd reported of Mullins, who had been on the stage and in movies (*The Sideshow Mystery,* 1932), "It is indeed amazing to watch so vast a personage doing a whirlwind acrobatic act. . . . He dances, fast and furiously, and engages in a comedy knock-about 'business' that would be found strenuous by any trained 'Physical culturist.' . . . He is alert, intelligent, well read, affable and friendly." Reproduced in "A Century of Medical Oddities," *Newsweek,* January 7, 2008.

"horn" that grew to almost ten inches before it was surgically removed six years later by one Dr. Joseph Souberbeille. The image contains a black wax model of Madame Dimanche mounted on a board and photographed in profile to show the growth hanging down over her face (fig. 20). Finally, the sixth image offers an example of cultural and racial difference positioned as medical oddity (fig. 21). It exhibits the left hand of a Chinese nobleman, having cropped out of full view the person to focus on his extraordinary features: twisted fingernails ranging from five to six and a half inches in length.

Based on context alone, almost any image that finds itself in a collection of medical photographs will surrender its vision of human variation to the representation of medical deviance. But there are cases in which *Newsweek* seems to reach the limits of medical defamiliarization. The limit cases are important because they disabuse beholders of their inclination to accept the idea that all subjects of medical photographs deviate naturally, in and of themselves, from medical norms, while at the same time questioning the norms being imposed to create the category of oddity. The third image pictures an x-ray of a dog, "but not a real one," caught in the throat of a little girl (fig. 22). The photograph reveals the "toy pooch," nose down, against the backdrop of the girl's throat, lung cavity, and rib cage, producing a study in abstraction, save for the black profile of the toy. The caption explains that the photograph comes from a collection of "radiographs depicting items that were successfully removed from the throats and airways of patients by a pioneering specialist." Aside from the suggestion of injury to the girl, quickly dismissed, the image seems to appear uniquely on the basis of its aesthetic qualities—a perfect example of making strange by photographic technique—for it displays no suggestion of biological oddity.

The eighth image, depicting a young boy affected by polio, uses typical conventions of the medical photograph, making sure to place on view the entire specimen. Nevertheless, there are no signs of physical deformation, as found in the other photographs of human subjects, and except for the wary look on the boy's face, the only indication of things gone awry is the primitive steel brace attached to the orthopedic shoe on his right leg (fig. 23). The justification for including the photograph among a century of medical oddities is apparently that polio, "which struck Franklin D. Roosevelt in the 1920s, is now almost unheard of in the United States."

Dennis N.Y.

Figure 20. Wax model of Madame Dimanche, or Widow Sunday, who lived in Paris around the beginning of the nineteenth century. The horn on her forehead attained a length of 9.8 inches by her eighty-second year, having begun to form six years earlier. It was successfully removed by Dr. Joseph Souberbeille (1754–1846), a noted French surgeon. Models such as this one of Madame Dimanche are known to have been in a number of American medical and popular anatomic museums by the mid-nineteenth century. At present no model other than the one at the Mütter Museum (different from that pictured here and part of the original collection of Dr. Mütter) is known to exist. Photograph by James F. Wood, ca. 1892–1900, from the album of photographs by Wood presented to the Mütter Museum in 1898. Reproduced in "A Century of Medical Oddities," *Newsweek*, January 7, 2008.

Figure 21. Photograph, second and third fingernails 6 ½ inches; fourth 5 inches. From an album by John Glasgow Kerr, M.D. (1824–1901), of photographs of his practice in Canton, China. Fingernails were grown very long among some of the elite in China as a symbol of their high social standing. Reproduced in "A Century of Medical Oddities," *Newsweek,* January 7, 2008.

Given the panic surrounding polio in the United States during the twentieth century, it is not surprising that its disappearance would be celebrated, but the photograph itself does not seem to bear witness to the polio panic. Rather, the small-featured boy in a crew cut invokes gentleness and innocence rather than strangeness, his status as a human oddity being established by a huge backstory and the steel prosthesis bound to him.

Finally, the ninth image seems to break with the conventions of the medical photograph by exhibiting a mange mite magnified in size by 150

Figure 22. Skiagraph (radiograph) from the Dr. Chevalier Jackson (1865–1958) collection of foreign bodies removed from the throats and airways of patients by pioneer bronchoesophagologist Jackson and his colleagues. Toy dog in esophagus. Anna Zurawinski, age three. Radiograph by Dr. Willis F. Manges, February 28, 1919. Dr. Jackson presented his collection of swallowed objects to the Mütter Museum in 1924. Reproduced in "A Century of Medical Oddities," *Newsweek*, January 7, 2008.

diameters—a species still in existence that preys on horses (fig. 24). The only apparent reason for the insect's inclusion in the collection is to display medical technology, although the magnification renders the *sarcoptes equi* monstrous ("Don't worry, that's not the actual size," the caption reassures), and the allusion to disease is not far away. The "parasitic mite," the caption elaborates, "lives within the subcutaneous tissue of a horse," causing "scabies, a transmittable, itchy skin infection that riders can pick

Figure 23. Infantile paralysis (polio) after operation, with apparatus (leg brace). Photograph by J. Rennie Smith, Newark and Asbury Park, New Jersey, ca. 1880s. Donor: Dr. DeForest Willard (1846–1910). Reproduced in "A Century of Medical Oddities," *Newsweek*, January 7, 2008.

Figure 24. Photomicrograph, female itch insect of horse (*Sarcoptes equi*), magnified 150 diameters. Photograph by Brevet Major Edward Curtis (1838–1912), by order of Surgeon General Joseph Janvier Woodward (1833–1884) for the Army Medical Museum, ca. 1865–67. Reproduced in "A Century of Medical Oddities," *Newsweek*, January 7, 2008.

up from a horse." But the appearance of the insect does expose in part the rationale underlying medical photography. The medical model of disability, which lodges defect in the person rather than in the person's social environment, disqualifies the unhealthy and diseased as inferior people, and they are easily grouped with other species thought inferior, such as animals and insects.[17] As the final photograph in the series, the parasitic mite calls for an insidious and retroactive reading of the previous images of disabled people as examples of beings existing at the lower end of the evolutionary chain, beings whose appearance is thought strange, beings therefore labeled oddities.

While the riddle of modern art is how to recognize the disability in art, the riddle of the medical photograph is how to recognize the art in disability. The aesthetics of human disqualification narrows both recognitions, asking beholders to dismiss art that shows too many signs of disability and to close their eyes to the artistic techniques used by medical photographers to disqualify their subjects. The perspective that sees in both cases the aesthetic value of disability is hard to find. Neither missing point of view will be possible in a large way until we find the motivation to represent disability aesthetically as a qualified rather than disqualified subject.

Coda

In February 1998 *New York Press* published an essay by Norah Vincent that attacks the emerging discipline of disability studies as "yet another academic fad" (40). Nevertheless, disability studies apparently fails as a discipline not because it is too chic but because it attracts incompetent, weak, and dishonest people. Camille Paglia calls disability studies "the last refuge for pc scoundrels" (40), but if we believe Vincent, disability studies is also a refuge for ordinary scoundrels, not to mention scholars and students of poor quality. Disability studies supposedly attracts people of questionable moral character—"academic careerists" and "ambulance-chasing publishers" who want to profit from the newest fad—as well as mediocre and flawed minds—the "victim-obsessed," the "second-rate," and the psychologically dependent (40). Vincent seems especially keen to discredit disability studies by associating it with intellectually inferior

Figure 25. Gary Leib, "Disability Chic," *New York Press,* February 2–11, 1998

and psychologically damaged scholars, and when she interviews various leading lights in the field, she is more intent on exposing their psychological weak spots than on capturing what is original about their contribution to disability studies. Lennard Davis, Vincent tells us, melts into "self-righteous goodspeak" at the mere mention of disability, while Michael Bérubé speaks in a voice that is "silky and kind" when he argues that disability is an idea necessary to understand human rights (40). Disability studies deserves no place in the university, it seems, and no self-respecting scholar should have anything to do with it.

If there is any doubt that Vincent wants to disqualify disabled people as physically defective, morally degenerate, or psychologically damaged, the cartoon accompanying the essay should make her purpose obvious. The cartoon, drawn by Gary Leib, pictures a man in a wheelchair being pushed by a woman in a nurse's uniform (fig. 25). Leib overlays the drawing with a variety of disqualifying aesthetic markers: some associate the disabled with physical ugliness and lack of intelligence, while others attempt to promote the idea, despite all evidence to the contrary, that the disabled enjoy a privileged, exclusive, and wealthy lifestyle. For example, as beads of sweat run down his face, the disabled man in the wheelchair grips a cigarette holder in his mangled teeth and toasts his public with a martini. Behind him and pushing the wheelchair is his nurse attendant. Her eyes are vapid, and her breasts are bursting out of her tight-fitting uniform. Most hateful, however, is the fact that Leib draws the cartoon in a way that re-envisions people with disabilities as Nazi soldiers. The

disabled man in the wheelchair wears a monocle, summoning the image of an SS officer. The message of the cartoon is shocking and direct in its attack on disabled people; it manages to represent the disabled as poor, inferior, and undeserving creatures who have managed somehow to attain a position of wealth and power superior to other people. The cartoon asks its beholders to believe that the disabled as a group belong to the privileged few, to a dominant class, and to an infamous story of genocide and military expansionism, deserving comparison with the Nazis, some of the greatest criminals in human history.

By way of conclusion, let me pose three questions that I do not intend to answer but offer as background music to Gary Leib's cartoon and other artworks used to disqualify people with disabilities. What would it mean to call a person sick without it being a disqualification? What would it mean to call an artwork sick without it being a disqualification? What is the relationship between these two questions? Applying the aesthetics of human disqualification according to business as usual will give no satisfying answers to these questions. Rather, the way forward requires nothing less than a radical rethinking of the relationship between aesthetics, disqualification, and oppression, one in which the systemic oppression of disabled people would fail, and fail precisely, because it could no longer be based on human appearances, features, and conditions deemed inferior.

Chapter 3

What Can Disability Studies Learn from the Culture Wars?

My concern in this chapter is threefold. First, I will be arguing that disability is a significant register in the many and various disputes that have come to be known as the American "culture wars." The culture wars are not only about what culture will mean in the future but also about who deserves to be included in a specific culture, and the determining factor in these political decisions depends often on being able to display a healthy body and mind. Statements that label cultural attitudes, minority groups, lifestyles, and works of art as "healthy" or "sick" are not metaphors but aesthetic judgments about the physical and mental condition of citizens. My general purpose here is to rethink the culture wars from the point of view of disability studies, a revision that entails not only a critique of the reliance of cultural and aesthetic ideals on the healthy and able body but an appreciation of alternative forms of value and beauty based on disability.

Second, I want to suggest that a political unconscious represses the role of disability in cultural and aesthetic representation. This issue is by necessity related to my first concern. Fredric Jameson argues that the experience of human community functions as a "political unconscious" that represents the "absolute horizon" of all interpretation (17).[1] The political unconscious, he concludes, determines the symbolism by which the forms of aesthetic objects are given as representations of community, but what has not been considered is whether the political unconscious may also

regulate aesthetic forms, excluding those suggestive of broken communities and approving those evocative of ideal ones. My specific test case here is the controversial Sensation exhibition shown at the Brooklyn Museum of Art in 1999, but my main point will be that the inclusion of disability changes the definition of the political unconscious in surprising ways.

Third, I claim that aesthetics is pertinent to the struggle to create a built environment accessible to people with disabilities. The debate in architecture has so far focused more on the fundamental problem of whether buildings and landscapes should be universally accessible than on the aesthetic symbolism by which the built environment mirrors its potential inhabitants. While universal access must remain the ambition of the disability community, a broad understanding of disability aesthetics reveals the hidden inhibitions and defense mechanisms that work against advances in universal design and undercut the political and social participation of people with disabilities. It also shows that aesthetic disgust with disability extends beyond individual disabled bodies to the symbolic presence of disability in the built environment. In short, we see again the influence of a political unconscious. Here my particular goal is to give some idea of the group psychology that lies beneath the rejection of disability and accessible architecture from the public sphere. This part of my argument requires as a jumping-off point a brief consideration of the Heidelberg Project in Detroit.

Culture and the Body Politic

In 1990 conservative politicians in the United States attacked the ranting profanity and feral behavior of performance artist Karen Finley to make their case to close down the National Endowment for the Arts (NEA). The "talented toiletmouth," whom the NEA has funded on three occasions, fills the stage with shrieks and spit, sometimes stripping off her clothes and smearing chocolate, alfalfa sprouts, and yams over her buttocks. Her wild orations about excrement and menstruation rattled the shockproof veterans of the New York City downtown art scene in the late 1980s—and outraged the enemies of the NEA who could not grasp the critical element in her performances. "I use certain language," Finley explains, "that is a symptom of the violence in the culture" (Lacayo 48). For the conserva-

tives, Finley and other controversial artists are obscene and un-American, one more sign, as Newt Gingrich put it, of "the cancer eating away at our civilization."[2]

In 1996 a Michigan Farmer Jack supermarket fired Karl Petzold, a "courtesy clerk" who bagged groceries for ten months, after shocked customers complained about his verbal outbursts of profanity and racial epithets. Petzold is one of 200,000 Americans with Tourette syndrome, a neurological condition characterized by involuntary movements and vocalizations. The Michigan Court of Appeals heard the case to determine whether Tourette syndrome is a disability worthy of protection under the Michigan Disabled Civil Rights Act. Farmer Jack attorneys made the argument that Petzold's verbal outbursts clearly violated the company's rules barring abusive language or rudeness to customers. Petzold's attorney argued that his client never said the words at issue, only fragments of them, and that workplace accommodations should be granted for his disability, including allowing him to wear a surgical mask to muffle his outbursts or to carry a card to explain his condition to customers. In the end, the court found in favor of Farmer Jack, ruling that the plaintiff's disability affected his performance on the job. About the lawsuit Petzold commented, "I just want to do what's right and help other people who have my disorder so they don't have to go through what I've gone through" (Suhr B6; see also *Petzold v. Borman's, Inc.*).

These two episodes may seem worlds apart, their resemblance superficial. The first turns on questions of aesthetic taste. The second is about political inclusion. But they express with equal power the current struggles in the United States about the ideal of a common culture. Do certain kinds of bodies have greater civil rights than others? Which is more important, the baby's body or the mother's body? Who should bear the cost to make public buildings accessible to people with disabilities? Who gets to have sex with whom? Whose bloodlines will Americans claim as their birthright? These are political questions for the simple reason that they determine who gains membership, and who does not, in the body politic, but the apparent oddity of the culture wars consists in the fact that the debates over these questions have used aesthetic rather than political arguments. The flash points in the battle are not on the senate floor or in the chambers of the powerful but in classrooms, museums, theaters, concert halls, and other places of culture. Opposing sides tend not to debate

political problems directly, focusing instead on the value of reading certain books, the decency of photographs, paintings, and statues, the offensiveness of performances and gestures, the bounds of pornography, the limits of good taste. The culture wars are supposed to be more about who gets into the culture than who has culture, and yet it is difficult to raise one issue without raising the other.

Aesthetics tracks the emotions that some bodies feel in the presence of other bodies, but aesthetic feelings of pleasure and disgust are difficult to separate from political feelings of acceptance and rejection. The oppression of women, gays and lesbians, people with disabilities, blacks, and other ethnic groups often takes the form of an aesthetic judgment, though a warped one, about their bodies and the emotions elicited by them. Their actions are called sick, their appearance judged obscene or disgusting, their mind depraved, their influence likened to a cancer attacking the healthy body of society. Such metaphors not only bring the idea of the disabled body to mind but represent the rejected political body as disabled in some way. The culture wars appear to be as much about the mental competence to render judgment, the capacity to taste, and the physical ability to experience sensations as about a variety of controversial judgments, tastes, and feelings. They are as much about the shapes of the individual bodies accepted or rejected by the body politic as about the imagination of a common culture.

The status of disability, then, is not just one controversy among others in the American culture wars. Disability is in one way or another the key concept by which the major controversies at the heart of the culture wars are presented to the public sphere, and through which the voting public will eventually render its decisions on matters both political and aesthetic. For to listen to opposing sides, the culture wars are about nothing more or less than the collective health of the United States.

The culture wars not only represent minority groups as mentally and physically disabled—and demand their exclusion from the public sphere as a result—they reject works of art that present alternatives to the able body. Only by understanding that health is the underlying theme of the culture wars may we understand that these two trends are related. The most scandalous artists in recent controversies about arts funding, for example, give their works an organic dimension that alludes to bodies gone awry, and these allusions are largely responsible for their shock

value. They summon an aesthetic revulsion equivalent to the disgust felt by many persons in face-to-face encounters with people with disabilities, thereby challenging the ideal of a hygienic and homogeneous community.[3] Karen Finley's avant-garde performances confront the audience with a spectacle of errant body fluids: spermatozoaic alfalfa sprouts and excremental chocolate ooze over her body. In one performance, *Lamb of God Hotel,* she plays Aggie, a woman using a wheelchair having her diaper changed. Andres Serrano's notorious *Piss Christ* immerses a day-glow crucifix in a vat of the artist's urine, capturing the startling contradiction of Christianity's all-too-human son of God defiled by a mortal body and its waste fluids. Other photographs by Serrano present abstract expressionist patterns composed of blood and semen, still lifes arranged with human and animal cadavers, and mug shots of the homeless, criminal, and aged. Robert Mapplethorpe's most memorable photographs capture the homoerotic body and serve it up to a largely heterosexual population. Perhaps his most outrageous work is a self-portrait revealing a bullwhip stuck up his rectum. It summons ideas of the devil as well as S/M practices, of course, but it also presents the image a man who has grown a tail, invoking a body whose deformed shape is less or more than human.

These stunning works make a contribution to the history of art by assaulting aesthetic dictates that ally beauty to harmonious form, balance, hygiene, fluidity of expression, and genius. But their shock value owes less to their quibbling with certain aesthetic principles than to the bodies and organic materials presented by them. They represent flash points in the culture wars not only because they challenge how aesthetic culture should be defined but also because they attack the body images used to determine who has the right to live in society. People with disabilities elicit feelings of discomfort, confusion, and resentment because their bodies refuse cure, defy normalization, and threaten to contaminate the rest of society. We display bodies objectionable to the body politic, disrupting the long-standing association between instances of aesthetic form and what Fredric Jameson calls the political unconscious. The political unconscious, I want to argue, enforces a mutual identification between forms of appearance, whether organic, aesthetic, or architectural, and ideal images of the body politic. It accounts for the visceral and defensive response to any body found to disturb society's established image of itself.

Jameson, of course, defines the political unconscious as a collective

impulse that situates the experience of the human group as the absolute
horizon of all interpretation. In fact, the existence of the group is for him
so much a part of human experience that he considers the consciousness
of individuality itself as a symptom of estrangement from collective life.
Notice, however, that the political unconscious has no content other than
its ability to reference human community as a formal totality. It exists to
ponder social totality, but what it refuses to ponder is a vision of com-
munity as less than perfect. To conceive social totality at the level of form
envisions both objects of human production and bodies as symbols of
wholeness. The political unconscious establishes the principle of totality
as the methodological standard of all human interpretation. It installs the
image of an unbroken community as the horizon of thought, requiring
that ideas of incompetent, diseased, defective, or incomplete community
be viewed as signs of alienation. This means that the very idea of disability
signals the triumph of fallen or defective consciousness, despite the fact
that there are no real, existing communities of human beings unaffected
by the presence of injury, disease, defect, and incompleteness. In short,
the political unconscious is a social imaginary designed to eradicate dis-
ability.

The political unconscious upholds a delicious ideal of social perfec-
tion by insisting that any public body be flawless. It also displaces mani-
festations of disability from collective consciousness, we will see, through
concealment, cosmetic action, motivated forgetting, and rituals of sympa-
thy and pity. Advertisements, media images, buildings, and habitats work
to assert the coherence and integrity of society, while public actions like
telethons and media representations of heroic cripples mollify the influ-
ence of disability. Bodies that cannot be subsumed by ritual and other
public action represent a blemish on the face of society, and they must be
eliminated, apparently whatever the cost.

Diane DeVries provides a familiar account, unfortunately, of the
political unconscious at work, of the visceral disgust and accompanying
violence often directed at people with disabilities. She reveals that observ-
ers of the disabled body often feel compelled to fly into action, to cure or
kill the ungainly sight before their eyes. DeVries was born with short arms,
no hands, and no legs:

once when I was a kid, I was in a wagon and we were in this trailer

park, and some kid came up to me with a knife. He said, "Aw, you ain't got no arms, you ain't got no legs, and now you're not gonna have no head." He held me right there, by the neck, and had a little knife. It was one of those bratty kids that do weird things. (Cited by Fine and Asch 48)

DeVries's testimony recounts in part a childish prank, but its force as a political lesson derives from its underlying association with a series of familiar reactions and institutions, all of which reverberate with the compulsive requirement, anchored by the political unconscious, to manufacture ideal images of the body politic. The bratty kid is part assassin who would kill off what displeases him and his society, part cosmetic surgeon whose aesthetic sense imagines cleaner lines for the disabled body, part architect who hates unaesthetic designs, part budget cutter who would eliminate waste and partition resources more economically.[4]

"Sick Stuff"

The brouhaha over Sensation, the exhibition in 1999 of the young British artists at the Brooklyn Museum, showed that the culture wars are far from over. It also showed how predictable and ferocious are public, official sentiments about bodies seen to be less fit, hygienic, and healthy than the ideal.[5] The Saatchi Collection presented the public with a spectacle of bodies sufficiently scandalous to rival the uproars created by Finley, Serrano, and Mapplethorpe. Mayor Rudolph W. Giuliani's first reaction was to reach for his budget knife. He attacked the show and tried to cut off city funds to the Brooklyn Museum, although the courts eventually stopped him. "The city shouldn't have to pay for sick stuff," he declared (Blumenthal and Vogel B1). The "sick stuff" in the exhibit included Chris Ofili's *The Holy Virgin Mary,* an icon of the Virgin Mother decorated with elephant dung, Marc Quinn's *Self,* a bust of the artist carved in nine pints of his own frozen blood (fig. 26), and Damien Hirst's *This Little Piggy Went to Market, This Little Piggy Stayed at Home,* a pig sliced in half lengthwise and suspended in formaldehyde. What these artworks have in common, of course, is their organic nature. They use real bodies, body parts, and body products as their medium, transforming the museum into

Figure 26. Marc
Quinn, *Self*, 1991,
London, Jay Jopling/
White Cube

a shadow world of the mortuary or hospital and exhibiting without mercy
the organic foundation of human life and death.

If aesthetic form always imagines a body politic, the young British
artists seem to say, then art objects should invoke more dramatically and
truthfully the different kinds of bodies that join together to constitute
political collectivities. The Sensation collection incorporates a political
body, filling the museum space with individual corporeal objects that
magically come together, like citizens, to form a community of bodies, but
the artists choose not to represent the bodies normally accepted by mod-
ern society. Rather, they focus on the fringes, imagining corporeal forms
usually rejected by the public and challenging their audience to rethink
its image of bodies both individual and collective. More specifically, the
artworks are all in one way or another suggestive of disability, whether
they excite thoughts immediately of the disabled body or merely imply it
by meditating on hygiene, reimagining physical coordinates, or turning

able bodies into curiosities. The show made political enemies and shocked the public for this reason, and this reason alone. Sensation upset popular expectations about the beauty of art and confronted its audience with a different aesthetic economy—an aesthetic economy based on the otherness of disability and increasingly difficult to find in a world obsessed with fashion, uniform beauty, health, hygiene, and the consumer products that make fetishes of them.

Most obviously, the Sensation exhibition exposed its audience to the influence of disability by giving the institution of the freak show a place within the walls of the museum. Allusions to the freak show decorated everything from the entrance to the Sensation exhibition, to its advertising, program, and admission tickets. All included prominently the dramatic and exaggerated "health warning": "The contents of this exhibition may cause shock, vomiting, confusion, panic, euphoria, and anxiety. If you suffer from high blood pressure, a nervous disorder, or palpitations, you should consult your doctor before viewing this exhibition." Even the phone number for ticket reservations promised injury, alluding to Hirst's fourteen-foot tiger shark floating in a glass tank of formaldehyde solution: "Call 1-87-SHARKBITE for tickets!" The freak show traditionally provides a channel for the expression of public disgust toward extraordinary bodies, but this venting does not necessarily make these bodies more threatening or hateful. It sometimes has the opposite effect, inspiring spectators threatened by mass society with vivid examples of unique bodies and minds. Rosemarie Garland Thomson's theory of the freakish body elucidates this double effect.[6] On the one hand, she explains, the "bodies of the severely congenitally disabled have always functioned as icons upon which people discharge their anxieties, convictions, and fantasies" (56). On the other hand, in societies where the "standardization wrought by mass culture" threatens democratic ideas of freedom and independence, the "freakish body" may function "as a kind of egalitarian shrine" (69). This dichotomy accounts for the fundamental ambiguity of the Sensation exhibition—what might be seen as the choice presented by it to the audience. The exhibition became an event attractive to crowds because it promised, like the freak show, to astound with examples of outrageous human bodies and behavior, but its inclusion of disability also transformed the increasingly predictable experience of the museum, asking spectators, in effect, to accept or reject the bodies before them.

Rather than having the usual aesthetic experience, then, visitors to the Brooklyn were confronted by a class of objects that refuse conventional human measure, for they prefer to be understood only in their own terms, according to ideas representative of their particular autonomy. These artworks strive to free themselves from convention, shining forth as only themselves and asserting their own unique form and integrity as presences dwelling both with us and apart.[7] A diverse audience of Manhattanites made the journey to Brooklyn. Many Brooklynites visited their home institution for the first time. None of them would have considered going to a circus freak show, but they stood in line to admire Jake and Dinos Chapman's mutant conjoined twins, sometimes connected to mimic sexual positions, their genital organs transposed to their faces (color pl. 15), and Hirst's *A Thousand Years,* featuring maggots crawling out of the ears of a mock cow's head and fruit flies going up in smoke in a nearby bugzapper. Some visitors rejected what they saw with a gasp. Many witnessed an appearance of beauty that asserted itself as an undeniable part of their world.

Mostly, the crowds came, thanks to Mayor Giuliani's negative publicity, to see the exhibition's own "elephant lady," Ofili's *The Holy Virgin Mary.* The work is on the surface among the least related to disability contained in show, but the controversy surrounding it reveals that the painting provokes an aesthetic response to rejected bodies and body products. Ofili painted his hip-hop version of the Madonna as a black woman with one breast missing and the other composed of a ball of shellacked elephant dung. The work decorates the Virgin with sparkling glitter and cutouts of women's buttocks from pornographic magazines, an allusion to naked putti in Old Master paintings, but a closer look reveals that the elephant dung and floating female posteriors are not the only corporeal objects inscribed in the "Afrobiotic" painting. The lip-line of the Virgin's Mona Lisa smile is an icon of a sperm, and the folds of her dress mimic eleven subtle vaginal openings. None of these features presents as overtly sexual, but the total effect recalls the sexual receptivity of the Virgin in the traditional story. The fact is that Ofili's Mary, for all of her sexual undertones, remains as tranquil, reassuring, and dignified as conventional icons of the Virgin, and for this reason the adverse public reaction to her seems a mystery, until one focuses on hygiene and health as political ideals. Giuliani (who never actually viewed the work) and the press imagined

the painting as splattered or stained with excrement, as did its would-be vandal, Dennis Heiner, who tried to "clean it" by smearing white paint over its surface.⁸ It is as if the detractors of the painting experienced a collective hallucination of noxious bodies and body parts before its shimmering surface. What they apparently saw there was a woman with ethnic features and one breast, splattered with excrement and surrounded by pornographic images, who in no way, shape, or form fit their vision of an ideal human being, let alone the mother of God. Their response to her was immediate, visceral, and violent, displaying the inability not only to understand Ofili's witty commentary on the underlying abnormality of the woman called both virgin and mother but to free themselves from a political unconscious that works to obscure or eliminate any public experience of deformed or disabled bodies.

The works surrounding Ofili's Madonna represented disabled bodies and organic otherness with equal and sometimes greater power. In addition to Jake and Dinos Chapman's *Tragic Anatomies* and other biogenetic libidinal conjoined-twin statuary was their *Ubermensch,* a resin and fiberglass sculpture of Stephen Hawking perched in his wheelchair atop a rock promontory (color pl. 16), Gillian Wearing's video, *10-16,* which features a naked dwarf, Glenn Brown's reinterpretations of Dali's melting bodies, Mat Collishaw's *Bullet-Hole,* a massive photograph of a gunshot wound in a skull (color pl. 17), *Dead Dad* by Ron Meuck, a silicon and acrylic reproduction of his father's corpse, and Marc Quinn's *No Visible Means of Support* and *The Morphology of Specifics,* two works that display the anguish of human beings as they dissolve into nothingness or wilt away into bags of dried skin. Even Jenny Saville's classical studies of gigantic female nudes seem to chart the transformation of flesh into landscapes that are segmented and resegmented by arbitrary forces, while Cerith Wyn Evans's *Inverse Reverse Perverse,* a huge concave mirror accessible to spectators nostalgic for the house of mirrors of their youth, leaves no question about the exhibition's own understanding of its relation to the circus midway and freak show. There was hardly an example of an artwork in the Sensation exhibition that pictures what most people would consider a normal human body or behavior, and yet the total effect of the show was to challenge these very people to see in the representation of disabled bodies a reflection of their own body and behavior.

The Sensation exhibition offers proof of an aesthetic commitment

to a different body politic, one that struggles against the soft-pedaling of beauty, fashion, health, and hygiene as essential features of works of art or political communities.[9] Rather, Sensation committed to a vision of beauty as disability, manifesting it in physical form and insisting that it has the greatest political value when it confronts human beings, on a human scale, as part of their world. This idea of beauty may inspire a new vision of democratic political community in two ways. First, the work of art makes individual subjects aware of the fact that things exist beyond their control, challenging political ideals that imagine mental competence, physical health, consensus, economic efficiency, and the prevention of accidents, disease, and death as easily achievable goals. Second, the beauty of disability compels the imagination of political community on the basis of accessibility rather than exclusion. It tutors individual subjects in new affective responses, asking them to incorporate rather than reject unfamiliar ideas and physical forms, to tolerate mixtures of greater varieties and kinds, and to broaden their understanding of human beings and their behavior.

The imagination of different political communities, however, is hardly a simple process, as the public reaction to the Sensation exhibition demonstrated. Artworks have the power to influence the political unconscious, especially when they attack its reliance on symbols of the able body, since these symbols, too, are given by everyday experience. But aesthetic objects also metamorphose rather easily into curiosities when they represent the disabled body, and the artistic commitment to educate, please, and observe different forms of life may lose its original inspiration, if indeed it ever possessed it, veering toward voyeurism or the desire to shock. Spectators, too, may succumb to routine emotions, gawking at the strange beauty, complaining of its weirdness, stifling the gag reflex. The brilliance of the Sensation exhibition—and the reason that it became part of the culture wars—was to make the imagination of a new democratic community the subject of public controversy. Each individual who visited the Brooklyn Museum had to decide in public about the kind of community he or she desired to inhabit, had to make the choice whether to accept or reject disability as part of the integrity and future of American society. Neither choice would have been possible, however, if not for the political unconscious determining any observation of a body, if not for its insistence that any viewing of a body is a judgment about the shape of the body politic and the rules governing exclusion from it.

"Eyesores"

Poverty and crime assault the east side of Detroit. The houses decay, factories close, buildings are abandoned to drug dealers, prostitutes, and gangs. In 1986 Tyree Guyton sparked another episode in the culture wars by transforming two blocks on Heidelberg Street into a work of art. He seized a crack house and decorated it with brightly colored polka dots and the plastic body parts of children's dolls, christening it *Baby Doll House.* Then he seized another crack house and another, festooning them with an array of colors and discarded objects: shoes, pots and pans, pieces of found art, toys, broken appliances, stuffed animals, license plates, numbers and decals, and more and more polka dots. He tossed hundreds of shoes into the street in front of his house as a statement about the homeless. As the cars drove over them, the character of the collage kept changing. He began to hang shoes by the dozens from the trees in the neighborhood, inspired by his grandfather's memories of southern lynchings, where only the soles of the victims' shoes were visible to the people below. The crack dealers and prostitutes fled, as more and more tourists flocked to Heidelberg Street to view the surprising forms and colors of Tyree Guyton's art. *Newsweek* and *People* magazines ran feature articles.

But the Heidelberg Project also attracted the attention of the Detroit city government. Some neighbors complained to the city council that Guyton's artworks were "eyesores." Mayor Coleman Young inspected the site, declared it was not art, and targeted the urban assemblages for special demolition. Mayor Dennis Archer, after a brief respite, continued the attack. Despite the fact that Detroit has more than 15,000 abandoned buildings, at least one on nearly one-half of its 2,300 streets, city administrators have sent bulldozers repeatedly to Heidelberg Street over the years (Carducci 64; Whitfield). Guyton fought the demolition in the courts, wrestling with the city in an on-again, off-again battle intensified after each assault by the bulldozers. *Baby Doll House* (color pl. 18) went first and without warning in August 1989. The city destroyed four more houses in an early morning raid in 1991 and completed demolition of the parts of the project on city-owned land in 1999. Guyton believes that *Baby Doll House* attracted such violence because its images were so strong: the broken, naked dolls hanging out of windows and off the roof addressed too directly the issues of child abuse, abortion, and prostitution plaguing the

urban poor in Detroit neighborhoods (Yolles 27). *Baby Doll House* cast into the open, for all to see, the destruction of bodies and minds formerly hidden deep within its walls. It made the secret connection between urban decay and the diseased and disabled body an explicit theme of its form and content, awakening the defensive forces of the body politic and stirring them to busyness, like antibodies pursuing an infection. The city felt compelled, on this site alone, to clean up its waste, stop the decay, heal the blight, hide its blemishes, and soothe its wounds.[10]

Human communities come into being and maintain their coherence by imagining their ideal forms on the basis of other bodies. It is no accident, then, that descriptions of communities in disarray summon images of the disabled body and that, conversely, the appearance of disabled bodies in public provokes fears that the community is itself under attack or coming apart. The political unconscious accounts for this mutual identification between instances of form and perfect images of the body politic. It also accounts for the existence of so-called ugly laws—municipal ordinances that bar people from public spaces on the grounds that their appearance is offensive and poses undue legal liabilities. "Ugly laws" were found routinely in American city statutes until the 1960s and still exist in Columbus, Ohio, Omaha, Nebraska, and other municipalities. This typical example, no longer on the books in Chicago, demonstrates that the compulsion to maintain instances of ideal form in public buildings and streets echoes a primordial obsession with perfect, public bodies:

No person who is diseased, maimed, mutilated or in any way deformed so as to be an unsightly or disgusting object or improper person to be allowed in or on the public ways or other public places in this city, shall therein or thereon expose himself to public view. (Burgdorf and Burgdorf 863)[11]

The Detroit city administration could not outlaw the Heidelberg Project by the authority of ugly laws, which apply only to "unsightly" human beings, but it did classify the installation as an illegal dump site, and Guyton lost the battle in the courts to stop the demolition of all artworks on public land. Public aversion to disability may begin with individual human bodies, but it escalates rapidly to form a network of wider symbolism that includes nonhuman bodies, buildings, and many other

structures found in the built environment. The Heidelberg Project makes this process visible for all to see because its portrayal of disability combines dilapidation and trash as well as the display of disarticulated bodies. It exposes the conceptual transition from the public aversion to some individual human bodies to public fears about any example of dilapidation or disrepair found in the built environment. Finally, it uncovers the fact that city codes about property maintenance enforce an architectural version of ugly laws. City statutes and ordinances about building upkeep are designed to eliminate "eyesores"—the quaint but not so innocent name for the painful sensation accompanying the perception of ugliness, disunity, or dilapidation in the built environment. But the notion of an eyesore would make no sense if not for its dependence on the underlying symbolism of the disabled body. The public imagines diseased and disabled bodies as a hazard—obviously—but its fear of disability also contaminates its vision of cityscapes, confusing bodies, buildings, and skylines according to the ratio of some mysterious human geography.

Culture is not merely a web of symbols. It is a web of body symbols. Disability activists have focused so far on negative representations of the human body, on how the desire to represent perfect, individual bodies denigrates or excludes the experience of disability. If culture is really composed of body symbols, however, it means that the struggle by disability activists against negative body images must extend far beyond physical images of the individual human body strictly speaking to its symbolic resonance in other bodies. Beauty, order, and cleanliness in the built environment occupy a special position among the requirements of society because they apply to artificial bodies our preoccupation with our own body, including its health, integrity, and hygiene. Only an analysis of this powerful symbolic connection will explain why prejudices against the disabled body persist in the built environment, and only then will disability activists be able to shift emphasis from the individual human body to the imaginary bodies undergirding architectural theory, employment law, and conceptions of citizenship.

A man extending a cane before him and a three-bedroom colonial home stretching a wheelchair ramp into the street are equally disconcerting to the public eye. Both ignite a vigorous, defensive impulse to cure or fix the offending body. Conversely, beautiful, harmonious constructions automatically summon ideas of elegant, graceful people, as in this descrip-

tion of the John Hancock building in Boston, designed by I. M. Pei: "Pei and his principal designer, Henry Cobb, devised a sixty-two-story tower proportioned as slimly as a fashion model, sequined in reflective glass panels" (cited by Knox 358).[12] Other examples of the imaginary connection between body and building may be found throughout architectural theory not only because the political unconscious exerts a stranglehold on the kinds of bodies acceptable in the built environment but because modern architectural theories define the form and function of buildings with explicit reference to a politics of the body. Lewis Mumford claimed that the state of building at any period represents a "legible script" (403) detailing the complicated processes and changes taking place in the body politic itself, while Louis Sullivan insisted that pure design in architecture maximizes utility by reproducing the essence of the human being.[13] Of course, this essence represents human beings in normative terms, both physically and mentally. These and other aesthetic dictates represent architecture itself as providing a transcendental expression of human perfection, situating in the crafting of concrete, wood, plastic, and steel the ability to overcome limitations of the human body and mind, but they also use the built environment to maintain a spatial caste system at the expense of people with disabilities. This caste system not only targets individual disabled bodies for exclusion but also rejects any form of appearance that symbolizes disability.

Perhaps the most revealing example of the relation between the political unconscious and architectural theory exists in the work of Le Corbusier. In 1925 he conceived of a diagram called the *modulor* that utilizes the proportions of the body to help architects design buildings and other human habitats (fig. 27). It was to provide a standard scale by which buildings and human beings could be connected. The modulor presents the image of an upright male—six feet tall, muscular, powerful, and showing no evidence of either physical or mental disability. It pictures the human body as a universal type, with no consideration of physical variation. Ironically, Le Corbusier wanted to tie buildings to the human beings living in them, but his theories privilege form over function and establish one basis for what Rob Imrie has called the "design apartheid" of modernist architectural practices.[14] In fact, design apartheid describes with accuracy the exclusionary system apparent in many episodes of the American culture wars. Works of art called ugly ignite public furor. Unaesthetic designs or dilapidated buildings are viewed as eyesores. Deformed bodies appear as public nuisances. Not only do these

Figure 27. Le Corbusier, *Modulor*, 1925, Paris

phenomena confront the public with images of the disabled body; they expose the fact that the public's idea of health is itself based on unconscious operations designed to defend against the pain of disability.

Hysterical Architecture

Successful methods of fending off what is painful or distressing choose appropriate courses of action by recognizing the threat, considering it,

and making a judgment about it. In addition to these methods, there exist various unconscious, defensive inhibitions that rely on a range of patho-logical behaviors and mental operations. These defensive mechanisms are observable in actions by individuals and the public, but they are obvi-ously much more difficult to identify and analyze in the case of groups, since social pressure makes discovering them less probable and the sheer number of people and the absence of anything approaching a genuine theory of group psychology make treatment impossible. "Mass hysteria" and "group delusion" are, after all, rather sad theories and do not take analysis far beyond the sensationalism implied in the phrases themselves. Nevertheless, some form of group psychology appears to be at the ori-gin of public reactions to disability, for the defensive measures are too consistent to be merely coincidental. It is as if the phobias, inhibitions, defensive reactions, and avoidance patterns that spring up to meet any formal instance of disability, whether organic, aesthetic, or architectural, represent collective versions of what are normally thought to be individual defense mechanisms.[15] These group inhibitions preserve the self-image of the community, its ego function as it were, by striving to banish distress-ing emotional impulses, visceral signs of anxiety, and threats of injury or pain, amounting to the equivalent of a collective flight-reflex in the pres-ence of painful stimuli.[16]

The culture wars were bound to display a panorama of phobias, inhi-bitions, censorship, and avoidance of bodies imagined as diseased or defec-tive because they make the metaphoric connection between able bodies and healthy societies an explicit theme of public controversy and because their posture is defensive in nature. In effect, the American culture wars amount to a striking episode of collective inhibition in action: they rep-resent a critical moment when the existing culture is trying to defend its ideal image against forces that would transform it. The NEA controversy, *Sensation*, the Heidelberg Project, and the official responses to them pro-vide only a few samples of possible case studies exposing collective defense mechanisms at work. But the same defensive ideas, reactions, and behav-iors appear even where explicit public controversy has no place, the most surprising and unsettling being design projects friendly to the disability community. Here mechanisms of defense are not easy to explain without further consideration of the ways in which mental behaviors buttress the political unconscious. I refer to the bungled actions, instances of counter

will, and disturbances in memory readable in the most amiable efforts to make the built environment accessible to people with disabilities. These phenomena might be collected, following Freud, under the heading of "hysterical architecture," since they encompass plans and design implementations contrived to provide access but burdened by a symptomatic inhibition against disability. The reference to psychoanalysis makes sense not only because defensive measures against disability often mimic hysterical symptomology but because Freud illustrates the exchange of symptoms in hysteria with the analogy of a frail woman carrying too many packages.[17] The disabled woman, her arms overflowing with packages, tries to walk down the street, but she inevitably drops a package, and when she bends down to pick it up, she drops a second package just as she recovers the first, and on and on, to the point where progress is futile. Freud claims that each package represents a symptom, one of many external signs of the same underlying problem. The analogy is especially pertinent to defensive measures in the built environment because the disabled woman is marked by a series of external signs that signal the presence of her disability, and yet the exchange of external signs works like a shell and pea game to hide her disability or at least to displace attention from it.

In the case of the built environment, of course, the shuffling of the external signs of disability cannot be blamed on the psychology of people with disabilities, as in the example of Freud's hysteric. The architecture is itself "hysterical" in its desire to ward off the signs of disability, for each attempt to make the building accessible produces another attempt either to block accessibility or to conceal the marker of disability tattooed by the accessible features on the skin of the building. The end result is a zero-sum game in the favor of phobia, inhibition, and discrimination.

Each person with a disability can recount experiences with defensive inhibitions against accessible architecture in the public environment. Local examples in my hometown of Ann Arbor, Michigan, are numerous, some of which reflect trends in building and landscaping evident at the national level. Designers of parking lots for shopping malls in Ann Arbor suffer from a bizarre counter will when it comes to handicapped parking. Often they fill the median—separating the parking lot from the store entrances and next to which handicapped spaces are always found—with large decorative rocks that are extremely difficult to walk over and impossible to cross with a wheelchair. The practice effectively places a rocky

barrier reef between the handicapped spaces and the destination of the wheelchair users. The four handicapped spaces for the graduate library at the University of Michigan are buttressed by a three-foot high retaining wall, decorated with flowers and inconveniently located between the parking places and the rear entrance of the library (fig. 28). The sidewalks leading to that entrance are also strategically blocked by an obstacle course of concrete planters, approximately three-feet square and brimming with colorful pansies.

An example of motivated forgetting in accessible architecture at the U.S. national level is found in the government lawsuit against Ellerbe Becket of Minneapolis, one of the largest architectural firms in the country (Dunlap). Ellerbe Becket has designed over a half-dozen sport stadiums, and each one demonstrates a "pattern or practice of discrimination" in its placement of wheelchair locations, according to the U.S. government. The law requires that wheelchair locations have "lines of sight comparable to those for members of the general public." But Ellerbe Becket arranges wheelchair locations so that their users cannot see when the crowd stands. The firm has tried to argue that government guidelines and laws do not require that people in wheelchairs be able to see over standing spectators.

Jim Knipfel details two extraordinary instances of bungled actions toward disability in his comic memoir *Slack Jaw*. Knipfel is one of 100,000 Americans with retinitis pigmentosa, a genetic condition that attacks the photoreceptor cells in the retina, eventually producing blindness. One of his many adventures includes spending the better part of one morning trying to locate the New York State Department of Social Services Commission for the Blind and Visually Handicapped at 270 Broadway in New York City. After roaming up and down the even-numbered side of Broadway between the 100 and 400 blocks for a few hours, he finally asks a homeless man where to find the address and then describes the "nasty tendency" found inside the front doors:

> "Excuse me?" I inquired without getting too close. I didn't want to startle him. "Do you know where Two-seventy Broadway is?"
> Without a word he raised a finger and pointed across the street.
> As it happens, 270 Broadway is the anomaly, an even-numbered building on the west side of the street.
> Once I got through the front doors, I was in near-total darkness.

Figure 28. Handicapped spaces, Graduate Library, University of Michigan at Ann Arbor, 2002

This is a nasty tendency I've discovered in places that are designed to "help" the blind. Willis Eye Hospital in Philadelphia was the worst in this respect. The reception area is a cavernous, unlit room scattered with floor-to-ceiling concrete pillars. You could sit there all day and be entertained by the zany antics of blind people walking headlong into post after post, like a giant pinball machine. Here at 270 Broadway, at least, there was only a long unlit hallway.

I asked a man where the elevators were, and he said, "Right over there," which, of course, helped me not at all. Once I did feel my way to the elevators, I found a man down on his hands and knees inside, banging away with a hammer at a piece of metal that had come loose. (184)

Finally, misdirection may also indicate defensive inhibitions at work. Handicapped signage is sometimes unclear, using the same icons to mark where handicapped entrances are and are not, and often signs disappear abruptly en route, leaving people wondering at every fork in the road. For old construction, designers trying to meet new accessibility requirements plot courses with more curves than a cobra, but new construction is just as likely to lead people with disabilities into buildings along a snaky course.

Figure 29. UPS truck, handicapped spaces, Mason Hall loading dock, University of Michigan at Ann Arbor, 2002

Figure 30. Grass clippings, handicapped spaces, Mason Hall loading dock, University of Michigan at Ann Arbor, 2002

Figure 31. Trash, handicapped spaces, Mason Hall loading dock, University of Michigan at Ann Arbor, 2002

Following handicapped signage often gives one the impression of being caught in a labyrinth. The shortest distance between two points is rarely a straight line when people with disabilities are involved—"a crooked path for crooked people" appears to be the motto behind some attempts to open buildings to accessibility.

Defensive countermeasures, as these examples show, work to conceal the blemish on society represented by disability. The personal fear and shame that have led historically to the institutionalization of people with disabilities by their own families is a common trope in this pattern of avoidance. But defensive avoidance extends well beyond individual bodies and personal actions to encompass the behavior, ideas, and physical appearance of society itself. Ugly laws and less official sanctions against people with disabilities strive to decrease their presence and lessen their influence in the community. Architecture and landscape design not only attempt to project a sense of beauty but exclude people deemed ugly or defective by making their access to society difficult or impossible. City codes about building upkeep guarantee a sense of harmony for the eye and maintain a uniformity unaffected by any sign of dilapidation or defect. More significantly, friendly attempts to provide access for people with disabilities are sometimes disrupted by countermeasures that undo the process of accessibility itself. It is as if the public interprets ramps, accessible doors, and signage for the disabled as symbols of disability that require a mustering of defense mechanisms. In no time, plants and flowers clutter wheelchair ramps, handicap signs are tucked away, and decorative rocks and wood chips block accessible walkways. Nature abhors a vacuum, and society treats handicapped parking places and accessible pathways as empty spaces to fill: locales marked by accessibility inevitably become handy collecting points for trash, building materials, or delivery trucks (figs. 29–31).

Conclusion

My purpose here has been to explore, under the pressure of the American culture wars, how the aesthetic representation of bodies—individual and collective, organic and artificial—leads to the oppression of people with disabilities. The culture wars are not just about different political factions

in conflict (conservative versus liberal) or about a historical backlash against the 1960s (the usual argument) but about the incorporation of different physical and mental types into the American body politic. On the one hand, civic beauty, political consensus, social harmony, and economic vitality summon images of the healthy body. On the other hand, whenever sickness, dirt, political disagreement, social chaos, and economic depression appear, society responds by generating images of the disabled or diseased body. Nevertheless, most commentators, including those with disabilities, have not registered the relevance of disability to the culture wars, and only the disability community recognizes the cultural meaning of fights about employment law, citizenship, and accessibility. This is obviously the case, as Jameson has argued, because the political operates at a deeply unconscious level. The political unconscious cements the secret connection between beauty, health, and social totality through innumerable images and representations, some generated by art, commerce, and the media, others imbedded in the bodies of leaders and the shapes of buildings, city streets, tools, furniture, automobiles, and other instances of form.

The culture wars have used aesthetic rather than political arguments to influence public policy because concepts such as "health," "well-being," and "beauty"—so important to ideals of social perfection—often rely on appearance, and appearance is inevitably a matter of aesthetic form. Now it is generally accepted that works of art call for aesthetic judgments, but we rarely consider that manifestations of sickness and health also elicit judgments of this kind. In fact, judgments about art objects are widely thought to be different from judgments about the abilities of human beings, especially with regard to physical appearance, health, and mental competence. Moreover, it is now possible to question the use of aesthetic standards to judge artworks—most art critics today would object if a show or museum excluded an art object because it was deemed ugly. This self-conscious and critical attitude does not arise when it comes to the exclusion of people of disabilities from the built environment. My point is that aversion to and hatred of disability are also aesthetic reactions but that objections to aesthetic standards and tastes are rarely raised when it comes to the inclusion of disabled people. In fact, aesthetic judgments about the built environment remain unquestioned when architects make the case against accessible designs on the grounds that access produces ugly build-

ings, despite the fact that those buildings called beautiful are fashioned to suppress the disabled body from public view. Obviously, people with disabilities suffer because their individual appearance is thought by others to be aesthetically displeasing, but this truth tells only half the story. The sense of rejection felt by people with disabilities, over and above personal humiliations and individual affronts, is doubled when one considers how profound is the symbolic exclusion of disability by society.

Ideal versions of human appearance are preserved through aesthetic representations that bridge the gap between individual and collective existence. Indeed, aesthetics may be the most effective means of bridging this gap, for in the absence of aesthetic representation, it is not clear that human beings would be able to imagine what political community is, let alone understand their place in it.[18] Disability studies cannot avoid a similar conflation between aesthetic and political form, since it must invent its own imaginary communities, but we might take advantage of the confusion in a number of ways. First, the study of cultural representations of the disabled body and mind needs to continue, including stereotypes elaborated by art, literature, the sciences and social sciences, medicine, the media, law, commerce, and politics. Second, the study of the disabled body must be extended to its symbolization by other bodies and the vast array of cultural forms, such as objects of art, buildings, environments, and consumer products. This second step will help disability activists to determine the extent to which defensive trends organize public spaces, to offer theories about the psychology motivating the collective fears, inhibitions, and patterns of avoidance that censor disability, and to tackle prejudices against disability operating beyond the representation of the individual body. Finally, the disability community should continue to intervene vigorously in culture wars, wherever they may be found, creating artworks, performances, theater, and political spectacle, imprinting disabled bodies and minds on the public landscape, and inventing new modes of beauty that attack aesthetic and political standards that insist on uniformity, balance, hygiene, and formal integrity.

Although all citizens have a stake in the healthiness of their country, it is time to understand health differently. The artists at the center of the American culture wars—Finley, Serrano, Mapplethorpe, Guyton, the young British artists, and others—might be thought of as a first wave in the struggle to make their communities more accessible and democratic.

They provide a powerful formula for questioning contemporary conceptions of health and beauty as well as suggest an arena for future political intervention. Current battles about culture and political self-image are being waged over the definition of health, and they are ripe for aggressive political action. Indeed, culture wars may have greater potential for political engagement than other phenomena on the world scene today. The political unconscious will always be in force, influencing conceptions of identities and bodies, both individual and collective, but because it is constantly shifting, social change is possible.

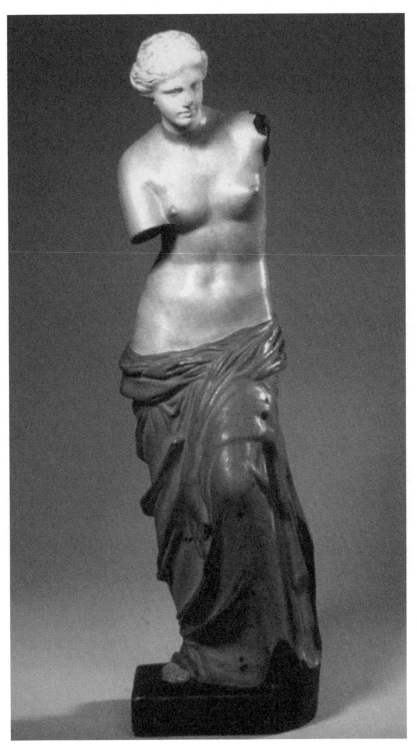

PLATE 1. René Magritte, *Les Menottes de cuivre*, 1931, Brussels, Royal Museums of Fine Arts of Belgium

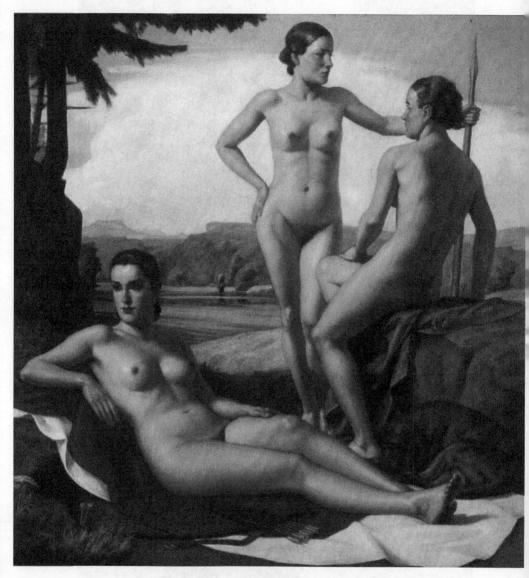

PLATE 2. Ivo Saliger, *Diana's Rest*, 1939–40,
Great German Art Exhibition, 1937

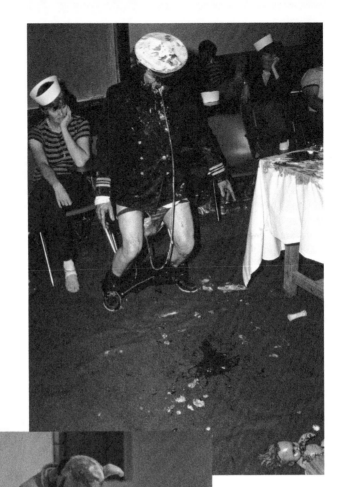

PLATE 3.
Paul McCarthy,
Death Ship, 1981,
performance

PLATE 4.
Paul McCarthy,
Mother Pig, 1983,
performance

PLATE 5. Judith Scott, untitled, no date, Creative Growth Center

PLATE 6. Judith Scott, untitled, no date, Creative Growth Center

PLATE 7. Judith Scott, untitled, no date,
Creative Growth Center

PLATE 8. Judith Scott, untitled, no date,
Creative Growth Center

PLATE 9. Oskar Martin-Amorbach, *The Sower*, 1937, Germany, Great German Art Exhibition, 1937

PLATE 10. Gisbert Palmié, *Rewards of Work*, ca. 1933, Germany, Great German Art Exhibition, 1937

PLATE 11.
Emil Nolde,
The Mulatto, 1913,
Harvard Art Museum

PLATE 12.
Ludwig Meidner,
Self-Portrait, 1912

PLATE 13.
Ernst Ludwig
Kirchner,
*Self-Portrait as a
Soldier,* 1915, Allen
Memorial Art
Museum, Oberlin
College; Charles F.
Olney Fund, 1950

PLATE 14.
Marc Quinn,
*Alison Lapper
Pregnant,* 2002,
Trafalgar Square,
London, 2007

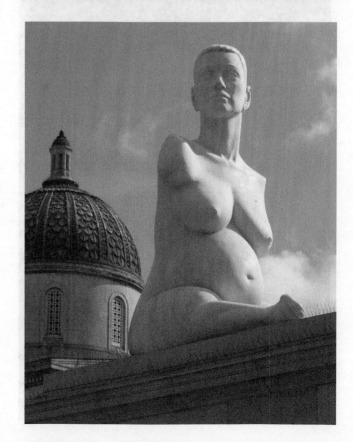

PLATE 15. Jake and Dinos Chapman,
Zygotic acceleration, Biogenetic,
de-sublimated libidinal model
(enlarged x 1000), 1995, London,
Jay Jopling/White Cube

PLATE 16. Jake and Dinos Chapman,
Ubermensch, 1995, London, Jay Jopling/
White Cube

PLATE 17. Mat Collishaw, *Bullet Hole*, 1988–93, London, Saatchi Gallery

PLATE 18. Tyree Guyton, *Baby Doll House*, 1986–89, Detroit

PLATE 19. Pablo Picasso, *Maya with a Doll*, 1938, Paris, Picasso Museum

PLATE 20. Pieter Brueghel, the Elder,
The Mendicants, ca. 1568, Paris, Louvre

PLATE 21. Thomas Eakins, *Portrait of Dr. Samuel D. Gross (The Gross Clinic)*, 1875, Philadelphia Museum of Art

PLATE 22. Aristide Maillol, *Les Deux Baigneuses ou Dina de dos et profil,* 1938, Paris, Maillol Museum

PLATE 23. Susan Dupor, *Stream of Consciousness*, 2003, St. Paul, Minnesota, University of St. Thomas

Chapter 4
Disability and Art Vandalism

In 1972 on Pentecost Sunday László Toth struck Michelangelo's *Pietà* fifteen times with a three-pound hammer, while crying out, "I am Jesus Christ!" He broke the arm of the Madonna in several places, gouged out the left eye, and knocked off her nose. Redig de Campos, the director of the Vatican Museum, concluded that the masterpiece was "totally destroyed" (Alexander 72; see also Sagoff 457; Teunissen and Hinz). The *Pietà* now portrayed as the mother of God a woman with no nose and a disfigured face (fig. 32). The art world was thrown into turmoil, but it clung nevertheless to the ideal of the statue's previous referent, demanding that the work be restored to its fabled perfection. No one made the case that a disfigured woman was the statue's new referent, any more than one argues that the Venus de Milo represents a double amputee.

Vandalized images fail to represent what they represented before their injury—and yet we resist the fact. The act of vandalism changes the referential function of the artwork, creating a new image in its own right.[1] If this is true, two unforeseen consequences present themselves. First, the act of vandalism is an act of creation because a new image comes to life. Second, if a new image is created, it is potentially the case that a new referent also emerges. Beholders are free to fantasize about what damaged images mean, and as one beholder of these images, I wish to explore a very particular aesthetic fantasy—what I might also call a thought experiment.

Figure 32. Michelangelo, *Pietà*, attacked by hammer in 1972, Rome, Vatican Museum

My fantasy here is to imagine vandalized works of art in the context of disability studies. Are vandalized images disabled images? Are they images of disability? Finally, what of the makers of these images, the unrepentant vandals, whose compulsion to destroy an existing artwork creates a spectacular image in its own right? How does the discourse of disability affect their acts of destruction and creation?

The consideration of aesthetic works from the perspective of disability is a relatively new field. It has so far approached its subject matter straightforwardly, tracking the history of representing people with disabilities in art, literature, and film, most often with respect to detrimental prejudices and stereotypes. Sometimes it has challenged the status quo, demanding the inclusion of more positive or authentic images of the disabled body and mind. This is important work, but it misses the opportunity to consider a more vital resource for imagining disability because it accepts that the work of art represents its object transparently and mimetically. Either

the art object gets disability right or it doesn't. All aesthetic objects, however, summon an imaginary engagement with the world wholly dependent on their form as the primary medium of representation. The work of art must be there itself before it may be said to represent what is also there (or not). Aesthetic form may refer to the real, but it may just as likely ask its beholder, reader, or listener to fantasize about an imaginary referent whose reality then becomes synonymous with the form itself. Works of art summon into being what they only pretend to represent. This is how and why art changes our perception of the world.

There are, however, certain metaphysical rules internal to art that stand in the way of its ability to change perception. The most stable and intrusive ones, of course, have to do with the habitual expectation that art object and world will correspond in some degree of mimetic exactitude because they compel audiences to reject or correct wayward representations. In the case of disability, more intrusive may be the habit of naming distortions and defects in the art object as beautiful when the same flaws are seen in the real world as ugly. Anita Silvers examines this problem with great courage. She contrasts Picasso's *Maya with a Doll* to the irregular features of a friend affected by osteogenesis imperfecta, a disfiguring bone disease, confessing that she finds the same irregular face beautiful in the painting and ugly on her friend (color pl. 19). To reverse this unfortunate effect, Silvers argues, we must learn from art how to view disabled bodies and minds aesthetically, making the ideal of beauty more expansive and inclusive. Another example of the problem, although in topsy-turvy form, is provided by Nazi Germany's denunciation of the so-called degenerate art. Hitler saw in paintings by Picasso, Modigliani, Klee, and many others images of "cretins" and "cripples" instead of exemplars of modern art (cited by Barron 29) (figs. 3 and 4). He applied his disgust with human difference and disability in the real world to aesthetics, reversing modernist habits of viewing and making Germany's idea of beauty less expansive and inclusive. Apparently, the rules for viewing art blunt its capacity to represent disability. Hitler's disregard for these rules, however, is definitely not a solution to the problem.

Aristotle first described the pleasure that human beings take in aesthetic representation, revealing that the pleasure does not always extend to the object being represented. The sight of certain things gives pain, he argues, but we enjoy looking at likenesses of them, whether they are forms

Figure 33. Mary
Duffy, video still,
*Vital Signs: Crip
Culture Talks Back,*
1995

of deplorable animals or corpses (*Poetics* III.4.2–4). The rules for looking
at art and the world are utterly different, then, and although Aristotle does
not mention it, these rules affect how art portrays disability. Contrast two
versions of the same silhouette. The Venus de Milo, arms broken off at
the shoulder, represents one of the highest ideals of feminine beauty in
Western art, while Mary Duffy, a performance artist born without arms,
poses a threat to most people in her audience (figs. 1 and 33). She drapes
her naked body with white cloth in mock imitation of the famous Venus
to regain control of the public's reaction to her. I "hold up a mirror," she
explains, "to all those people who had stripped me bare previously . . . with
naked stares" (cited by Nead 78).

I do not want to suggest that there is no value in beautifying dis-
ability along the lines recommended by Silvers. In fact, it appears that the
action of representing disability usually renders it more beautiful, and if

this action has the capacity to make people with disabilities more acceptable to the social world, it can hardly be condemned. Nevertheless, there may also be value in pushing the representation of disability beyond the limits of representation itself. This would entail detaching the aesthetic from its beautification program in order to present a vision of disability made stranger, not prettier. It would entail changing not merely the content of art but the way that its form is perceived—changing not merely the form of artworks but the way that their aesthetic production and appreciation are defined. This new vision of disability would continue to rely on the resources of art, although the art in question might be as difficult to accept as the fact of disability. This is precisely the point.

In 1982 Hans-Joachim Bohlmann, a North German living on a disability pension since undergoing a brain operation, attacked Rubens's portrait of Archduke Albrecht in Düsseldorf's Kunstmuseum with sulfuric acid (see for more details Dornberg 1987, 1988). The red paint flowed like blood from the Archduke's face (fig. 34). Bohlmann claimed afterward that the figure's piercing eyes troubled him. Since the death of his wife in 1977, he had made a habit of vandalizing works of art. The causalities attributed to him number at twenty-three paintings, including Dürer's *Lamentation of Christ, Mary as Mater Dolorosa, Baumgartner Altar,* Klee's *The Golden Fish,* and a self-portrait of Rembrandt (fig. 5) and his *Jacob Blessing the Sons of Joseph.* Bohlmann attacks art, he explained, because he draws pleasure from destroying what others cherish, but his assaults have given little pleasure to the rest of the world.[2] Hubertus von Sonnenburg, Europe's premier restorer and conservator, said of Bohlmann, after he was sentenced to five years in prison, "He should have been hospitalized, not jailed. The man is obviously psychopathic."

In October 1988 Robert Cambridge entered London's National Gallery and fired a sawed-off shotgun directly into Leonardo da Vinci's *The Virgin and Child with St. Anne and John the Baptist*—widely known as the Leonardo cartoon (Taylor). The shotgun blast projected many splinters of the protective glass panel into the surface of the drawing, obliterating the Virgin's right breast and distorting the canvas backing of the work (fig. 35). Cambridge, an unemployed, ex-soldier in his late twenties, said at his trial that the attack was "a protest against the condition of society." He was detained indefinitely under a section of the Mental Health Act in a top-security prison at Broadmoor, Berkshire.

Figure 34. Peter Paul Rubens, *Portrait of Archduke Albrecht,* damaged by acid in 1982, Düsseldorf, Museum of Art

Figure 35. Leonardo da Vinci, *The Virgin and Child with St. Anne and John the Baptist,* vandalized by shotgun blast in 1988, London, National Gallery

In 1999 Dennis Heiner feigned illness to distract a security guard at the Brooklyn Museum of Art, darted behind a plexiglass shield, and squeezed white latex paint from a plastic lotion bottle in broad strokes across the face and body of Chris Ofili's *The Holy Virgin Mary*—a portrait of a black Madonna, decorated with pornographic cutouts and a clump of shellacked elephant dung (fig. 36).[3] Earlier in the year, Mayor Rudolph W. Giuliani had called Ofili's painting and the other works in the Sensation exhibition "sick stuff" and tried to cut off city funds to the museum. Heiner, a retired teacher and antiabortion activist subject to dizzy spells, attacked the painting as "blasphemous," saying that he intended to "clean it." The Brooklyn district attorney charged the seventy-two-year-old assailant with criminal mischief, making graffiti, and possessing instruments of graffiti—all misdemeanors because the damage to the painting was valued at less than $1,500. The Brooklyn Museum said in a statement that trustees and staff members were "shocked and extremely saddened by this incomprehensible act."

These three episodes show a grieving "psychopath" on disability pen-

Figure 36. Chris
Ofili, *The Holy
Virgin Mary,* cov-
ered with latex paint
in 1999, Brooklyn
Museum of Art

sion, an unemployed, ex-soldier with hopes of changing society, and a
seventy-two-year-old abortion activist affected by "dizzy spells" violating
celebrated works of art to advance their vision of the world. The actions of
each one raise the specter of mental disability, the implications of which
will be worth considering further in a moment. For now, however, I will
keep the connection to disability focused on the vandalized object—the
site of that active transformation of matter, feelings, and perception called
art. Observers of Rubens's portrait of the Archduke avert their eyes invol-
untarily from the ravaged face, while a piercing sense of injury attends
the vision of Leonardo's *Virgin* blown to bits. Life has been stolen from
them, but their march toward death seems never-ending, intolerable to
sense. The outrage accompanying the destruction of artworks expresses
the feeling that more than a mere object has been harmed. This exag-
gerated awareness of suffering makes sense once one realizes that com-
mentators describe violated artworks as if they were wounded human

beings. "Picture slashing," claims Peter Fuller in familiar phrasing, "seems rather to resemble violent crimes against the person, like rape, in that the impulses which drive someone to commit this act have no rational explanation" (14). Works of art are described as victims of assault, and observers of vandalized paintings and statues often convey a sense of insult and hurt at the injury, as if they or a family member had been personally victimized. The reaction of Redig de Campos, the restorer of the *Pietà*, is typical: "When I saw the damaged *Pietà* it made an impression on me as if—this is strange with regard to this Madonna—I had the impression of one who enters into the first-aid room of a hospital and sees one of his sisters or his wife who had been hit in an automobile accident and deformed" (Alexander 72). Vandals also attack the most tender parts of the human anatomy rendered by images—the face, eyes, breasts, and genitals—and these wounds elicit public sympathy for the artworks. Paintings splashed with acid or paint remover are said to bleed. Those cut with knives are said to be wounded. Statues hammered by vandals are described as battered and bruised.

Vandalized images often evoke the same feelings of suffering, revulsion, and pity aroused by people with injuries or disabilities, but they do it with an important difference. They divert the beholder's attention from the content to the form of the artwork. More conventional representations of disability may also generate emotional reactions in beholders, but they seem to erect a partition separating the real world from the work of art, as if its aesthetic status acted like a barrier against the fact of disability. This separation produces a "beautification" of disability, but it may be more accurate, following David Hevey, to describe the ultimate effect as "enfreakment" (53). Once on display, disabled bodies suggest a freak show because the fact of display in itself promises the experience of something unique and extraordinary. The conditions of display showcase disabled bodies as aesthetic objects, separating people from their own bodies and turning them into objects of curiosity, enjoyment, disgust, and knowledge. For all the pathos of *The Mendicants* by Brueghel, for example, its cripples still seem to inhabit their own little world, a world equally sad and comic (color pl. 20). They are static emblems of human difference, safely on display in a freak show, and we need not worry that they will cross the boundary between art and reality. Vandalized works of art, however, are experienced as suffering and disabled not because they present disabil-

ity as aesthetic content. Their content has nothing to do with disability. Rather, their shattered form invokes the idea of disability.[4] We know that they were not conceived as such. They were conceived as able-bodied, and we see the perfect image evaporate before our very eyes. The presence of injury arouses our concern for the object and triples the sense of immediacy projected by it. Because the vandal has violated the barrier between art and reality, the barrier no longer stands to protect us from the new and invasive emotions now attached to the work. The vandalized image may be broken, but its ability to represent its new object is somehow rawer, more immediate, more potent.

It is a commonplace to define aesthetics as a mode of subjectivization originating with the Enlightenment.[5] The aesthetic induces a moment of self-reflexivity in which one's subjectivity may be contemplated by projecting it to another site. Beholders stand before the art object and experience human freedom and being from a distance. The essence of the human, constrained by aesthetic form, is made quiet, more beautiful, and rendered momentarily comprehensible as a result. Art vandals breach aesthetic form, violating the analogy between art object and subjectivity, and yet they do not render this analogy ineffective.[6] They transform it, replacing the original referent with a different idea of subjectivity—the subject with a disability. "Art vandalism," Cordess and Turcan argue, "may be seen as a intermediate form between an attack on a thing and an attack on a person" (95), but this is the case only because the art object is experienced as more person than thing. The analogy between damaged work and disabled body is further evidenced by the claim that punishing art objects offers an important alternative to interpersonal violence (Cordess and Turcan 95; Fuller 14). Mitchell, for example, makes a proposal, partly tongue in cheek I believe, for a blockbuster exhibition called "Offending Images" in which visitors would be provided with all the materials necessary to attack copies of images as "a benign form of therapy" (131). "Stones, hammers, excrement, paint, blood, dirt, and eggs would be supplied," he writes, "and visitors would be invited to hurl, smear, and smash away to their hearts' content" (131). It could well be that destroying images will make some visitors feel good, although I find it a dubious form of therapy, but in the wake of the destruction beholders will certainly not feel as bad as they would if the disabled images were originals, because nothing as unique as a human being is being harmed. The emotional impact of art

vandalism is blunted by using forgeries and copies. We are no more worried about their suffering than about clowns executing pratfalls.

The originality of the work of art is not tied to its perfection but to its unique symbolization of human subjectivity. This symbolism is so forceful, so much a part of all artworks, that the act of vandalism cannot impair it, only direct it toward new ends, meanings, and emotions. In fact, a certain perception of disability is necessary to any work of art, to the sense that it is authentic. This is why restorers often insist that artworks, once damaged, cannot be returned to their original condition. The future authenticity of the work somehow relies on preserving its status as disabled. The restoration of the *Pietà* is emblematic of this telling phenomenon. Although de Campos understood that Michelangelo's masterpiece would have "value as historical evidence but not as a work of art," if missing pieces of the eye and nose of the Madonna were not replaced, he nevertheless made sure that the work could be easily restored to its *damaged* condition (Alexander 72). The water-soluble resin used to repair the statue was given a high fluorescence, so that the exact location of the restored areas could be easily pinpointed by ultraviolet light and removed at any time. The result is the possibility of another viewing experience of Michelangelo's masterpiece, one revelatory of its status as disabled:

> Professor de Campos turned all the lights off in the chapel and focused an ultraviolet light machine on the statue. Suddenly the group was glowing in all its wounded parts as if one were observing human organs under a fluoroscope. Wherever prosthetics had been applied, green pulsations emerged from the gloom. (Alexander 56)

The restoration of the Leonardo cartoon applied similar principles. A paper specialist from the British Museum worked for months with surgical instruments to remove splinters of glass and return the paper fragments to their original position. The positioning was achieved by rearranging the fragments on a life-size photograph of the cartoon. The restorer made no attempt to extrapolate Leonardo's original drawing strokes in the small gaps that remain between fragments but filled in the gaps with tiny pieces of paper fiber. Restoration techniques, although capable of it, do not restore damaged bodies to perfect condition but apply prostheses often visible as such. The paper fiber, like the resin in the restoration of

the *Pietà*, marks the places of injury and creates the impression of bodily wholeness, just as a prosthesis does for the disabled body. Prostheses function as indexes of disability, attesting to the authenticity of the object and protecting it against the accusation of fakery. They prove by their existence that the work of art is the genuine article and not a forgery perpetrated on the public.

As a representation of subjectivity, the art object is compelled to display the effects of change on that subjectivity, as if the ultimate value of the object depended upon it. The disabled image, once conceived as an image of disability, cannot be returned to perfection because the marker of disability comes to symbolize the object's authenticity as a work of art. Restoration techniques resist but never reverse completely the effects of aging, deterioration, accidents, and vandalism. In fact, forgeries are often detected because it is so difficult to reproduce the effects of deterioration. Imagine the *Mona Lisa* returned to the moment when Leonardo lifted his final brushstroke from the canvas, and one gazes upon an indisputable imitation—a monstrous fake. Prostheses may save the "appearance" of the art object, as Mark Sagoff argues, but they change its substance, turning it, little by little, into something other (459). Beholders grasp this fact intuitively, which is why vandalized works of art sadden and shock. It is also why they are capable of inspiring new visions of subjectivity, visions more attuned than those imagined by traditional art forms to the fragility and diversity of human beings.

Let me now return to an earlier topic, the connection between disability and the mental condition of the vandal. The public usually regards art vandalism as outside the bounds of socially acceptable behavior and in most instances considers the assailant to be deranged, incomprehensible, overwrought, or at least very peculiar. Opinion may move from indignation to sympathy once the personal sufferings of the vandal come to light, but rare is the act of vandalism that does not produce some variation on the accusation of mental disability, despite the fact that the kinds of vandalism on record diverge widely and there is ample evidence in the history of art linking destruction to creation. Most familiar are the examples of iconoclasm approved by the practices of modern art. They are meant to be avant-garde, to *épater les bourgeois*, and they do. Marcel Duchamp famously drew a moustache on a copy of the *Mona Lisa*. Robert Rauschenberg's *Erased de Kooning Drawing* consists of an ink and crayon

drawing by de Kooning meticulously erased over the course of a few months, leaving a phantom drawing of the original as a study in white on white. Jean Tinguely's *Machine for Breaking Sculpture* and *Homage to New York* were designed to autodestruct before the eyes of an awed public. Jackie Winsor's *Exploded Piece* is composed of a sculptural cube blasted to bits with plastic explosives and then carefully reassembled. Lucio Fontana slashes canvases. Gustav Metzger makes art by throwing acid.

The company of vandals, however, includes lesser-known artists as well, many of whom do not possess the avant-garde credentials of Duchamp or Rauschenberg. Usually, these vandals destroy to express outrage, although their motives may also be tinged by envy or delusions of grandeur. Students from the Ecole des Beaux-Arts in France kidnapped Man Ray's *Boardwalk* and fired bullets into it as a protest against modern art (Gamboni 282–84). In 1984 Hans Braun, a local artist, attacked a triptych called *Rosy Times* by Salomé, an explicit rendition of a homosexual orgy shown in an exhibition of avant-garde German art, to "set off a signal to alert everyone that this show has nothing to do with art" (Dornberg 1987: 102). Jubal Brown, a student at the Ontario College of Art and Design in Canada, intentionally vomited on Mondrian's *Composition in Red, White, and Blue* as an "artistic statement" about "oppressively trite" and "painfully banal" art (DePalma B3). He then began to ingest dye and to vomit on other celebrated works, planning a "trilogy, with one performance for each of the primary colors," in the hope of selling photographs of his work to a newspaper.

The most striking cases, however, from the point of view of disability studies, are acts of vandalism by the mentally disabled. It is worth remarking from the first that these destructive actions are often extraordinarily sophisticated—to the point where they either compete with avant-garde efforts or seem to mock them. László Toth, for example, used an elaborate argument to justify his attack on the *Pietà*. The points of assault— eye, nose, folded veil, and left arm—were, he explained, attacks on the falsely assumed virtues of the church. He also believed that he incarnated Christ and Michelangelo and, as both, reserved the right to continue his work on the statue. He chose as his instrument of destruction a sculptor's tool and declared that he had formerly ordered a "spotless boy" to create the *Pietà* without finishing it because he intended to complete it himself on Pentecost Sunday—which he apparently did, and he was not alone in

recognizing the action as an "artistic intervention." In mock acknowledgment of his work, young artists at the Swiss Institute in Rome proposed that Toth receive the annual art award of the Venice Biennale.[7]

In 1982 Josef Nikolaus Kleer, a twenty-nine-year-old student of veterinary medicine with a history of "manic-depressive psychosis," attacked Barnett Newman's *Who's Afraid of Red, Yellow, and Blue IV.* He took one of the plastic bars arranged on the floor to limit viewing distance and violently struck the painting. Then he placed several documents on and around the injured work: on its blue part, he placed a slip of paper inscribed "Whoever does not yet understand it must pay for it! A small contribution to cleanness. Author: Josef Nikolaus Kleer. Price: on arrangement" and "Action artist"; in front of the painting, a copy of the last issue of *Der Spiegel,* featuring a caricature of the British prime minister Margaret Thatcher on the cover as a holy knight standing before a dark-blue background in reference to the Falklands War; in front of the red part, a copy of "Red List," a catalog of remedies published by the German pharmaceutical industry; before the yellow part, a yellow housekeeping book holding a second slip of paper with the words, "Title: Housekeeping book. A work of art of the commune Tietzenweg, attack on the right. Not to be sold"; and lying somewhere on the ground, a red checkbook. On the basis of these articles, the police easily apprehended Kleer, but in his interrogation he claimed to be an artist, defining his action as a "happening" and a way of completing the painting.

Equally provocative is Tony Shafrazi's assault on Picasso's *Guernica* in 1974 at the Museum of Modern Art. Shafrazi, an Iranian living in New York, etched "KILL LIES ALL" on Picasso's condemnation of war and violence, but when questioned about his motives, he denied being a protestor and answered that he considered himself to be an artist and his "Guernica action," innovative art. Less than ten years later, incidentally, the Spanish painter Antonio Saura published a pamphlet declaring his hatred of the painting, noting the exceptional security protecting it and giving expression to his own destructive impulses: "I despise *Guernica.* . . . I hate the glass that prevents my knife from opening vaginas in the damned canvas."[8] He made no pretense that his disgust for the painting was an artistic intervention.

Whatever the motivation for attacks, whether aesthetic, protestant, or psychopathological, something like an aesthetic impulse emerges in the

common desire on the part of vandals to influence perception through the manipulation of primary materials. It may be for this reason that David Freedberg calls vandalism "a rude manifestation of aesthetics at a behavioural level" (cited by Cordess and Turcan 96).[9] The photograph of Dennis Heiner attacking Chris Ofili's *The Holy Virgin Mary* provides an illustration. Heiner stands before the painting, as Ofili once did, applying paint to the canvas with a broad stroke of his right hand (fig. 36). Nevertheless, it is difficult to accept that vandals might be artists. We allow that they are sick, envious, distraught, narcissistic, delusional, self-destructive, psychotic, possessed, or self-aggrandizing, but rarely creative. Despite the long history of associating genius and madness, the equation goes only so far, one of its limits apparently being the destruction of art. Vandalism by the mentally disabled is most easily viewed as a form of lunacy untouched by genius.

Given the sometimes startling resemblance between vandalism approved as aesthetic and outlawed as psychopathological, it is nevertheless hard to avoid asking whether prejudices against mental disability are essentially tautological. Is mental disability thought unaesthetic simply because we cannot view it as creative? The objection to viewing acts of vandalism as creative is twofold. First, no one wants—and this includes me—to encourage the destruction of masterpieces, and referring to vandalism as creative may put ideas in people's heads. Second, the metaphysical rules of art associate both aesthetic appreciation and artistic production with a specific range of intelligence and mental activity. The appreciation and reception of the work of art are topics well rehearsed in the history of aesthetics, but rarely are they considered from the vantage point of the disabled mind—no doubt, as I argued earlier, because the spectacle of the mentally disabled person, rising with emotion before the shining work of art, disrupts the long-standing belief that pronouncements of taste depend on a form of human intelligence as autonomous and imaginative as the art object itself. The ability of the work of art to take possession of an audience, although recognized as an essential feature of all successful art, only goes so far—it is almost always treated as serving a call to knowledge or greater self-possession, and those who are possessed by more powerful experiences are thought to be mentally defective. This is why the doctrine of disinterestedness is so crucial to aesthetic theory. It is a fail-safe device that maintains the slender difference between accept-

able and unacceptable reactions to art, while at the same time defining the value of the art object in direct proportion to the strength of the emotions and urges successfully resisted by its beholders. I may appreciate the Venus de Milo, but I may not become aroused and embrace her—although I should be tempted. The piercing eyes of Rubens's portrait of the Archduke Albrecht are meant to attack me, but I may not reciprocate—although, again, I should be tempted. If I succumb to temptation, I fail not only the test of aesthetic disinterestedness but also the test of mental health. The healthy beholder remains disinterested in the work of art, appreciative but not aroused, affected but not possessed, disturbed but not deranged.

All art is directly or indirectly the work of intelligence, according to the dominant interpretation, and the heightened emotions, delusions, and lunacy of art vandals abolish all consideration that human intelligence shines forth in them. Because art vandals do not "intend" to make works of art in the most capacious sense of the word, they do not deserve and cannot hold the title of artist. More typically, if their intentions are said to be aesthetic at all, they are striated by a form of "art envy"—either frustration by the inability to make true art or resentment over the success of popular or wealthy artists—and so vandals regress to a furious and invidious violence against what is lost to them.[10] Their intentions are not pure when they take hammer, paint, or pen in hand and begin to transform the surface of their primary materials. Theirs is not a life devoted to aesthetic expression, not a body exercised in the skills of making art, not a mind inspired by and knowledgeable about its traditions and possibilities. Art vandals are certainly not compensating for a lesser talent by turning to conceptual art. There is nothing aesthetic in their mind, intention, skill, or actions. And yet the most important criterion for identifying art would seem to be its ability to affect the emotions, sensibilities, and perceptions of the people who experience it. One thing is clear about art vandalism, despite its often confusing meanings: it possesses extraordinary resources to produce these kinds of changes in its audience.

Great works of art create a shock, a shock that is a rising out of sleep and dreaming. The intensity and value of artworks are absolutely inseparable from this awakening because it is an embrace of new life and different things. Great works are neither edifying nor uplifting. They do not provide positive role models. They do not have happy endings. Their new visions are always linked to the death or alteration of existing visions. No

work of art, then, is born without acting violently and adversely on what is already there. The sole purpose of art seems to be to create new forms, the greatest of which capture for our contemplation the world we inhabit and help us to think not about its endurance in the past but about its season in the future.[11]

Art vandalism is difficult to embrace as aesthetic creation for reasons both simple and complex. It cannot be offered as a solution to the problem of representing disability, despite the need for a solution, because no one wants to encourage the destruction of cherished works of art. It is unlikely that its example will change how we think about the forms of intelligence thought responsible for the creation and appreciation of art, even though the absolute rupture between mental disability and art needs to be attacked. In this sense, art vandalism might seem to have value only to serve a thought experiment exposing the limits of aesthetics and its representation of the many forms of human beings.

But when an act of art vandalism does occur, something more revelatory than a thought experiment is unleashed—the occasion, disturbing and shocking, for an awakening. In the spectacle of the beholder of art turned passionate vandal arises the vision of a different kind of aesthetics, one in which people react powerfully to works of art that in turn affect the emotions, sensibilities, and perceptions of others. The works themselves are subject to an accelerated deterioration more akin to the human life cycle than to the glacial existence of museum pieces, and they evoke as a result the forms of truth and beauty, both shabby and sterling, found everywhere in the world of human beings.

Chapter 5

Trauma Art:
Injury and Wounding in the Media Age

In the last scene of Sam Mendes's *American Beauty*—as foretold in the first—Lester Burnham dies. The film presents a series of epiphanies about his dreary life, but he finally approaches a moment of happiness, as he sits in his kitchen looking at an old black-and-white photograph of his wife, daughter, and himself bespangled by the dazzling lights of a carnival amusement ride. The camera angle holds him in profile, while the muzzle of a silver revolver approaches the back of his slightly balding head. The camera shifts to the white tile of the kitchen wall, the revolver fires, and Lester's brain splashes bright red against white. Lester's daughter and her boyfriend, Ricky Fitts, climb cautiously down the stairs to the kitchen to investigate. Ricky is a budding artist and the main spokesman for beauty in the film. He has an extensive collection of homemade art films and almost always carries a video camera. He records homeless people and trash because they overwhelm him with sensations. Mendes's screen image and the viewfinder of Ricky's camera often merge, as if the film-maker were using the young artist's vision to tutor the audience about the ancient craft of beauty. For example, at one remarkable point early in the film, we are abruptly given the grainy image of a dead bird, while another character is heard asking Ricky what he is doing.

"I was filming this dead bird," he answers.

"Why?"

"Because it's beautiful."

Ricky is the first to discover Lester's body. He drops to his knees to inspect the bloody head, and the camera captures his point of view. Lester's skull is positioned on the white kitchen table, as if in a still life, his tranquil features reflected in a pool of luminous red blood. The lips are almost smiling, and the eyes are open and clear. Ricky groans with awe—speechless—but the ecstatic expression on his face is meant to tell us that he has once again discovered something beautiful.

There are few Hollywood films that comment on the contemporary art scene. Fewer still make a contribution to it. *American Beauty* seems to do both. Ricky Fitts never expresses an opinion about contemporary art. He is hardly an art critic. Nevertheless, his philosophy of art summons what some art critics call "trauma art," and his final vision of Lester's death head—and any number of his experimental films—would fit perfectly in the contentious Sensation exhibition shown to so much controversy in 1999 at the Brooklyn Museum of Art. Ricky, like many contemporary artists, has realized that there is "an entire life behind things" and that it creates the occasion for new forms of art. This art, however, is often shocking in its display of wounded bodies, disabled people, and traumatized flesh. Mat Collishaw's *Bullet Hole* (color pl. 17), a huge photograph of a gunshot wound in a skull mounted on 15 light boxes, provides a close-up of Ricky's vision of Lester, while Marc Quinn's preoccupation with the human body, especially his own, gives the idea of a bloody head a surrealistic twist: in *Self* (fig. 26) Quinn presents a bust of his head sculpted out of his own frozen blood. These stunning works by young British artists resonate with other works exploring the traumatic nature of modern life, be they Damien Hirst's notorious manipulations of animal flesh in artworks such as *This Little Piggy Went to Market, This Little Piggy Stayed at Home*, a pig sliced in two lengthwise and suspended in formaldehyde as a medical specimen, Jake and Dinos Chapman's goofy and garish explorations of genetic experimentation in *Zygotic acceleration, Biogenetic, de-sublimated libidinal model*, multiple conjoined twins with genital organs sprouting from their faces (color pl. 15), or the Chapman's display of the disabled genius Steven Hawking in *Ubermensch* (color pl. 16).

Of course, the preoccupations visible in these works are not the unique province of the Sensation exhibition. Trauma art has overtaken the contemporary art world as well as the wider media representation of cultural

events. Another notable and controversial example is the work of Andres Serrano. *Piss Christ,* a day-glow crucifix floating in a vat of Serrano's own urine, was at the center of the NEA controversy, but other works take his love of flesh and body substances to even greater lengths. *The Morgue* is a photograph of the head of a victim of infectious pneumonia; *Cabeza de Vaca* pictures a severed cow's head on a platter, and *Frozen Semen with Blood* is one of many abstract expressionist works created by photographing concoctions of human fluids run together and frozen.

Like the still life of Lester Burnham's head, these artworks seem to reflect on the contemporary art scene. At the same time they comment on the nature of social violence. And yet there is something active in them more difficult to capture. They are not merely about the art world or social violence. Their self-reflexive attitude toward both culture and violence works hard to anchor the one in the other, as if their purpose were to expose the fact that we recognize the presence of culture more and more by images of traumatic injury. Of course, that trauma serves as an index of culture is an idea that has been with us at least since the Romantic age, when Rousseau first charted the nature-culture split and Wordsworth summoned images of a benevolent nature by which to measure the violent and alienating tendencies of society. The Romantics understood culture as human violence directed against human beings, but their response to the trauma of modern life was to flee into nature, where they found, to their dismay, only more and more consciousness of human fragility, violence, and death.

Trauma art pushes these insights a step further by insisting that trauma is readable increasingly as a signifier not only of culture but also of aesthetic culture. The aesthetic representation of trauma replays the idea of culture with an added dimension, serving both as the principal sign of the "cultural" and as a way of transforming what "culture" means. Modern art represents trauma as the primary indicator of modern life, whether defining it as human alienation, the love of violence, or the susceptibility of human beings to disease and disability.

Disability has emerged as a central aesthetic concept not only because it symbolizes human variation but also because it represents the fragility of human beings and their susceptibility to dramatic physical and mental change. The capacity to be wounded, injured, or traumatized is not always considered a feature of disability, but it should be. I want to insist that

disability studies include trauma within its definition of disability, but it is equally important to insist that trauma studies accept disability as a key concept. First, a merger between disability studies and trauma studies will allow us to conceive of wounds as disability representations on a par with those typically considered in disability studies. Second, it will allow us to borrow the interest of trauma studies in global media to think about the disabled body as a product of the electronic age. Third, and most crucial, it will allow us to enlarge the concept of mental disability to include the psychic impairments, psychological injuries, and mental traumas provoked by modern life.

Is the growing appearance of the disabled and wounded body in art the result of the perception that modern existence is increasingly traumatic? Might disability play a double role in this perception? The disabled body is at once a symbol of the trauma of modern life and a call to discover a more inclusive and realistic conception of culture, one that recognizes the fragility as well as the violence of human existence.

Recently, critics in visual studies have begun to treat trauma as a major concept for understanding media society. Trauma is the proper response, they say, to the panic culture produced by global capitalism, and yet many questions remain.[1] Images of wounded and disabled bodies may trigger a sense of trauma, but in whom and by what mechanism? If an artwork is traumatic, it is so because it supposedly captures an event personal to the beholder. But artworks of this kind are not about the death or injury of a loved one, a close relative, or even a fellow countryman. The works are traumatic because they mean more than they should, and not in the way that the work of art always means "too much"—this would indicate that artworks are only and always traumatic, and they are not. These works of art disturb because they attach an excess of meaning to the objects designed to convey meaning. More specifically, their meaning grows and circulates via what I am tempted to call the materiality of the body.

Trauma art poses a radical challenge to conventional models of aesthetic explanation. It is at once impersonal and painful—which means it both communicates between cultures and retains an affective power. It is often more challenging to aesthetic form than representative of it—which means that it is readable as "aesthetic" in the modernist sense, and yet it disrupts the paradigm of modernism because it offers a specimen or sampling of culture rather than representing it in broad or universal

terms. Trauma art produces emblems of "culture" but in unexpected ways, perhaps because "culture" itself is no longer the same.

The function of art seems to be changing in culture, and trauma art records the change. Traditional artworks that contain trauma in an aesthetic frame no longer please us, despite the fact that these kinds of works have grown more vicious everyday and fill our museums. Increasingly, we are attracted to art forms and entertainments that make fathoming the distinction between real and artificial violence an urgent but baffling task. Reality TV dedicates itself to bloody car crashes, dog attacks, police brutality, and talk shows that feature obscenities and fistfighting. These new forms of entertainment use footage from real events photographed by the police or news media because their emotional effect relies as much on trauma as on the inability of the spectator to know what is real—which means that everything is real. There is no way to escape the emotional impact of these phenomena, even though one desires to, because there is no perceivable distinction between the thrill and terror felt before so-called artificial forms of violence, such as slasher films, and what is felt before the media reportage of biological disasters, terrorist bombings, ethnic conflicts, and famines. Simply put, there is no context in which the differences between the artificial and the real might be understood.

Trauma art thrives on this double image of violence—that of being itself and the bearer of meaning beyond itself. It also places violence against people in the service of both cultural identity and the exhaustion of culture. The display of trauma reads as an index of culture, while simultaneously announcing that culture is dying. In fact, this is the way that most people in the world identify U.S. culture and its influence. We recognize the influence of the United States by its fascination with violent behavior, but we also fear that this violence, so typically American, foreshadows the end of culture as we know it. The point here is not that the growing violence of the cultural is coeval with its Americanization (the young British artists, for example, are not Americans); it is only to acknowledge the widespread intuition that the United States is the premier site in which to study the trauma now embodied in aesthetic objects.

To say that trauma art is about "culture" is to recognize that it possesses a symbolism, one that constitutes an excess of communication that arcs from specific objects or individual bodies to responses related to collective emotions. Trauma art compels beholders to experience the contra-

dictory impulses of this symbolism as emotional fusions, invoking what used to be called "transubstantiation." A particular and ordinary object becomes the subject of intense focus, with the result that it changes into another object, but an object of a special kind, one that maintains a peculiar materiality, while achieving a universal and communicable meaning beyond its materiality. In short, the objects and bodies become symbols without their signifying effects being attributed to the power of a specific language. The symbolism remains in the thing itself, charging it—and it alone—with extraordinary significance.

If this description sounds familiar, it is because it fits extremely well with a model of thought that dominated the study of culture for many years—ritual. The excess of meaning in traumatic images and art forms, I want to claim, is best understood in the context of a return to ritual. The media age compounds this ritual effect—or, rather, provides the context for its emergence—in the desire for a form of communication that produces affective responses in a world audience, without requiring the mediation of specific world languages. It grasps at a symbolism based on the manipulation of objects, in particular, injured human and animal bodies. Art and other forms of representation are growing increasingly ritualistic, and their impact is more shocking and compelling as a result.

Ritual Bodies

Before the beginning of this century, anthropologists associated ritual with repetitive and standardized behavior, primarily symbolic in character, often attached to objects, and aimed at influencing human affairs involving the supernatural realm (Kertzer 8–9). Today the meaning of ritual has changed considerably as a result of two factors. First, the effect of secularization gave ritual behavior a new emphasis; since the early 1900s, ritual has been linked not to religious behavior but to symbolic action per se. Second, structural anthropology stressed myth and linguistic patterns, shifting attention almost exclusively to the *symbolism* of ritual. Clifford Geertz and Victor Turner revived the study of ritual for our day by focusing on this symbolic character, with the consequence that many anthropologists now typically identify ritual as any moment or area in which meaning is invested, crystallized, or displayed (Dirks 487).

Nevertheless, some features long associated with ritual have not been discarded. Emile Durkheim made perhaps the most significant contribution to the definition of ritual when he developed the idea of the collective representation. Collective representations are symbols of community disguised as sacred ideas. They express a desire for social cohesion, creating a form of solidarity without consensus. In fact, most anthropologists today take it for granted that ritual forms aim, whether successfully or not, at social cohesion. Ritual is crucial to the theory of collective representation because these representations originate most powerfully when embodied in material objects. "Collective representations," Durkheim argued, "originate only when they are embodied in material objects, things, or beings of every sort—figures, movements, sounds, words, and so on—that symbolize and delineate them in some outward appearance. For it is only by expressing their feelings, by translating them into signs, by symbolizing them externally, that the individual consciousnesses, which are, by nature, closed to each other, can feel that they are communicating and are in unison" (335–36). Ritual action dramatizes the collective ideas by which a given community imagines its status as a community because rituals give these ideas material form. The schools of Geertz and Turner may not agree completely about the function of ritual, but both accept Durkheim's linkage between ritual and collective representation. Geertz claims that culture is not found in people's heads but in the public symbols used to communicate the worldview of a society to its members and to future generations. For Turner, symbols are not vehicles for seeing a worldview but operators in a social process. They transform society by moving actors from one status to another. Nevertheless, both Geertz and Turner accept that culture is embodied in public, material symbols (see Ortner 374, 376–77).

Certain schools of anthropology give a precise character to symbols. They insist that ritual relies on bodily symbolism, that something like a ritual body underwrites collective representation. Marcel Mauss's early and important essay on the technology of the body argues that the human body is always treated as an image of society. Similarly, Turner claims that the human body itself is the base and origin of symbolic classification, while Mary Douglas has enlarged upon a similar claim at great length in her work (Turner 90). We can find a reflection of this position outside the field of anthropology in the work of Michel Foucault, who privileges

the body as the site of the micropolitics of power. I raise this connection between ritual and the human body because I do not believe it an accident that modern art has embraced the disabled body as a primary aesthetic symbol. The disabled body is the modern body. I also want to suggest that modern art advances through its preoccupation with the disabled body a preoccupation found at another site—the media—and that the fascination of modern art and the media with the disabled body is based on its adaptability to collective representation.

There is, however, an important limitation placed on symbolic action in current anthropological theories of ritual. Durkheim claimed that the god of the community is the community itself, and that divinity is a collective representation projected to a transcendental site. But Durkheim's collectives are always defined as communities whose members are present to each other. The symbolic action of ritual, whether invested in bodies, gestures, or material objects, operates on groups that must be defined as gatherings of human bodies. I know of no anthropologist who does not accept Durkheim's definition of community on this point. When Geertz claims that ritual communicates a worldview, for example, he is not in fact discussing the world. He is referring to a single, rather small collection of human beings. This explains why the example of Balinese cockfighting is the cornerstone of his theory of ritual display. Geertz shows that ceremonial repetitions of hierarchical power among the Balinese are equivalent to its social realization, but this realization is limited to a certain arrangement of bodies in space (412–53). The school of Turner likewise embraces Durkheim's definition of community. The spectacle of the ritual process creates a "communitas" present physically to and felt by its members.

It is obvious that the nature of community changed rather drastically during the twentieth century. In fact, these changes were already apparent to group psychologists working at the end of the nineteenth century. In the early 1900s, Gabriel Tarde changed forever the theory of group formation by introducing the idea of the "public." Tarde defined the "public" as a community whose members are not present to each other but who compose a community by virtue of their ability to communicate through print and other media technologies. Tarde argues not for a psychology of crowds, then, as had Gustave Le Bon, but for a psychology of the public. Unlike a crowd, the public represents a "purely spiritual collectivity, a dispersion of individuals who are physically separated and whose cohe-

sion is entirely mental" (277). "The public could begin to arise," Tarde
explains, "only after the first great development in the invention of print-
ing, in the sixteenth century" (279). He also mentions the railroad and
telegraph, especially for their ability to increase the formidable power of
the press and its ability to enlarge the audiences of orators and preachers.
"The public can be extended indefinitely," Tarde concludes, "and since its
particular life becomes more intense as it extends, one cannot deny that
it is the social group of the future" (281). In short, Tarde anticipated the
media age and the new forms of collective representation that develop
because of it. In fact, collective representation always had an element of
virtual community at its heart. It involves a projection, to a transcendental
location, of the image of community desired by a particular community.
The media age merely realizes this projection with technology. We are
assaulted everyday by images of ourselves and our communities projected
from the vertical site of mechanical reproduction. We are a public by vir-
tue of these shared images.

The Work of Disability in the Age of Mechanical Reproduction

Walter Benjamin explored in a famous essay the resources of mechani-
cal reproduction for attacking the cult value of art.[2] He argued that pho-
tography, film, and lithography, among other forms, introduce profound
changes in the ancient craft of the beautiful. These new forms supposedly
destroy the ritual aura of the artist and artwork, enable art to illustrate
everyday life, and make art available to the masses. This is all true to a
degree, but Benjamin was mistaken when he claimed that mechanical
reproduction distances art from ritual values. In fact, the ease with which
mechanical reproduction represents human trauma forces art to return
to the scene of its emergence from ritual, where human violence against
humans and the rise of signifying practices were first fused together.[3] Of
course, to say that ritual fuses together violence and human significance
is to recognize that ritual has a religious function, although today one
might as well refer to it as a cultural function, since no one after Hegel has
found it tenable to separate the cultural and the religious. Hegel first allied
religion with the higher values of culture, and his legacy has produced
the series of readings visible in our own day, including Marx's, that attack

both religion and aesthetics as violent ideological constructions. Once we have recognized trauma as an integral feature of culture, however—and it begins to register increasingly as evidence of the presence of culture in the aesthetic sense—we should realize that we have not left behind but returned to the ritual era. Ritual is alive and well today because mechanical reproduction has made it impossible to escape the representation of trauma as culturally meaningful. Displays of human suffering, injury, and disability are readable as art because they carry the burden of meaning in our culture. As art grows more brutal and violent scenes register increasingly as art, the cult value of the aesthetic reemerges—which is to say that it returns to its status as rite.

Trauma art returns aesthetic experience to the sacred dualities of ritual, where the only distinction recognizable between the real world and the shadow world of the sacred is the surplus of meaning in the latter. Ritual gives to traumatic images a function beyond death or the urgencies of animal existence; it attaches human significance to trauma and presents its spectacle as laden with higher meaning and purpose. The desire to transform the human now apparent in aesthetic forms as diverse as body modification and high-art painting finds its origin in the era of ritual.

It is no accident, as I mentioned earlier, that new forms of art have embraced the disabled body as a primary aesthetic symbol. The only way to understand this effect is to acknowledge the use of the body by the media age as a collective representation. Images of the body, especially of traumatic bodies, are available to people on a daily basis as never before, and if it is the case that the body is one of the privileged sites of symbolic action, this development cannot be meaningless. The media age has made possible a return to ritual that has renewed the effectiveness of the body as a collective representation. The disabled body has evolved such a strong presence in the art world for this reason.

The Case of Andy Warhol

The work of Andy Warhol hinges on two factors whose fusion contributes to his unique place in the history of art. On the one hand, Warhol is the first artist to have made mechanical reproduction essential to his mature work. His embrace of silkscreening, enlargement, symmetrical formatting,

and serial repetition seems to remove human craft from his work and to give it the glow of factory production (Warhol 7). His art is mechanical, his place of work, the Factory, and he claimed famously that he wanted to be a machine. On the other hand, Warhol is uniquely American, both because of his dependence on the commercial and media culture of the United States and because he depicted American forms of death, wounding, disability, and violence with a power unrivaled before or since. His *Car Crashes,* for example, portray hideous deaths; they are among the most traumatic images in the history of art, and they consequently elicit powerful, psychological responses. Other works represent or allude to the open wounds in American society created by political assassinations or the suicides of celebrities. These and similar images come from the media, and it is this origin that led Warhol to the techniques of mechanical reproduction, as if the images could not be reproduced for aesthetic effect without acknowledging that they were already being reproduced because of their appeal to a mass audience. That this reliance on mechanical reproduction emerges simultaneously with Warhol's preoccupation with the deaths of both the famous and unknown is not an accident, I insist, but a discovery about the power of ritual in the media age.[4] Warhol transforms mechanical reproduction's threat to ritual into a cult logic either by basing his subject matter on totems of American culture (soup cans, the dollar bill, the handgun) or by capturing mass spectacles of disability and death in the form of traumatic art objects (car crashes, race riots, assassinations, executions, suicides, celebrity illness). The emotions of Warhol's art are created by allowing individual events, bodies, and objects to be overlaid with communal significance. This significance relates specifically to the power of trauma to invoke a vision of collective existence, which explains why his work seems to "contain" trauma, that is, both to expose and organize it, to witness it both as a threat to and symbol of "America."

The conventional interpretation of Warhol's work attributes its power not to the ability to contain but to create a distance from trauma. His art supposedly empties images of their meaning, attacks with serial repetition the speed with which pictures are consumed, and ironizes the numbing of experience induced by daily exposure to trauma, disability, and panic (Warhol 17; see also Crone). Similarly, the passivity of his personality serves only to mimic the permanent stupor produced by the alienating environment of American consumerism. No difference, no emotion, and

no new ideas are possible in media and commercial culture. The constant, undifferentiated flow of information and images puts the imagination to sleep, exhausting both our waking and dreaming existence.

If the conventional interpretation of Warhol were correct, his works would have little impact beyond mere commentary, and one would expect his force to ebb, as more and more images pile up and the context for his irony is lost in the rush of time. In fact, even his earliest art objects retain today the ability to call up powerful responses: they seem to tap into a collective American consciousness, exposing both who Americans are as a people and what they most fear about themselves. Even for beholders who do not recognize the historical events and symbols pictured by his works, Warhol maintains the power to shock and stun because he exhibits so ruthlessly traumatic bodies, accidents, and events: the profile of a crouched figure plunging to death from a great height, the limp body of man impaled with great force on a telephone pole, the jaws of a savage police dog tearing into the legs of a fleeing protestor, a woman in a black veil, named Jackie, contemplating with funeral expression the death of her beloved.

Warhol's art is so shocking and poignant because he possesses the uncanny ability to pick out and enlarge objects and images that arouse, because of their vivid attachment to trauma, extreme emotions about what it means to live life in common. The power of repetition in his work is not merely a function of mechanical reproduction but of the rhythms and patterns of daily life conceived as a specific form of collective existence. In fact, Thomas Crow claims that Warhol's use of mechanical reproduction increases rather than numbs sensitivity to trauma. Repetition serves to enhance the referential power of Warhol's art because it registers "the grim predictability, day after day, of more events with an identical outcome, the levelling sameness with which real, not symbolic, death erupts into daily life" (Crow 1996b: 60–61). In short, what happens vividly and repeatedly determines the collective imagination of an existence lived in common, defining its symbols, affects, and organization. Moreover, Warhol dramatizes the breakdown of commodity culture, Crow explains, by exposing the inadequacy of mass-produced images compared with "the reality of suffering and death" (1996b: 51). His art feeds off the violence of consumerism, providing both a counterintuition about what American society should ideally be and a powerful expression of what it is. For Crow, then,

Warhol is political because he reveals the collapse of American consumer society into violence and inauthenticity. He dramatizes the representations of media society to create a "kind of history painting" (Crow 1996b: 57) that exposes how dangerous and transitory fame and other consumer products are.

It has often been observed that violence levels the forms of distinction produced by consumer society. Nevertheless, violence has the capacity to create its own brands of distinction. It underscores, in blood, eruptions of individuality recognized instantly by communities and commemorated by them in a fashion that underwrites their own conceptions of their future as a collective form of life. Warhol is usually seen as a philosopher of the first observation, someone who either uses or abuses the power of "brand names." In fact, he is a philosopher of the second observation, a thinker who understands the resources of violent actions, the injured, and disabled bodies for collective representation. Aesthetics and ritual merge in his art because both present the private as the substance of public communication. This accounts for the seemingly contradictory effects of his works. They are "political," as Crow understands, because they make visible the instability, falsity, and danger of symbolic networks, giving the lie to the fake harmony of a consumer society that pretends that all conflicts can be resolved because all are exchangeable. But Warhol's works are intensely private as well because they exhibit how the social world attacks individuality—even as it produces it. The social seems to neutralize individual feelings and thoughts because it enforces a horizon of collective interpretation that fits particular events, bodies, and objects into a cycle of repetition whose meaning is beyond the ken of individual minds. Individuals respond to this social imperative with feelings of alienation, and no one has a better eye for these feelings than Warhol. But it is a mistake to see Warhol exclusively as a painter of consumerism gone bad. Alienation is supposedly a new emotion produced by the rise of secularization, but the age of ritual manufactured a good share of it. The ritual process also creates victims who feel like victims because it treats individuals as symbols required for collective action. Frantic participation of individuals in collective life does not define a new condition created by modernity in general or consumerism in particular. It defines the human condition as such.

Hal Foster describes the "return of the real" in aesthetics as a response

to the trauma of modern existence (127–68). In the specific case of Warhol, he understands that the choice between what he calls the simulacral and referential interpretations is false. Warhol does not ask his beholders, Foster claims, to decide between a world of commodity fetishism and a world of brutal facts that exposes the inauthenticity of consumerism (130). He fuses together these two worlds in a "traumatic realism," presenting a picture of reality that terrifies because it calls forth affects incommensurable with its objects (130). Foster claims that traumatic realism transgresses the line between the public and private spheres because it both wards off and opens one to death, disability, and wounding (136). In particular, he locates traumatic artworks in the Lacanian real—the psychological register that ascribes a bloated plenitude to objects and events—but what he does not pursue is the idea that the real is the experience of ritual. For if the symbolic is composed of kinship relations (the social) and the imaginary records the life of the body (vision, gesture, surface), the real is the register in which the body undergoes a process of transubstantiation that charges it with meanings seen as hierarchically superior to those of the social world. The ritual body exists beyond the social body, even though it takes the form of one physical entity among many in the community, because its surplus of meaning is projected to the vertical site of transcendental authority. Nor is the ritual body identical to the body positioned in time and space. It is a body that bursts the coordinates of time and space, appearing to determine rather than being determined by them.

Warhol promised that modern society would give everyone fifteen minutes of fame. He was supposedly commenting on the fickleness of American consumerism, whether considering the famous or the almost famous. In fact, he was thinking about death, disability, and disaster, and their productiveness as collective representations in which the body as spectacle is presented to the public as a symbol of its own collective nature. The famous and almost famous in his works are dead or dying—and only notable because of it. It makes no difference whether he is picturing Marilyn Monroe, Jacqueline Kennedy, Mrs. Colette Brown, or Mrs. Margaret McCarthy (see *Tunafish Disaster*, 1963). It makes no difference because, while individual and temporary fame may be one product of disaster, the ultimate product is not the fame of the individual—thus the fifteen-minute time constraint—but the identity of the culture. Warhol's works are more about America than its famous or unknown victims. Their

bodies are only the material used to symbolize this culture. His work on unknown disaster victims is about the making famous of the dead and thus about the coming into being of the society that kills them. His work on celebrity victims reveals that the famous are sacrificed to create that broader horizon of signification called "America." Both types of work reveal that trauma is the principal signifier of the cultural as such. It is as if Warhol's art announces that culture appears only with the consciousness of trauma. The victims and wounded bodies portrayed in his art do not die or suffer alone. They have caught the attention of a collectivity, through great cost to themselves, and are famous for its sake. They are sacrifices killed on the altar of America.

The Tank Hero of Tiananmen Square

Let us pause to look at an example beyond the American context, though one that will return us to it because of the unassailable Americanization of the world media. The Tiananmen Square massacre of 1989 was among other things a struggle for the right to represent the collective image of China. The struggle was extremely violent, as is often the case in matters of collective representation, but the violence guaranteed that the events would be given cultural significance if only the proper focus could be found. This competition for focus is evident in the words of Chai Lang, a student leader of the pro-democracy movement. "We knew," he said the day after the massacre, "that the purification of the Republic could only be achieved by our sacrifice" (Iyer 192). The Chinese Communist Party sought to assert its image of China by purging competing representations. Its audience was internal and nationalistic, but a different, more international focus was given to the rebellion, despite the CCP's efforts. On June 5, 1989, an unexceptional figure in slacks and a white shirt, carrying a shopping bag, was photographed in Tiananmen Square by the Western media as he blocked the advance for twenty minutes of a column of seventeen tanks. The lead tank swerved to the right, but he moved to block it. It swerved left, and the unknown rebel again placed his body in harm's way. Then he climbed onto the tank and exchanged words with its driver, until bystanders dragged him away, and he disappeared forever into the crowd. All that remains of the event are the photographic images, but they

are no small thing because they impressed the tank hero's image vividly on global memory. "Almost certainly he was seen in his moment of self-transcendence," *Time* magazine reported, "by more people than ever laid eyes on Winston Churchill, Albert Einstein and James Joyce combined" (Iyer 192).

The image of the unknown rebel resonates with an ancient, ritual truth about what it means for one human being to risk injury for many others. The tank hero did not exactly sacrifice himself—we do not know that he was killed—but he did disappear, and he now figures as a kind of sacrifice by virtue of his absence.[5] That he is viewed as a sacrifice is demonstrated by the fact that his absence from the continuing scene of his representation reads as if it were an action by "him" for "us," although it is not certain who "we" are. That is, his actions are viewed as more representative of claims made on the part of a collective than any he might make for himself. He is, in short, a "hero," a figure who stands for ideals of value to a polity and so a figure claimed by polities as representative of themselves.

Perversely, violence against human beings is both symbolic of the cultural as such and symbolic of any one culture's highest ideals. It is this double symbolism that the media age both conceals from view and uses as its first principle of meaning production. On the one hand, media images of traumatic and disabled bodies travel so easily from culture to culture because they are floating signifiers of the cultural. On the other hand, these images gain a stunning potency in local contexts because any given culture will readily attach its own communal meanings to them, thereby transforming a floating signifier into a collective representation capable of invoking particular meanings. Global studies understands these effects as symptoms of the extraterritoriality of meaning, although the theory is inadequate to the actual phenomenon because the point to emphasize is not that meaning in the global world has become groundless or extraterritorial but that there is much greater competition over when and where meaning will be grounded.

The media response to the tank hero provides a powerful example of this competition. Both East and West found the image equally appealing and useful, and it is easy to see why. First, the violence displayed by the image, which relies on the opposition between the fragility of the human body and the brute power of the tanks, conjures a symbolism easily trans-

formed into collective representation. Second, the simplicity and stark-ness of the image lend it great translatability, prompting its status as an icon for different cultural claims. Third, the availability of the image via the media to a global audience means that any number of communities will compete to attach their own specific cultural meanings to it.

Somewhat predictably, the competition in this case breaks down between East and West. *Newsweek* magazine displays concisely the American appropriation of the image in the "People of the Year" issue of 1989: it includes the now famous picture of the unknown rebel facing down the tanks with the caption: "In Beijing, a lone youth showed a profile in courage" (fig. 37). The tank hero's actions summon the memory of other heroic sacrifices in the name of liberty, a number of which were recounted in *Profiles in Courage* by the assassinated president John F. Kennedy. Here the tank hero represents one man standing up for the rights of others—the very icon of Western liberal individualism. Or, as *Newsweek* described it, "a lone man armed only with courage faced down a column of tanks" ("Special Report" 19). In this view of society, individuals fight for liberty, and once it is won, it must be displayed in individual terms, even if many people share it. Thus, Agence Presse France reported, in another variation of Western individualism, that the unknown rebel's "fearless image in the face of violence represents the spirit of the Chinese people," and Pico Iyer of *Time* magazine described the tank hero as "one lone Everyman stand-ing up to machinery, to force, to all the massed weight of the People's Republic—the largest nation in the world, comprising more than 1 billion people—while its all powerful leaders remain, as ever, in hiding some-where within the bowels of the Great Hall of the People" (192).[6] Each of these accounts emphasizes crucial elements in the collective representa-tion of Western liberal society: individual courage before brutality and numerous enemies, a secret affiliation with another community yearn-ing for freedom, a vivid account of an event or image that captures the struggle by an individual for liberty, usually at the cost of death, disability, disaster, or disappearance from the scene of representation.

The appropriation of the tank hero by the Chinese Communist Party was multiple and more complex than the Western usage.[7] China Central Television broadcast the footage on June 5, a day after the crackdown on the network by the CCP. In other words, the appearance of the film clip on national television was not the work of the rebels but of the ruling regime

Figure 37. Tank hero, *Newsweek,* December 25, 1989

in the process of putting down the revolt. To its foreign audience, the government claimed that the People's Liberation Army exercised restraint: a column of seventeen tanks halted and tried to maneuver around a lone, unarmed individual. A few weeks after the rebellion, the Chinese Foreign Ministry continued to make this argument in press conferences. To the national audience, the CCP sent another message. The footage reminded the people in Beijing of the raw power they would find in the Square should they be foolish enough to join the rebellion. It also showed the disposition of the PLA. People had been feeding soldiers in the hope that they would support a coup, but the image of the tanks in action demonstrated that the army had not been won over and remained solidly behind the CCP.

More than twenty years after Tiananmen Square, the Western view dominates interpretations of the tank hero's image everywhere, except in China. In 1998 *Time* magazine named the unknown rebel one of the top

twenty leaders and revolutionaries of the twentieth century. Numerous Western websites celebrate the tank hero and translate his resemblance into works of art and political images. In China it is a different story. The CCP is uninterested in the unknown rebel for obvious reasons, but liberal-minded Chinese are equally reluctant to revisit his image, either because it is too painful or too politically sensitive to discuss in public. In short, the image failed to achieve status in China as a collective representation of the principles valued by the pro-democracy movement. Perhaps the competition for the image between the liberal democracies and the CCP was too strong to permit another community to appropriate it as a representative symbol. Perhaps interpretation is one of the spoils of victory, and the rebels were defeated.

The many and opposing meanings attached to the tank hero expose the fact that traumatic bodies may serve the collective representation of competing communities. Images of wounding, danger, disability, and disaster travel well for this reason. Nevertheless, my interpretation of the tank hero raises two cautions worth keeping in mind for future work of this kind. While ritual always strives to produce collective representations, it does not always communicate common understandings of its central symbols, and collective representations are by their nature extremely difficult for any one individual to interpret (Bell 183). This is especially true in a global world where images and objects are uprooted from their local context and circulated by competing communities as potential symbols of themselves. If we are to gain some understanding of this new climate of meaning, we will need not only to produce many more case studies of traumatic images and their multiple, local contexts but to develop strategies to account for how the media age uses the ritual fascination with traumatic bodies to globalize the influence of collective representation itself.

Coda: September 11

The vision of Americans proposed by *American Beauty* as an armed populace ready to attack anyone perceived as different seemed obsolete for a time after the events of September 11. The terrorism in New York and Washington impaired the efficacy of violence as a cultural signifier of the

United States both at home and abroad. Americans suddenly saw themselves as victims of foreign aggressors, but more important, the world also viewed the United States as a victim for the first time in a long while. The terrorists traumatized Americans and turned their attention from the dangers of home to faraway places populated by people strange to them. "Why do they hate us?" was the question posed by American newspapers and television shows, and many Americans asked themselves the same question in their hearts. This polarity between the known "us" and the unknown "they" temporarily split the understanding of what violence in the United States is and how to represent it. On the one hand, there is the story told by *American Beauty*—a quintessentially American story because only in the United States does one find gun collections in the den, blood-splattered kitchen walls, and firing guns as a form of therapy or self-help. The revolver, as Warhol knew, is a totem of American society as surely as violence is its national pastime. On the other hand, September 11 made this view of the United States seem unpatriotic and irresponsible. Violent films, television programs, and art exhibits were pulled from view after the attacks, and the media mentioned the desires for cooperation and peace as primary American virtues. Moreover, the events seemed to give every reason to perceive violence as an external force, alien to American society. The war on terrorism surely tried to make a project of this perception, demanding that Americans view violence as coming from un-American sources, sources infinitely creative in their ability to make weapons against the United States out of the most ordinary objects.

Predictably, however, the attempts by politicians and the media to expel American violence to the outside have largely failed. Less than five months after the attacks, the representation of trauma became acceptable again, and films momentarily deemed too violent for distribution were back at the multiplexes. The military might displayed in the wars in Afghanistan and Iraq reaffirmed the standing of the United States as the greatest power in the world for both its friends and enemies, while the newly created Office of Homeland Security quickly returned the attention of Americans, although somewhat inadvertently, to the forms of violence that most threaten the American way of life, that is, the American way of life itself. Thanks to security measures designed to reveal hidden terrorists in the United States, the most ordinary and generic Americans have been removing their shoes and emptying their pockets at airports

2.10

GALLERY

The Things They Carried

A sampling of items airline passengers have tried – and failed – to bring on board in recent weeks. Photographs by Susan E. Evans

Before Sept. 11, inspectors confiscated only two to three pounds' worth of contraband each day at Orlando International Airport. But since then, the daily haul has grown to approximately 20 pounds. The week these photos were taken, the most commonly seized items were nail scissors, but at least one turkey-basting needle and a vegetable peeler were also among the loot.

Figure 38. Susan E. Evans, *Implements of Terror*, 2002, New York, Ricco Maresca Gallery of Chelsea

under the suspicion of being mass murderers. Many of these same ordinary Americans either found it comical or useful to send letters laced with phony anthrax to their neighbors. September 11 may have established box cutters as the weapon of choice for terrorists, but the widespread fear of fellow American citizens has marked more ordinary objects as "implements of terror"—toenail clippers, safety pins, children's forks, corkscrews, golf tools, pen knives, and hair picks (fig. 38).[8] These common objects, now rendered murderous by ritual action, offer a vision of trauma difficult to reconcile with their simple materiality. They have become symbols of collective truth. They are trauma art. It is as if they ask Americans to accept, with the rest of the world, that the United States is culture at its most violent and traumatic. They reveal where the danger lies. It lies within.

Chapter 6

Words Stare like a Glass Eye:
Disability in Literary and Visual Studies

If we look at an isolated printed word and repeat it long enough, it ends by assuming an entirely unnatural aspect. Let the reader try this with any word on this page. He will soon begin to wonder if it can possibly be the word he has been using all his life with that meaning. It stares at him from the paper like a glass eye, with no speculation in it. Its body is indeed there, but its soul is fled.

—William James

The children of the present generation are the first in a long time who will not take their cultural identities from books. Statistics reveal that film, museum, concert, and sports attendances are up in the United States but that fewer and fewer people are reading books. Those strange moments in nineteenth-century novels when young heroes strike poses, dress, coif, and woo by the book are gone, perhaps forever. Children are now more likely to take their models from television, films, glossy magazines, or video games. My colleagues at universities throughout the world report that students now possess, thanks to the expansion of visual culture, an enviable talent for decoding images, often to the detriment of reading ability. To be frank, I am not so convinced: in my experience, the most literate students continue to be the best readers of images. But I do agree that we are in the midst of an unprecedented explosion of visuality. A new era has dawned, and we are not prepared for it.

Ours is the era of the image, the book is in decline, and yet cultural studies has never been more invested in the act of reading. An extraordinary emphasis on language characterizes the last seventy-five years of

theory in the academy. Spun by the so-called linguistic turn, our approaches have emphasized close reading, juggled binary oppositions as elementary structures of language, traded the importance of presence for the power of *écriture,* and embarked on the "reading" of paintings, buildings, consumer objects, and human bodies. Cultural studies would seem to be a response to the changing times, but it has actually established the prototype for applying the methods of literary reading to extraliterary phenomena. J. Hillis Miller claims that words are the medium of cultural studies, and he is right (1992: 17). Nor is the preference for reading limited to literature professors. Anthropologists and other social scientists describe themselves routinely as readers. Clifford Geertz, for example, states that "doing ethnography is like trying to read (in the sense of 'construct a reading of') a manuscript," and he often likens cultures to poems that contain their own interpretations, interpretations released by acts of close reading (10, 18, 452–53).

The preference for reading is only a metaphor, I understand, but it is a metaphor with a reason because it undergirds the linguistic prejudices defining our favorite critical methods. The attachment to the metaphor seems theoretical and emotional. Readings based on linguistic presuppositions aim to teach the language by which understanding is produced. When no language is manifest, readers are obliged to invent one; otherwise, the translation between the "language" of reading and the "language" of the object does not take place, and the object remains unreadable. Perhaps the impulse to read an image is a measure of the desire to control it. Images too complex to be read refuse this control, and they challenge the authority of reading as a privileged activity because they demonstrate a surplus of meaning untranslatable into linguistic terms.[1]

A picture may be worth a thousand words because no one word is ever adequate to the excessive expressivity of images. Often, the excess of meaning is perceived as emotion, but there is no reason to deprecate it as unintellectual, unless one is interested in policing what intellectual response is. Policing is, of course, the usual reaction to images when "read" on their own terms, for in the battle between word and image, images are always found excessive or defective. On the one hand, we dread the meaning associated with images. They represent an excess or surplus that obliterates words and the need for them. Images tempt our children with pleasures that words cannot offer but do not teach them anything in return.

It would be better if they put their head in a book. On the other hand, we have the doctrine of *ut pictura poesis,* in which only a relationship to a prior and hallowed text legitimizes images.[2] Paintings are speaking pictures, but their speech is stuttering and defective when compared with the graceful tongue of poetry. Or images possess only mute speech. Here literary readers play the role of speech pathologist to help images express themselves better. If paintings are mute speech, are poems blind vision? Does poetry stare back at its readers like the "glass eye" in William James (726)? I emphasize the presence of disability in these slogans for a reason and ask that it be kept in mind.

At the moment when everyone seems to agree that the image reigns, the preference for reading dominates the university. Only a literary approach to images seems right and proper. What would it mean to reverse this proposition, to apply to words the theories and methods of visual studies? Would this reversal make literary works more accessible and interesting to students? Would it bring academia into the twenty-first century? These questions are worth thinking about, but it must be remarked, first, that a reversal of the status quo is not easily achieved, and this fact may be important in itself. Irreversibility is a sign that prejudices are at play, and the power of prejudice manifests itself whenever we try to reverse the proposition currently defining the interpretation of words and images. To call for a reading of a painting summons not a moment of hesitation, but to picture a word or group of words as an image provokes a host of qualifications. Perhaps it makes sense to view concrete poetry with visual theory. The marbled page in *Tristram Shandy* may invite the approach, and so on. But how would one start to apply visual studies to words as a general theoretical practice? One would need to begin at least by making an argument about the materiality of words because visibility requires the presence of a body.

Words Made Flesh

Erich Auerbach's *Mimesis* locates the origin of Western realism in Homer's visual culture—the phrase *visual culture* is not used but is clearly implied—and of all Homer's images, none is more emblematic for Auerbach than Odysseus's scar. Homer casts a bright and uniform light on the details of everyday life, Auerbach claims, making "things stand out in a realm where

everything is visible." Homer "leaves nothing half in darkness and unex-
ternalized." Characters and their surroundings "are brought to light in per-
fect fullness" (3, 5, 6). In opposition to the style that visualizes every detail
for readers, Auerbach sets the Hebrew Bible's lack of interest in everyday
matters and their specific images. Its characters do not have recognizable
scars that reveal their identity. They do not use their right hand or their
left. When they speak, we do not know whether they are indoors or out-
doors. Auerbach admires Homer but considers his flirtation with image
culture detrimental to knowledge and interpretation. Jean-Paul Sartre
claimed famously that "the image teaches nothing" (10, 148). Auerbach,
who also read Hegel with care, concludes that Homer's poems "contain no
teaching" because they conceal "no secret second meaning." They "cannot
be interpreted" (13). The image of Odysseus's scar is supposedly empty of
meaning, and yet it marks out the hero's identity. How are we to account
for its power?

The reading of a word changes visible space.[3] When we read, we look
through the fence of the text, past the rails of meaning, to meaning itself.
But to learn to read is also to acquire a new use of the body. It is to recast the
body image. When words gain materiality and appear in the world as vis-
ible things, reading comes to a halt, but words acquire an additional power
as a result.[4] They stand still, producing a seizure of meaning, interrupting
the ordinary transparency of the page, and exposing the materiality of lan-
guage. They become bodies—Odysseus's scar and James's glass eye are par-
adigms—and they may act upon other bodies. The word becomes image,
which is to say an object visible under the sign of desire. The image requires
a scene in which something appears as something else. It represents a form
of behavior in which we direct ourselves toward a body, bringing it to our
knowledge and making it exist in a more intimate sense.[5]

Odysseus's scar is an example of words becoming body and acquir-
ing the power to act upon other bodies as a consequence. It is no accident
that Homer chooses the scar as the emblem of Odysseus or that Auerbach
chooses it as the emblem of Homeric style. The scar is exemplary pre-
cisely because it is a scar. It embodies Odysseus for readers—readers of
every generation, past, present, and future—because while customs may
change, technology evolve, and languages differ, human beings always
have skin, and their deepest wounds always heal with a scar. Scars have
the capacity to represent difference because the details necessary to indi-

viduation acquire their mimetic power by virtue of their connection to bodily wounds, cuts, defects, and deformities. To detail is in fact to cut, and many details preserve this primordial association with the slicing, abrading, or disturbing of a surface, whether the disruption involves flesh or nonorganic skin. Naomi Schor's history of the detail provides vivid evidence to support this assertion. *Reading in Detail* is a book that tries at every turn to explain what is unreadable about the detail, which is to say, what it pictures. What it pictures is a certain excess that Schor calls the feminine but that might be called disability, whether summoned by Reynolds's aversion to "deformity," Hegel's negation of "little scars" and "warts," Flaubert's haunting embrace of Homais's "pockmarked" face, or Baudrillard's refusal of consumerism as "a cancer of the object" (16, 26, 56, 63). The detail serves in the history of aesthetics not merely as a negativity or sign of decadence but as a diagnostic tool useful to discriminate between the nondisabled and disabled body (43–44). Healthy bodies in art do not have details. They are unmarked. Details appear as pathology in aesthetics because they discover the reliance of images on the difference of the disabled body. For ever since Odysseus's scar, wounds and images have been closely allied.

All images picture bodies, but the most compelling images often summon visions of the human body, and of these the ones that picture wounds or markers of physical or mental difference are the most potent for the imagination.[6] For words to rise to the surface of the text and stare back at readers like a glass eye, they must acquire the status of the detail, and where there are details, human difference is not far away. It is not merely that a recognizable formula or syntactic device, like a metaphor or simile, organizes the words to new effect. It is as if a body rises to the surface of the page and moves into the emotional consciousness of the reader. A word is like a tomb heaped high over a dead warrior as a sign to some passerby in later time to stop and remark on it.[7] But unlike the spectacle of the dead rising from the tomb, there is nothing macabre about bodies rising from words. These bodies fascinate and absorb our attention rather than terrifying us. They compel us, like doubting Thomas, to probe the miracle in the details, to put a finger in the wound.

Absorption in details, whether on the surface or not, is one signal that a reading has taken the unusual course from word to image and that the text calls for visual analysis. The premier theorist of absorption in paint-

ing is Michael Fried, whose career spans from an early attention to the objecthood of modern abstract art to recent theories contrasting theatricality and absorption in French realist painting. Absorption for him usually refers either to thematic elements by which a painting tries to ignore that it was made for a beholder (thereby refusing theatricality) or to the literal absorption of the moment of the painting's creation into its canvas. An example of the first from *Courbet's Realism* is Jean-François Millet's *Man with a Hoe,* where the exhaustion of the subject figures as absorption in a task to the exclusion of being seen (Fried 1990: 41); of the second, *The Man with the Leather Belt,* where Gustave Courbet twists his subject's right hand into a position that mirrors his own hand painting the canvas (Fried 1990: 75, 80). Fried's excursion with *Realism, Writing, Disfiguration* into nineteenth-century American painting and literature introduces a small but significant modulation in the theory of absorption, one designed, in effect, to shoot the gap between painting and literature. His apparent subject is the materiality of writing in Thomas Eakins and Stephen Crane, but his analysis takes the further step of treating writing turned material as a visual effect or image, proving a useful demonstration of how visual studies may be applied to literary works. In short, when Fried turns from Eakins to Crane—and the order is not coincidental—he looks at Crane's writings as if they were paintings.

What distinguishes Fried's approach, although hardly stated explicitly, is that bodily disfiguration directs both the materiality of writing and its absorptive powers. Fried establishes the idea in the case of Eakins's *The Gross Clinic* by representing writing as cutting with the surgeon's scalpel (Fried 1987: 20). In *The Red Badge of Courage* and elsewhere, he isolates the materiality of writing in Crane's obsession with the image of a corpse whose upturned face begs, as if a sheet of white paper, to be written upon (Fried 1987: 99–101, 121). In both cases, the moment of absorption occurs in the presence of the disabled body, whether visualized as wounded in Eakins or dead in Crane. Beholders of *The Gross Clinic* cannot turn away their gaze, despite the painful sight (color pl. 21). Their eyes probe, along with the surgical instruments, the depths of the flesh opened to their gaze, becoming fixed and absorbed in the wound.[8] Similarly, the reader of Crane fixates on the words so forcefully that their materiality absorbs the gaze, but the scene of this occurrence, Fried argues, almost always includes a description of a wounded body, since it is the figure of writing in Crane.[9]

At these moments, Crane's fixation on writing rises to the *surface* of the page as an image—the image of the disfigured upturned face with open unseeing eyes—to meet and to absorb the reader's eye.[10] Crane wants his readers to see what he sees in the act of writing—words embodied on the printed page—but the use of the disabled body to create the visualization adds another level of fascination.[11] The specific material details of Crane's text are inseparable from bodily disfigurations, demanding the conclusion that visibility and the disabled body are closely linked. Fried's emphasis on acts of seeing, both literal and metaphoric, allows disability's contribution to the image to stand forth. His pursuit of the image of the wounded body appears relentless and single-minded, until one realizes that he has discovered something vital about the nature of the image, something that merits a relentless and single-minded approach.

Fried's technique provides a model not only of how to picture words but also of how to bring visual theory to bear upon words embodied as images. The result is a theoretical claim for a different mode of absorption, one that identifies the power of disabilities and impairments to rivet the attention of beholders. The modification does not endanger his theory of absorption in any way but enriches it by concentrating on specific properties of texts and images that make them more visible and compelling to the eye of the beholder. More important, the discovery has both formalist and political implications because it suggests that aesthetic form and appearance require that certain populations of human beings and their physical and mental features be represented as different from other people and their features. The details of art, it seems, require the differences of people, but this is not to say that all images of difference are created equal. It is the critic's job to make clear their aesthetic and political costs, just as it is the right of all persons to protect themselves against unjust images of difference.

To theorize the image, then, is to participate in a form of discrimination, to understand that the attention of beholders depends on images of difference—images not always just—and that visual culture is dependent on such differences. "Photography is," Roland Barthes states in *Camera Lucida*, "a science of desirable and detestable bodies" (18). The statement describes not merely a science of photography but a science of the image because every image commands one to see and discriminate a body. I like it. I do not like it. Barthes is in fact the most conspicuous theorist of per-

sonal evaluation, but his judgment of images is determined less by simple discrimination than by what he calls "a desperate resistance to any reductive system," and his opinions have aesthetic and political value for this reason (8). A bodily consciousness of his own feelings guides his viewing of photographs, steering him away from reductive observations and allowing him to realize that some images provoke "tiny jubilations, as if they referred to a stilled center, an erotic and lacerating value" buried in himself (16). The result is a call to readers to witness how one person's emotions and perceptions about human difference expose the "fundamental feature, the universal," without which photography would not exist (9).

Feelings define Barthes's vision of photographs, but like a good theorist, he exploits them to create a theoretical approach, and this approach represents a theory of the image as useful for literary texts as for photographs precisely because it attends to how differences among bodies are established. The theory behind *Camera Lucida* has not the slightest interest in the "corpus" of photography; Barthes focuses on "only some bodies" and what his body knows of them (8–9). He wants to explore photography, he explains, not as a question or theme but as a "wound" (21), by which he means the sensitive point that rises out of the photograph, "shoots out of it like an arrow," and "pierces" him to the heart (26). Barthes uses the Latin word *punctum* "to designate this wound, this prick, this mark made by a pointed instrument." It refers to a "sting, speck, cut, little hole," and some photographs are "speckled with these sensitive points; precisely, these marks, these wounds are so many *points*" (27). The punctum, then, is the accidental cut, the disability, that defines the photograph as an individual image. Notice that the "image" does not equal the entire visual field of the photograph. The image resides in the piercing details. In fact, Barthes uses *punctum* and *detail* interchangeably, understanding that both lash, cut, and abrade a large visual field to make the image of difference appear. The image may teach nothing, but it does open wounds. Barthes gives himself over to these wounds, opens himself to cuts, bruises, and impairments that charge the body and mind with difference, sometimes forever.

It would strengthen my argument, I confess, if Barthes's vision of the punctum lined up consistently with images of the disabled body and mind. But he does not always pick out images of disability to define the punctum, although he insists that what is unique to a photograph is its wounding point. Accompanying his intense focus on "a corpse's one bare

foot" (23), "the huge eyes of two little boys" (25), "one child's bad teeth," "a monocle," "a blind gypsy violinist" (45), and a "girl's finger bandage" (51) are a pair of "strapped pumps" (43), "crossed arms" (52), and Bob Wilson's "posture" (57). Nevertheless, Barthes's absorption by uncommon bodies and minds is clear. Each image suggests to his eyes an individuating mark or cut. His concept of difference may be more metaphoric and personal than an obvious recourse to disability requires, and yet this preference, too, is useful because he makes it possible to conceive of the arbitrariness of disability. Barthes's insistence that the punctum is a wound, despite his inability to represent the wound as one specific thing or another, exposes a political element at work in the alliance between images and disability, because the details that he makes visible place in doubt easy associations with defects, irregular posture and gestures, deformities, blemishes, and other stereotypes of disability. Disability relies on the physical and mental impairment of bodies, but it also depends significantly on social convention. What represents an ability in one environment defines a disability in another. Barthes's intense scrutiny of visual culture showcases how perception for one remarkable person pins down the image of difference, moving it from arbitrary to fixed status. We search the visual field of each photograph with Barthes, hunting for the pricking point. One moment it is not there; the next it shoots out of the photograph like an arrow. The image pierces the eye of the beholder, but the visual field, too, has been pierced: a bloody spot appears where none existed before, a blemish, a hole, a bruise, a unique detail forcefully differentiating the visual field into marked and unmarked bodies. Specific environments and situations, then, determine the visibility of a disability and, consequently, its capacity to serve as an image of difference. This is not to say that disability is invisible in itself, although there are, of course, invisible disabilities. It is more accurate to say that every disability is technically invisible until it becomes visible under the pressure of social convention, which means that the appearance of disability is often linked to violence and prejudice.

No Face

Junot Díaz's *Drown* not only enlarges the understanding of how disability becomes visible but also allows me to apply to a literary work some of the

visual theories tested so far. A book of interlocking short stories, *Drown* has many visual elements, providing vivid snapshots of life in the Dominican Republic and New Jersey as well as exploiting a rigorous sense of form to drive words toward their material counterparts in images. Among the many wounding points, the most anguishing is the face of Ysrael, a recurring character pursued throughout the stories by other boys who want to see his face close up. The boys want to see Ysrael, whose nickname is No Face, because "when he was a baby a pig had eaten his face off, skinned it like an orange" (7). Ysrael literally runs through the book, and every time he is caught or almost caught, a high dramatic level is reached because Díaz withholds the image of the face from both characters and readers until key moments. (Ysrael usually covers his disfigurement with a hand-sewn mask of thin blue cotton fabric, ridden with fleas.) The image of the face, skinned like an orange by the pig, represents a detail that wounds readers (and characters), tempting them so effectively to envision it that Díaz's words, like Homer's or Crane's, impose themselves materially. For example, the morning when Yunior and his brother, Rafa, hunt down and subdue Ysrael for their viewing pleasure, Rafa peels two oranges for the brothers to share for breakfast: "The next morning the roosters were screaming. . . . Rafa went into the smokehouse and emerged with his knife and two oranges. He peeled them and handed me mine" (9). The detail of peeled oranges mentioned by Díaz cuts readers not only by visualizing Ysrael's disfigurement but by picturing the brutishness and cruelty of Rafa and the other boys who would peel away the disabled boy's face a second time to satisfy their visual hunger.

When Díaz finally unmasks Ysrael's face, readers and characters alike experience the connection between disability and cutting details. The exposition of violence is always prone to details: where violence leaves its mark, representation is forced into the most vivid and visual registers. Rafa subdues Ysrael by smashing a cola bottle on the top of his head, sending him slamming into a fence post and sprawling to the ground. Then the two brothers roll their victim onto his back, tear off the mask, and expose his face to view:

> His left ear was a nub and you could see the thick veined slab of his
> tongue through a hole in his cheek. He had no lips. His head was
> tipped back and his eyes had gone white and the cords were out on

his neck. He'd been an infant when the pig had come into the house. The damage looked old but I still jumped back and said, Please Rafa, let's go! Rafa crouched and using only two of his fingers, turned Ysrael's head from side to side. (18–19)

The scene, like the institution of the freak show, objectifies human difference for display both to satisfy curiosity and to entertain. Ysrael is made an object for exhibition: his eyes are cloudy, and he does not return the look of the brothers, allowing them to penetrate him at will with their stares. As in Eakins's *The Gross Clinic,* the wound absorbs the gaze of beholders, making it difficult for them to tear their eyes away, despite the pain and violence displayed there. The brothers are simultaneously repulsed and fascinated. Rafa penetrates the face with a look but touches it only gingerly, with two fingers, as if he might catch a contagious disease from it. Yunior wants to run away. These reactions, not physical characteristics, transform Ysrael into a freak. His difference from the other boys is confirmed by their morbid fascination with his bodily features. They set out to find someone who is different from them and they succeed in their mission. Under their gaze, Ysrael metamorphoses from human child into the creation called No Face.

Díaz's treatment of Ysrael throughout *Drown* confirms that images of disability have a special power to absorb and wound beholders, as well as that people will go to extreme lengths to pin down images of difference. However, it is the story "No Face" that provides an extended look at how images of difference may rise to the surface of the page and at how disability oscillates under the pressure of various social situations between invisibility and visibility. Díaz uses uppercase typography as an image of Ysrael's difference—it is the only time the usage occurs—but also produces a mini case study about how the arbitrariness of social convention marks the appearance of disability in the public eye:

In the morning he pulls on his mask and grinds his fist into his palm. . . . He has the power of INVISIBILITY and no one can touch him. Even his tío, the one who guards the dams, strolls past and says nothing. Dogs can smell him though and a couple nuzzle at his feet. He pushes them away since they can betray his location to his enemies. So many wish him to fall. So many wish him gone.

A viejo needs help pushing his cart. A cat needs to be brought across the street.

Hey No Face! A motor driver yells. What the hell are you doing? You haven't started eating cats, have you?

He'll be eating kids next, another joins in.

Leave that cat alone, it's not yours.

He runs. . . .

The ambush comes when he's trying to figure out if he can buy another johnnycake. Four boys tackle him and the coins jump out of his hand like grasshoppers. The fat boy with the single eyebrow sits on his chest and his breath flies out of him. The others stand over him and he's scared.

We're going to make you a girl, the fat one says and he can hear the words echoing through the meat of the fat boy's body. He wants to breathe but his lungs are tight as pockets.

You ever been a girl before?

I betcha he hasn't. It ain't a lot of fun.

He says STRENGTH and the fat boy flies off him and he's running down the street and the others are following. . . . He runs, down towards the town, never slipping or stumbling. Nobody's faster. (143–60)

The thin blue cotton face cover, like the mask of invisibility described in mythology or comic books, renders Ysrael INVISIBLE. Paradoxically, it both conceals and reveals his disability. His notice by others can be set off by the most meager of gestures—making the mistake of letting a dog nuzzle him or picking up a cat in the street—as if they served as indexical signs pointing out his movements in the visual field. Like Díaz's typographical images for the disabled boy, "INVISIBILITY" and "STRENGTH," Ysrael is a nonpresence marked out for all to see if only the proper elements scheme to place him in view. It only takes a second for the brutality to erupt around him, for a violent outcry to pierce the quiet and bring a mob of enemies to his pursuit. The STRENGTH of his legs is a direct result of the hatred tracking him. Others might be the object of hatred—a fat boy, a viejo, a cat, a dog perhaps. Their differences, too, risk becoming suddenly detectable; it is almost as if they conspire to make Ysrael's difference more visible to save themselves.

Social convention has no power to discriminate disability without the

presence of a body. All human beings have bodies, and everything they do or is done to them happens through their bodily state. But social convention produces changes in this state by altering the way some bodies perceive other bodies. Bodily differences become images—that is, acquire the power of representation—when they are construed as disabilities. This fact puts in mind two valuable observations about the appearance of disability: first, that social convention determines the perception of disability as negative; second, that the distinction often maintained between visible and invisible disabilities is as much a product of social convention as the perception of any given feature of a person as a disability. When disability is made visible as a negative image, the suffering of the body really begins because, while physical impairment and injury may be painful, social injury is more painful for human beings. This is one message of "No Face."

Conclusion

In the war between word and image, the image plays the role of disabled soldier. It loses the battle every time. It is glass eye or body without soul in James, what teaches nothing in Sartre, the mute cousin of the word in Auerbach because it speaks no secret second meaning. It is often what the academy finds most lacking and terrifying about the contemporary moment. The image is only and always its own poor self, excessive or defective. The strategy behind my analysis here has been twofold: to reverse the hierarchy between literary and visual studies by using disability studies as a pivot point and to attempt a revision of the image—not to deny its disabled status but to assert the value of disability for the human imagination. It is not clear whether the disparagement of the image derives from its reliance on disability or whether its disparagement takes the form of calling it disabled, as if it were being called a name. The answer may be unimportant because the value of the image will never be understood as long as its connection to disability is described negatively. If images find their value in disability, perhaps it is time for literary studies to picture them differently, to stop treating them like the family idiot and to recognize their rich and many meanings. For when, eventually, we turn again to reading, we may discover that words, too, are richer and more meaningful as a result.

Chapter 7

Conclusion: Disability in the Mirror of Art

Art is the mirror of nature, it has often been said, but what of disability reflected in the mirror of art? We have seen that the representation of disability by modern art produces unanticipated effects, turning traditional conceptions of aesthetic beauty away from ideas of the natural and healthy body. Supposedly, the fabled perfection of art began by mirroring the faultless beauty of nature. Greek and Roman art focuses almost always on the beautiful physique, and this focus, so difficult to shake, endures until the modern age. Thus, Winckelmann claims at the origin of art history in the eighteenth century that the beauty of Greek sculpture descends directly from the beautiful nature of the Greek body, beautiful nature and healthy bodies still being for him practically synonymous (17, 20, 106). Similarly, Baumgarten conceives beauty as the mental harmony felt by the beholder before a body. The experience of aesthetic objects organizes in itself the internal consistency of the mind.[1] Aesthetics is implicitly, if not explicitly, about perfecting human beings. Today some theorists of mimesis continue to believe that images trap the psyche in the illusion of human perfection, and although this perfection may prove to be a mirage, it has tenacious durability. Lacan speculates in "The Mirror Stage" that the human ego discovers at an early age the false image of its own perfection in the mirror. The small child, barely able to stand, nearly incapable of controlling its movements, looks into the mirror to discover the static but

masterful image of a mature and able body—a perfect image of the ego that the child will never be able to live up to.

Disability breaks the mirror of art as traditionally conceived by putting into question the art object's relation to perfection, but the beauty reflected in the broken mirror grows more beautiful as a result. The more we enter the modern age, the stronger the equation between art and disability—and to the point where it is difficult to recognize art in itself without summoning the notion of disability. Disability, disease, and injury have become the figures by which aesthetic beauty as such is now recognized, and more and more art critics are beginning to realize it. Hal Foster associates wounding and injury with an aesthetic realism born of the trauma of modern existence. Linda Nochlin claims that the modern in art is made out of the loss of wholeness, embracing the impression that fragmentation reigns, connections in life have been shattered, and permanent values have disintegrated (23–24). She traces the "essence of representational modernism" to the French Revolution as the historical moment when the body in pieces becomes for modernity a "positive rather than negative trope" (8). Leonard Barkan attributes the origin of modern art's appreciation of the fragmentary, broken, and injured to the unearthing of classical fragmentary statuary in Renaissance times, calling the modern idea that fragments have "value independent of any potential for being made whole again" "a category shift" (122), one that reorients the "whole project of making art in response to broken bodies" (209). For modern art, disability represents the outer boundary of the body diversely conceived, throwing off associations with defect, degeneration, and deviancy. In fact, so strong is the modern equation between art and disability that we cannot help but begin to view past works of art in terms of the irrepressible image of disability given by the modern world.

Nevertheless, the force of specific time-bound arguments seems compromised by the fact that aesthetic representation has a long-standing relationship with the human desire to understand the human differently. This is obviously a historical project in the sense that it unfolds in time, but the timeline of the concepts given to define the human is at best rhapsodic, retroactively conceived, and absent any goal or endpoint that we might concretely imagine. I add this statement as a caution about the weight of time on argument, but my real purpose is to make clear that disability aesthetics relies throughout this book on a simple and direct definition of the

aesthetic relation between bodies appearing in the world—what I might dare call the first principle of my argument. The making of any object, out of any substance, by a human being is also in some way a making and remaking of the human. If aesthetics and the human are inseparable, it is because art is the process by which human beings attempt to modify themselves—and this process is a crucial factor in human history. The object of human craft is the human being, and the most immediate sign of the human and the material out of which we craft it is the human body.

We all have bodies. This is not a truism. It is not an exercise in the obvious. It is a fact—and a fact of a special kind. It is an incontestable fact. Everything we do, we do as or by means of our body. We cannot get beyond the fact that we are bodies. The body is, simply put, where everything in human culture begins and ends.

We might expect, given the centrality of the body in history, that every human impulse would go into perfecting and beautifying it. For a long time it did. This impulse is obvious in the history of aesthetics, its collaboration with eugenics, and the emergence of aesthetic surgery as a means to beautify people thought not to have natural beauty.[2] But if aesthetics is about the desire to perceive the human differently, it must consider human beauty differently as well, and if the contents of this book show anything, it is that beauty has become a radical concept by virtue of its rooting in disability. Beauty is other today—and like no other time in human history.

A brief look at two paintings may serve as a conclusion to my argument, describing the effect, whether intentional or not, of combining disability and aesthetic value. Both paintings engage disability in relation to self-reflection, asking how artworks put disability in the place of the beholder's mirror image. The first and earlier painting does not take disability as its explicit subject matter, although it is now impossible, thanks to the centrality of disability to the ambition of art, not to read it that way. The second painting is the work of a disabled artist, and it takes her experience of disability as its theme. Nevertheless, the symbolism of the painting makes it difficult to reduce the content only to disability, suggesting that disability now claims a broader symbolic dimension touching on human imagination and aesthetic self-transformation.

Les Deux Baigneuses ou Dina de dos et profil by Aristide Maillol has many typical features associated with his work. The woman or women

are fleshy, with round stomachs and heavy thighs; their breasts are small; and they wear their hair up in a twist (color pl. 22). But the painting also unfolds a fundamental ambiguity that ends by confirming the irrepressible representation of disability in modern art. The title asks the beholder to decide whether the painting represents one or two women, but the decision cannot be made absolutely without destroying the defining symbolism of the work. The conceit is to render the back and profile of Dina Vierny as an encounter between two bathers, providing the experience of volume given by sculpture, but the unity of the human body renders the conceit problematic in the absence of a mirror, explaining why the painting requires the presence of water as a possible reflective surface.[3]

Reflection thus becomes the master trope of the painting, but this trope is anchored by the representation of disability, whether the work portrays one or two women. If the painting includes two women, it shows them reflecting on themselves in comparison to one another. Whether the encounter is erotic is not clear, but the image demands in any event to be read as a scene of desire. Either the women desire to possess one another or to be one another, producing the conundrum recognized by feminist thinkers about modern identity in which women are pitted against one another as they judge their bodies either superior or inferior.[4] Here the fragmentary form of the woman in the pool signifies that crucial physical difference—the difference that demands to be read as either the superiority or inferiority of one figure. If the painting includes only one woman, it pictures a woman examining her reflection in a pool—the archetypical scene of narcissism. But here the archetype fails because the reflection is not more perfect than the original. Narcissus does not fall in love with his better. Or, perhaps, the reflected figure is the more perfect: disability in the mirror of art revolutionizes the idea of perfection to include the impairment of foreshortened limbs.

The riddle of Maillol's painting is, at the very least, to move between these two interpretations, but one idea appears to be constant, whether the painting depicts two women or one: the work presents a confrontation between ability and disability. The figure in the foreground is ablebodied, but the figure in the background, because of the immersion in the water, appears as if her limbs are cut off, despite the fact that there is no reason why a reflection in water should automatically give the image of amputation. Rather, a more informed interpretation understands that the

woman in the pool mirrors Maillol's embrace of the tradition of fragmentary classical sculpture and its definition of beauty. In this tradition, the loss of limbs demands to be understood as the essence of beauty. Maillol copies the beauty of the Venus de Milo here, as he does elsewhere (see his last sculpture, *Harmonie*, 1940–44, a bronze statue of an armless woman), capitalizing on the modern tradition of representing beauty by incompleteness, breakage, and disability. If there are two women in the painting, the disabled one is named the more beautiful, as if Maillol wishes to contrast an aesthetic, fragmentary, and broken beauty to a lesser, intact beauty. If there is one woman in the painting, she appears to imagine her form more perfectly as incomplete or disabled, as if she aspires to the legendary beauty of the Venus de Milo. In both cases, disability represents the aesthetic value and the summit of what beauty might achieve. The equation between art and disability found throughout modern art is confirmed by the fact that there is really no way to interpret the incomplete figure as other than beautiful.

Susan Dupor's *Stream of Consciousness* shows a woman swimming downstream in a narrow river surrounded by lush vegetation, her reflection lightly visible and doubling her in the water around her (color pl. 23). She is not, however, looking at the reflection. Her eyes are closed, and she seems to be sleeping, relaxed and taken with the inner life of consciousness, as in a dream. Only the appearance of nine hands rising out of the surface of the stream startles the tranquil scene. The hands mirror the hands of the swimmer, as if to mimic her future strokes as she advances downstream, but the painting is not an exercise in cubism, blurring, or trompe-l'oeil. Its goal is not to depict motion but thought, as the work's title indicates, for Dupor is deaf, and this painting, like many others by her, includes multiple hands as a method for expressing the presence of sign language. The stream in which the swimmer courses represents a stream of consciousness expressed in hand signs.

Although disembodied hands may seem to eyes untutored by Dupor to have a chilling effect, as if severed hands or the hands of strange beings were reaching out around the primary figure of the painting (see also *Courtship* or *Halcyon*), the effect here is not macabre because the hands are neither surrealistic nor gothic. They clearly belong to the swimmer, and they express a world in which she is deeply absorbed. Nor does the mirroring of the swimmer elicit a potentially damaging encounter in

which two women judge one another's physical beauty as superior or inferior. The mirror image suggests self-reflection, but in the absence of narcissism, because sign language mediates the action of self-reflection. The swimmer is not self-absorbed but absorbed in language—a language at once natural to her and artificial: the language of hand signs is both a part of the river and its natural surroundings and a social artifact used for communication with other people. More important, the work represents sign language with multiple disembodied hands, invoking the idea of fragmentary statuary, as in Maillol, but pushing the tradition of broken beauty in a new direction. Rather than representing beauty by removing body parts, Dupor's painting multiplies them, suggesting that disabled bodies possess a beauty and amplitude previously ignored. The swimmer flows through a world in which perfection does not provide the only standard for human ability and beauty. Spread out before her are the living symbols of a beautiful and expressive future defined by a radically different conception of the human body and mind.

The aesthetic desire to transform the human revolutionizes beauty by claiming disability as the form of physical and mental diversity with the greatest potential for artistic representation. The figure of disability checks out of the asylum, the sick house, and the hospital to take up residence in the art gallery, the museum, and the public square. Disability is now and will be in the future an aesthetic value in itself.

Notes

CHAPTER 1

1. Marc Quinn revisits the idea that broken sculpture represents disabled bodies in *The Complete Marbles*. The series presents a number of disabled people who are missing arms and legs. In interviews with his subjects, Quinn asks explicitly whether broken Greek and Roman sculptures have any emotional resonance for them. His exchange with Catherine Long, born without a left arm, is especially intriguing:

> MQ: Before we did this project, when you saw broken Greek and Roman sculptures, did you ever have any feeling that there was a kind of emotional resonance for you that may not have been there for other people?
> CL: Not really emotion, but when I've looked at broken statues, I've thought other people probably consider them to be beautiful objects, but I know that's possibly not the way I might be viewed by society as a whole. I know that people like myself—disabled people—have felt that people relate to a broken statue differently to the way they might to a person with a disability. (26)

2. The pathbreaking rejection of intention as a standard of interpretation is W. K. Wimsatt and Monroe C. Beardsley, "The Intentional Fallacy."

CHAPTER 2

1. The address for Smile Train's website is www.smiletrain.org (accessed February 19, 2008).

2. The list of celebrity friends from the West includes Christie Brinkley, Tom Brokaw, and Bette Midler, among many others, but no people of color. Thus, even when the children are cured, and their disabled status vanquished, their racial difference remains as a sign of disqualification, at once stigmatizing the children and justifying the intervention by benevolent representatives of white modernity. See http://www.smiletrain.org/site/PageServer?pagename=special (accessed February 19, 2009).

3. Smile Train also presents the threat of disability as an emotional reason to rescue unhealthy people living under inferior conditions in faraway lands. Kim and Jarman provide a brilliant discussion of this trend in the context of postcolonial studies: "we

argue that Western or modern gestures to rescue people with disabilities in non-Western or 'pre-modern' locations strategically function to produce hierarchies between different societies and nations. . . . Trading upon modernity's mask of benevolence, these hierarchies are often signified by one group's charitable acts scripted as the 'selfless' and 'generous' rescue of disabled people who have been exploited, mistreated, or expelled by societies defined as 'pre-modern'—that is to say, groups automatically coded by a relative 'lack' of development" (53–54).

4. I take this formulation from Snyder and Mitchell: "Disability as the master trope of human disqualification in modernity prefaces an understanding of inassimilable racial and ethnic differences by providing an empirical designation for 'unfit' bodies. Like discourses of national differences that, in turn, support investments in absolutist racial differences, disability may provide a key to the recognition of an underlayer of classification systems based on disqualifying bodily traits that jettison certain people from inclusion in the continuum of acceptable human variations" (127–28).

5. Some key texts on intersectionality relating to disability include Barbee and Little, Beale, Butler and Parr, Fawcett, Hayman and Levit, Ikemoto, Jackson-Braboy and Williams, Martin, O'Toole, Siebers (2008b), and Tyjewski.

6. Attendance at Entartete Kunst far outstripped the numbers at the Grosse Deutsche Kunstausstellung, raising serious doubts about Hitler's taste in art. Entartete Kunst traveled to twelve cities between 1937 and 1941 and attracted more than three million visitors. For more information on the two exhibitions, see Barron and Siebers (2000).

7. Carol Poore's analysis of Schultze-Naumburg is especially effective (53–55). Her analysis of disability and Nazi culture catalogs in great detail the variety of uses to which the Nazis put disability, including its propaganda and pictorial value (67–138).

8. From 1939 to 1945 between 200,000 and 250,000 mentally and physically disabled people were executed under T-4 and other euthanasia programs in Nazi Germany. Between 300,000 and 400,000 people were sterilized. The moral legacy of this history casts a shadow over contemporary debates about abortion, assisted suicide, the human genome project, mercy killing, and wrongful birth.

9. One notices here, incidentally, the influence of Winckelmann's emphasis on classical art's mimicking of the beautiful Greek body, but Winckelmann's love of corporeal perfection did not prevent him from embracing fragmentary and broken statuary, such as the *Torso Belvedere,* as the height of aesthetic beauty, while the Nazis were incapable of accepting any kind of human deformation or incompleteness as art. One searches in vain among Hitler's speeches on art for anything resembling Winckelmann's admiration of broken beauty. For a small analysis of fragmentary classical statuary in the context of disability, see Siebers (2008a).

10. For a superb analysis of the controversy, see Ann Millett: "Public space and its monuments," she argues, "have been gendered male and raced white traditionally, and public space is largely ableist in attitude, not to mention accessibility (or lack thereof)."

11. For example, Kim Levin reviews Quinn's work positively in the *Village Voice* but describes disability in negative language:

At first sight, it looks exactly like a hall of sublime white marble antiquities. . . . But something, you suddenly realize, has gone terribly wrong. . . . Take a

closer look at the embracing couple at the entrance. Titled *Kiss,* the piece harks back to Rodin and the romantic Beaux Arts sculptors. It invokes all the obsolete clichés of beauty, perfection, and idealization. Marvel at its outmoded skill, until cruel reality sinks in. The male figure has stunted thalidomide arms. The female's arm is normal but she has only one. Take a good look at the others too. Their truncated and missing parts aren't due to the vicissitudes of time but are the result of accident, genetic defect, or iatrogenic calamity. Quinn exploits the romance of classical antiquity—which depends on the mutilations of time and the notion of loss—to confront us with our own avoidance of the horrific fragility of the human condition.

12. Nor is it clear why Quinn's sculpture of Lapper succumbs more to "narcissism, self-pity, and self-obsession" (Dalrymple) than Velásquez's self-portraits or paintings of little people. Rather, similar to the example of the so-called degenerate art, commentators project their feelings of revulsion toward the artwork onto the artist or subject of the work.

13. On the one hand, it is not clear what it means, beyond metaphor, to experience a human being as an art object, but I worry that it relies on a form of objectification to which people at the extreme poles of human beauty are especially susceptible. On the other hand, to grant to disability represented in an artwork the privilege of being aesthetically beautiful would produce a paradigm shift supportive of disabled people without the risk of objectifying them.

14. *Newsweek* provides a glimpse of the medical ideology at work in the essay by placing a running header at the top of each page: "To Your Health. Health for Life." Reader comments on the essay refer to a "disease free golden age" and complain that only the greed of drug companies delays its arrival.

15. Michael Davidson makes the case that disability should be linked formally to defamilarization, arguing that the defamiliar body of disability creates aesthetic effects akin to those produced by formalist techniques.

16. The illustrations here come from the catalog, *Mütter Museum: Historic Medical Photographs,* rather than from *Newsweek,* because web images cannot be reproduced with sufficient quality. To view the images as presented by *Newsweek* visit: http://www.newsweek.com/id/77018?GT1=10755 (accessed March 11, 2009).

17. This practice is characteristic of medical eugenics. Pernick notes that eugenic treatises and films in the United States highlight the "repulsive ugliness of the 'unfit'" by comparing them to cattle (94). Hitler, of course, compared "defectives" to "wild beasts" (GHDI).

CHAPTER 3

1. See also Dowling, who provides a concise reading of the "primitive communism" important to Jameson's theories.

2. These are Newt Gingrich's words, describing controversial artists funded by the NEA, in particular Andres Serrano.

3. On the psychology of face-to-face encounters, see Fichten and Amsel; Kleck, Ono, and Hastorf; and Stiller.

4. A corollary to DeVries' experience appears in the account of a boy born with

one thumb. Surgeons removed the thumb to give his hands symmetry (cited by Marks 67).

5. Lawrence Rothfield, ed., *Unsettling "Sensation,"* collects reactions to and interpretations of *Sensation* from a broad group of cultural commentators. It is worth noting, however, that the volume never mentions disability as a factor in the controversy over the exhibition.

6. References are to Thomson, *Extraordinary Bodies.* Notice that the freak show is also one of the last sites where ordinary citizens are granted the "authority to interpret the natural world" (70).

7. See my discussion of the relation between beauty and otherness (Siebers 1998a).

8. Many newspaper articles describe the painting as stained with elephant dung or feces (see Barry and Vogel; and Goodnough). Giuliani himself exaggerated the amount of elephant dung and its impact on the painting, while making some rather embarrassing admissions about his own creativity: "Anything that I can do isn't art. . . . You know, if you want to throw dung at something, I could figure out how to do that" (Goodnough) and "having a city-subsidized building have so-called works of art in which people are throwing elephant dung at a picture of the Virgin Mary is sick" (Blumenthal and Vogel). Dennis Heiner launched his attack under the mistaken impression that the painting was "covered in human feces" (Rayman and Gardiner). The confusion continues two years later in an attack by George Will: "The Brooklyn Museum of Art, like an infant squealing for adult attention, specializes in the naughtiness of the untalented. Two years ago it put on 'Sensation,' an exhibition of the works of young British artists—average age, 35—including the portrait of the Virgin Mary splattered with elephant dung" (A11). On the attempted vandalism, see McFadden.

9. The cover story, "The Familiar Face of Fascism" in *Utne Reader* (December 1995), exposes many striking connections between the fashion and beauty industries and the rejection of "degenerate" bodies by the Nazis and fascists (see, especially, Golsan and Eco; see also Siebers 2000a).

10. Many commentators have remarked with irony the special priority granted to protests by Heidelberg residents. Although complaints about abandoned buildings are widespread in Detroit, the city cannot respond to them because it lacks the funding to clean up neighborhoods. Action on complaints against the Heidelberg Project is the rare exception (see Carducci; Hurt; and Newman).

11. I follow Burgdorf and Burgdorf's account of ugly laws (see also Lifchez 2 n. 2 and Imrie 15, 62).

12. In this particular case, however, the illusion of health proved disastrous, since hundreds of the glass panels cracked before the building was occupied and had to be replaced with a stronger glass at a cost of $8.2 million. The building also shifted in the wind, requiring further construction, costing $17.5 million, to stabilize its thin frame and to install two 300-ton adjustable counterweights near its top to resist wind pressure.

13. Sullivan discusses everywhere the connection between bodies and design imperatives. For an illuminating discussion of modern architecture, focusing on Sullivan and Le Corbusier, see Imrie, chap. 4.

14. Designers and architects learn to design buildings, environments, and products for "average" people, and, of course, the "average" person is always able-bodied. The

incarnation of the "average" in the built environment not only excludes bodies that do not fit the norm but imbeds in the flesh of that environment the desire to preserve the able body over all other forms and shapes. But the "average" person does not really exist, for someone who is average at one point in life fails to be average earlier or later on. Children and the elderly, for example, do not have average bodies. Averageness is a ratio used to reject human variation, and of these variations the disabled body is the easiest to exclude. See Imrie 19, 81–87, whose discussion of Le Corbusier and architectural standards is invaluable.

15. Freud, in *The Psychopathology of Everyday Life,* initially defines mechanisms of defense with reference to hysteria and, appropriately for my argument, in language ripe with architectural metaphors: "We are forced to regard as one of the main pillars of the mechanism supporting hysterical symptoms an *elementary endeavour* of this kind to fend off ideas that can arouse feelings of unpleasure . . . to banish distressing affective impulses like remorse and the pangs of conscience. . . . It may be surmised that *the architectonic principle of the mental apparatus lies in a stratification—a building up of superimposed agencies*" (6:147). He then abandons the idea of defensive processes for the theory of repression, only to revert to a theory of defense in his later work. He uses the concept of defense "explicitly as a general designation for all the techniques which the ego makes use of in conflicts which may lead to neurosis" (20:163).

16. I find the connection between the ego and the self-image of political bodies suggestive for thinking about the defensive posture of public reactions to disability but cannot assert it rigorously, given the undeveloped state of group psychology as a discipline. Some thinkers using a Lacanian orientation, however, have pursued this line of thinking productively, most obviously Žižek.

17. The analogy between hysteria and the disabled woman maintains the superficial demand for balance, coordination, posture, and outward appearance of perfection as the measure against which the disabled body and mind must compete. I apply it as well as the term *hysterical architecture,* with this caution, to insist on the importance of the superficial in the workings of the political unconscious. One can literally read the defensive reactions against disability in the commotion agitating the external skin of accessible buildings and their approaches. As I will enumerate below, the commotion around disability and its symbols is sometimes cosmetic, obscuring markers of disability with decoration, and sometimes dissembling, complicating accessible entrances with erroneous signage or complicated distribution points. In most cases, the impression of superficiality dominates (see Freud 11:21–22).

18. My *The Subject and Other Subjects,* esp. chaps. 1 and 6 (Siebers 1998b), elaborates at great length on the necessary supplementation of the political by the aesthetic.

CHAPTER 4

1. W. J. T. Mitchell addresses the phenomenon of offensive images and the violence frequently directed against them. "A kind of theatrical excess in the rituals of smashing, burning, mutilating, whitewashing, egg- and excrement-throwing," he writes, "turns the punishment of images into a spectacular image in its own right" (115).

2. Bohlmann gave a different reason for his attack on the three Dürers in Munich, explaining that he was protesting the deduction from his disability pension of money to compensate for earlier acts of art vandalism (Dornberg 1988: 63). This raises the

issue whether certain acts of vandalism might be viewed as protests against the oppression of people with disabilities.

3. McFadden provides a full account of the episode. Additional details may be found in Rayman and Gardiner, and Feuer.

4. Consider an account by Middleman of a mediocre student painter of abstract forms who blows up his works before an art class. Formerly unable to elicit emotions, they become "powerful effigies"—powerful effigies of disability, I would add: "With one suave gesture the student pushed down the handle that protruded from the top of the box to explode the whole bunch. Each painting went up in a separate puff of smoke. . . . When the dust settled the emerging paintings had a presence that in their tattered state far outdid whatever predictions one might have made about the outcome, even if one had known the procedure in advance. They were powerful effigies of desecration, fraught with meanings that went deep into the psyche, uncompromising statements that mingled terror and despair" (19). My thanks to John Cords for bringing this essay to my attention.

5. Although the meaning of subjectivization is often disputed, the fact that aesthetics produces it is not (see my discussion in Siebers 1998b: v, x, 8–9, 78).

6. It may be objected that the analogy between subject position and aesthetic object holds only for works that actually portray human beings. The portrait, then, would be the primary material from which to create new representations of disability. If aesthetic form is experienced as subjectivization, however, the destruction of nonfigural and nonrepresentational works of art should also provoke reactions of outrage. The history of iconoclasm provides ample evidence: abstract works attacked include Josef Beuys's *Bath-Tub,* Marcel Duchamp's *Fountain,* Barnett Newman's *Who's Afraid of Red, Yellow, and Blue III* and *IV,* Man Ray's *Boardwalk* and *Object to Be Destroyed,* among many others.

7. My account of Toth and Kleer follows Gamboni, who makes an even stronger case that delusions about being Jesus fit with the Western idea of the artist as creator (on Toth see 203–4, 265; on Kleer 207–10).

8. On Shafrazi and Saura, I follow Gamboni 192, 265–66.

9. For an argument about the proximity between the emotions of vandals and those felt by everyday beholders, see Freedberg 1985: 7–10. An expanded version of the argument appears in Freedberg 1989: 405–28.

10. Fuller is one of many commentators who makes this argument.

11. I elaborate on this argument in Siebers 1998b, chaps. 1 and 7. See also Castoriadis 229, 233–34.

CHAPTER 5

1. The work of Arthur Kroker comes to mind in this context. See also Caruth's psychoanalytic approach.

2. This section reflects ideas and language explored in a different context in Siebers 2000b.

3. René Girard argues that the origin of symbolicity arises in the context of human violence.

4. *129 Die (Plane Crash),* 1962, a hand-painted copy of the front page of the June 4, 1962, *New York Mirror,* effectively begins Warhol's series on death and disaster, but

it is the only work in the series that is not mechanically reproduced, for by late 1962 with *Suicide,* he had discovered silkscreening. It is apparently the interest in the media display of death and trauma that turns Warhol to silkscreening and other mechanical techniques.

5. It was first reported that the tank hero, originally identified as nineteen-year-old Wang Weilin, was summarily tried and executed some days after making his place in history. A year after the events of June 5, when Chinese leader Jiang Zemin was asked about the fate of the symbol of Chinese freedom, he replied, "I think never killed" (Iyer 193). The identity and fate of the tank hero are now generally admitted to be unknown.

6. See also Talbott, "Defiance," who describes the tank hero as "One man against an army. The power of the people versus the power of the gun. . . . For a moment that will be long remembered, the lone man defined the struggle of China's citizens" (10).

7. Concrete information about the Chinese context is hard to find, so I have had to rely for my analysis on informants, some of whom were on Tiananmen Square during the events of 1989. I owe a great debt of gratitude to conversations with Liu Kang, Kenneth Lieberthal, and Lydia Liu. Faults in analysis are my own. See also Zhou He for a chronology of the events and a first-rate examination of the media coverage, with special emphasis on CCTV, Voice of America, and *People's Daily.*

8. *Implements of Terror* by Susan E. Evans originally appeared as "The Things They Carried," in the Gallery feature section of the *New York Times Magazine.* The title of the photograph refers to the phrase used to describe the objects at the Orlando International Airport. The photograph carries this statement by the artist: "Post tragedy we are forced to examine that which may provide both possibility and opportunity of threat. In doing so, we find both. Such an examination, though ultimately incurred for our protection, personalizes your national fear of further terrorist attacks. Working with the Orlando International Airport, I photographed on scene with a 4″ (5″ camera, items not making it past security checkpoint where passengers have the option not to get on the plane with the item or 'throw it away' by giving it to security."

CHAPTER 6

1. It is a prejudice of literary study to assert either that the complexity of texts is greater than that of nontextual objects or that nontextual objects simply do not exist.

2. Svetlana Alpers tracks how the consideration of painting as a narrative art, associated with the Italian Renaissance, is inadequate to Dutch visual culture of the seventeenth century. I am indebted to her discussion of *ut pictura poesis* (xix).

3. "The reading of a word is a modulation of visible space," explains Maurice Merleau-Ponty (167). His insistence on the bodily experience of images and reading lies behind many of my formulations.

4. Georges Poulet's work provides an example of the idea that reading continues only as long as words have no material reality: "That object wholly object, that thing made of paper, as there are things made of metal or porcelaine, that object is no more, or at least it is as if it no longer existed, as long as I read the book. For the book is no longer a material reality" (57).

5. Whence the idea that images are always double, a lamination of two visions, of

being and meaning. Sartre's shorthand for this idea is that "the image is a conscious-ness" (4).

6. I argue in chap. 4 for the connection between wounded bodies and images, using anthropological evidence and theory. Notice that the "wound" need not be represen-tational—that is, part of the original image's form and content—but may be damage added later, for example, by an act of vandalism (see chap. 3).

7. I take inspiration and language for this assertion from Anne Carson's discussion of the epigraph (73).

8. Fried's analysis is worth citing at length for its devotion to the absorptive power of the wound: "No one who has ever stood before *The Gross Clinic* needs to be reminded just how complex and disturbing are the responses. . . . In the first place, the extreme sharpness of detail and almost *trompe-l'oeil* illusionism with which both the opera-tion and the hand and scalpel have been represented irresistibly attract the viewer's attention. But the operation itself—not just the oozing incision but the pull of the retractors against its sides and the probing of the wound with the long, thin, pencil-like instrument—is acutely unpleasant, indeed painful, to look at, though perhaps a crueler (because more unexpected) violence to our sensibilities is perpetrated by the image of Gross's scalpel-bearing right hand, crimson blood gleaming wetly upon his fingers and upon the point of the scalpel's blade, spotlighted against the background of his dignified black suit and vest. And yet despite that painfulness and violence we find ourselves unable to tear our eyes away from the scene—rather, we compulsively shift our gaze from the probing of the wound to Gross's hand and scalpel and back again—until at last it becomes apparent that something in all this must be distinctly pleasurable, which is to say that the act of looking emerges here as a source of mingled pain and pleasure, violence and voluptuousness, repulsion and fascination" (1987: 61–62).

9. When no disabled body appears as a figure of writing, Fried insists on making the connection: for example, he subsumes Crane's "quasi-words" to the "glass eye" that James uses to represent words that have lost their linguistic function and become bod-ies: "James's metaphors for the denaturalized or say 'materialized' word (a glass eye, a corpselike body) inevitably recall Crane's figures for the written page" (Fried 1987: 131).

10. As Fried puts it, "the passages that describe the faces and recount responses to them are where Crane's unconscious fixation on the scene of writing . . . comes closest to *surfacing* in a sustained and deliberate manner" (1987: 121).

11. Another mode of materialization emphasized by Fried is Crane's tendency to imbed his initials, S. C., for "narcissistic reasons" in his writing (Fried 1987: 125–26, 136, 147–53). Compare Hillis Miller's analysis of the materiality of proper names: "rep-etition of words and bits of words empties language of meaning and makes it mere unintelligible sound, as when the poet Tennyson, as a child, used to repeat his own name over and over, 'Alfred, Alfred, Alfred,' until it ceased to mean anything at all and he melted into a kind of oceanic trance. Try it with your own name, as I do here with mine: 'Hillis, Hillis, Hillis, Hillis'" (Miller 2001: 195). Without denying the power of repetition to defamiliarize, I think it equally important to note the status of proper names and initials as narcissistic particles that summon bodies.

CHAPTER 7

1. Kant departs crucially from Baumgarten's idea by defining aesthetic pleasure as the mental commotion felt by the subject in the presence of the art object, a commotion described in terms of otherness and possession. Aesthetic pleasure in Kant does not consolidate mental harmony but enlarges thought in the direction of other minds (see Siebers 1998a).

2. "Aesthetic values played a critical though little-known role in eugenic constructions of fitness and defectiveness," according to Martin Pernick; "Eugenics promised to make humanity not just strong and smart but beautiful as well" (91). On the use of aesthetic surgery as a cure for both the ugly body and the ailing psyche, see Gilman.

3. Although it is a convention to use the same model for multiple figures in painting (see also color pl. 2, Saliger's *Diana's Rest*), the convention here produces an impasse for interpretation. Unless the figures are interpreted literally as twins, the painting demands a more imaginative reading, one that sets aside the literal in favor of the symbolic.

4. See for example Diana Fuss, who argues that identification between women in commodity culture takes on an erotic charge, making it impossible to separate the desire to be and the desire to have.

Works Cited

Adam, Peter. 1992. *Art of the Third Reich*. New York: Harry N. Abrams.

Alexander, Sidney. 1973. "The Restoration of Michelangelo's *Pietà*." *American Artist* 37.2: 54–59, 72–75.

Alpers, Svetlana. 1983. *The Art of Describing: Dutch Art in the Seventeenth Century*. Chicago: University of Chicago Press.

Auerbach, Erich. 1953. *Mimesis: The Representation of Reality in Western Literature*. Trans. Willard R. Trask. Princeton, NJ: Princeton University Press.

Bacon, Francis. 1627. *The Essays*. London.

Barbee, L. Evelyn, and Marilyn Little. 1993. "Health, Social Class and African-American Women." *Theorizing Black Feminisms: The Visionary Pragmatism of Black Women*. Ed. Stanlie M. James and Abena P. A. Busia. London: Routledge, 182–99.

Barkan, Leonard. 1999. *Unearthing the Past: Archaeology and Aesthetics in the Making of Renaissance Culture*. New Haven: Yale University Press.

Barron, Stephanie, ed. 1991. *"Degenerate Art": The Fate of the Avant-Garde in Nazi Germany*. New York: Los Angeles County Museum of Art and Harry N. Abrams.

Barry, Dan, and Carol Vogel. 1999. "Giuliani Vows to Cut Subsidy over Art He Calls Offensive." *New York Times*, September 23, A1.

Barthes, Roland. 1981. *Camera Lucida: Reflections on Photograph*. Trans. Richard Howard. New York: Hill and Wang.

Baynton, Douglas C. 2001. "Disability and the Justification of Inequality in American History." *The New Disability History: American Perspectives*. Ed. P. Longmore and L. Umansky. New York: NYU Press, 33–57.

Baumgarten, Alexander. 1954. *Reflections on Poetry*. Trans. William Holther. Berkeley: University of California Press.

Beale, Frances. 1995. "Double Jeopardy: To Be Black and Female." *Words of Fire: An Anthology of African-American Feminist Thought*. Ed. Beverley Guy-Sheftall. New York: New Press, 146–55.

Bell, Catherine. 1992. *Ritual Theory, Ritual Practice*. Oxford: Oxford University Press.

Benjamin, Walter. 1969. "The Work of Art in the Age of Mechanical Reproduction." *Illuminations*. Ed. Hannah Arendt. Trans. Harry Zohn. New York: Schocken, 217–52.

Blumenthal, Ralph, and Carol Vogel. 1999. "Museum Says Mayor Knew Nature of Exhibit 2 Months Ago and Didn't Object." *New York Times*, October 5, B1.

Breton, André. 1960. *Nadja.* Trans. Richard Howard. New York: Grove Press.

Burgdorf, Marcia Pearce, and Robert Burgdorf, Jr. 1976. "A History of Unequal Treatment: The Qualifications of Handicapped Persons as a 'Suspect Class' under the Equal Protection Clause." *Santa Clara Lawyer* 15:855–910.

Butler, Ruth, and Hester Parr, eds. 1999. *Mind and Body Spaces: Geographies of Illness, Impairment, and Disability.* London: Routledge.

Carducci, Vincent A. 1990. "Detroit's Inside Outsider." *New Art Examiner,* January 17, 64.

Carson, Anne. 1999. *Economy of the Unlost (Reading Simonides of Deos with Paul Celan).* Princeton, NJ: Princeton University Press.

Caruth, Cathy. 1996. *Unclaimed Experience: Trauma, Narrative, and History.* Baltimore: Johns Hopkins University Press.

Castoriadis, Cornelius. 1991. *Philosophy, Politics, Autonomy: Essays in Political Philosophy.* New York: Oxford University Press.

"A Century of Medical Oddities." 2008. *Newsweek* (January 7): www.newsweek.com/id/77018 (accessed July 23, 2008).

"China's 'Tank Man' Probably Doesn't Know He's a Hero." 1999. Agence France Presse, June 2.

Collins, Patricia Hill. 2003. "Some Group Matters: Intersectionality, Situated Standpoints, and Black Feminist Thought." *A Companion to African-American Philosophy.* Ed. Tommy L. Lott and John P. Pittman. Malden, MA: Blackwell, 205–29.

Cordess, Christopher, and Maja Turcan. 1993. "Art Vandalism." *British Journal of Criminology* 33.1: 95–102.

Crone, Rainer. 1970. *Andy Warhol.* New York: Praeger.

Crow, Thomas. 1996a. *The Rise of the Sixties: American and European Art in the Era of Dissent.* New Haven: Yale University Press.

Crow, Thomas. 1996b. "Saturday Disasters: Trace and Reference in Early Warhol." Thomas Crow. *Modern Art in the Common Culture.* New Haven: Yale University Press, 49–65.

Dalrymple, Theodore. 2004. "Victimhood Equals Heroism." *City Journal* (Spring): www.city-journal.org/html/14_2_sndgs05.html (accessed July 7, 2008).

Davidson, Michael. 2008. *Concerto for the Left Hand: Disability and the Defamiliar Body.* Ann Arbor: University of Michigan Press.

DePalma, Anthony. 1996. "Student Says Vomiting on Painting Was an Artistic Act." *New York Times,* December 4, B3.

Díaz, Junot. 1996. *Drown.* New York: Riverhead Books.

Dirks, Nicholas B. 1994. "Ritual and Resistance: Subversion as a Social Fact." *Culture/Power/History.* Ed. Nicholas B. Dirks, Geoff Eley, and Sherry B. Ortner. Princeton, NJ: Princeton University Press, 483–503.

Dornberg, John. 1987. "Art Vandals: Why Do They Do It?" *Art News* 86, March, 102–9.

Dornberg, John. 1988. "Deliberate Malice." *Art News* 87, October, 63–65.

Douglas, Mary. 1972. *Natural Symbols.* New York: Vintage.

Dowling, William C. 1984. *Jameson, Althusser, Marx: An Introduction to "The Political Unconscious."* Ithaca, NY: Cornell University Press.

Dunlap, David W. 1997. "Architecture in an Age of Accessibility." *New York Times,* June 1, sec. 9, p. 1.

Durkheim, Emile. 1960. "The Dualism of Human Nature." *Emile Durkheim, 1858–1917:*

A Collection of Essays, with Translations and a Bibliography. Ed. Kurt H. Wolff. Columbus: Ohio State University Press, 325–40.

Eco, Umberto. 1995. "Eternal Fascism." *Utne Reader* 72, November–December, 57–59.

Evans, Susan E. 2002. "The Things They Carried." *New York Times Magazine,* February 10, 20.

Fawcett, Barbara. 2000. *Feminist Perspectives on Disability.* Harlow: Prentice Hall.

Feuer, Alan. 1999. "Man Is Arraigned in Defacing of Painting." *New York Times,* December 18, B3.

Fine, Michelle, and Adrienne Asch, eds. 1988. *Women with Disabilities: Essays in Psychology, Culture, and Politics.* Philadelphia: Temple University Press.

Fichten, Catherine S., and Rhonda Amsel. 1988. "Thoughts Concerning Interaction between College Students Who Have a Physical Disability and Their Nondisabled Peers." *Rehabilitation Counseling Bulletin* 32, September, 22–40.

Foucault, Michel. 1973. *Madness and Civilization: A History of Insanity in the Age of Reason.* Trans. Richard Howard. New York: Vintage.

Foster, Hal. 1996. *The Return of the Real: The Avant-Garde at the End of the Century.* Cambridge: MIT Press.

Freedberg, David. 1985. *Iconoclasts and Their Motives.* Maarssen, The Netherlands: Gary Schwartz.

Freedberg, David. 1989. *The Power of Images: Studies in the History and Theory of Response.* Chicago: University of Chicago Press.

Freeman, Hadley. 2004. "Why Shouldn't My Body Be Art?" *The Guardian* (March 17): www.guardian.co.uk/artanddesign/2004/mar/17/art.fashion (accessed July 26, 2008).

Freud, Sigmund. 1953–74. *The Standard Edition.* Ed. James Strachey. 24 vols. London: Hogarth.

Fried, Michael. 1987. *Realism, Writing, Disfiguration: On Thomas Eakins and Stephen Crane.* Chicago: University of Chicago Press.

Fried, Michael. 1990. *Courbet's Realism.* Chicago: University of Chicago Press.

Fuller, Peter. 1987. "The Psychology of the Ripper." *New Society,* July 31, 14–15.

Fuss, Diana. 1992. "Fashion and the Homospectorial Look." *Critical Inquiry* 18.4: 713–37.

Gamboni, Dario. 1997. *The Destruction of Art: Iconoclasm and Vandalism since the French Revolution.* New Haven: Yale University Press.

Geertz, Clifford. 1973. *The Interpretation of Cultures.* New York: Basic Books.

German History in Documents and Images. germanhistorydocs.ghi-dc.org/sub_document.cfm?document_id=1577 (accessed July 26, 2008).

Gilman, Sander L. 1999. *Making the Body Beautiful: A Cultural History of Aesthetic Surgery.* Princeton, NJ: Princeton University Press.

Gingrich, Newt. 1995. "Cutting Cultural Funding: A Reply." *Time,* August 21, 70–71.

Girard, René. 1978. "Differentiation and Reciprocity in Lévi-Strauss and Contemporary Theory." *"To Double Business Bound": Essays on Literature, Mimesis, and Anthropology.* Baltimore: Johns Hopkins University Press, 155–77.

Golsan, Richard. 1995. "Fashionable Fascism." *Utne Reader* 72, November–December, 60–61.

Goodnough, Abby. 1999. "Giuliani Threatens to Evict Museum over Art Exhibit." *New York Times,* September 23, B6.

Hayman, Robert L., Jr., and Nancy Levit. 2002. "Un-natural Things: Constructions of Race, Gender, and Disability." *Crossroads, Directions, and a New Critical Race Theory*. Ed. Francisco Valdes, Jerome McCristal Culp, and Angela P. Harris. Philadelphia: Temple University Press, 157–86.

He, Zhou. 1996. *Mass Media and Tiananmen Square*. New York: Nova Science.

Hevey, David. 1992. *The Creatures That Time Forgot: Photography and Disability Imagery*. London: Routledge.

Hurt, Charles. 1998. "Heidelberg Project Comes Down Next Week." *Detroit News*, September 18, C6.

Ikemoto, Lisa C. 1997. "Furthering the Inquiry: Race, Class, and Culture in the Forced Medical Treatment of Pregnant Women." *Critical Race Feminism: A Reader*. Ed. Katherine Adrien Wing. New York: New York University Press, 136–43.

Imrie, Rob. 1996. *Disability and the City: International Perspectives*. London: Paul Chapman.

Iyer, Pico. 1998. "The Unknown Rebel." *Time*, April 13, 192–93, 196.

Jackson-Braboy, Pamela, and David R. Williams. 2006. "The Intersection of Race, Gender, and SES: Health Paradoxes." *Gender, Race, Class, and Health: Intersectional Approaches*. Ed. Amy J. Schulz and Leith Mullings. San Francisco: Jossey-Bass, 131–62.

James, William. 1983. *The Principles of Psychology*. 1890; Cambridge: Harvard University Press.

Jameson, Fredric. 1981. *The Political Unconscious: Narrative as a Socially Symbolic Act*. Ithaca, NY: Cornell University Press.

Johnson, Harriet McBryde. 2003. "Should I Have Been Killed at Birth? The Case for My Life." *New York Times Magazine* (February 16): http://query.nytimes.com/gst/fullpage.html?res=9401EFDC113BF935A25751C0A9659C8B63 (accessed July 26, 2008).

Kertzer, David I. 1988. *Ritual, Politics, and Power*. New Haven: Yale University Press.

Kim, Eunjung, and Michelle Jarman. 2008. "Modernity's Rescue Mission: Postcolonial Transactions of Disability and Sexuality." *Canadian Journal of Film Studies / Revue Canadienne d'Etudes Cinématographiques* 17.1: 52–68.

Kleck, Robert, Hiroshi Ono, and Albert H. Hastorf. 1966. "The Effects of Physical Deviance upon Face-to-Face Interaction." *Human Relations* 19:425–36.

Knipfel, Jim. 1999. *Slack Jaw: A Memoir*. New York: Berkley Books.

Knox, Paul L. 1987. "The Social Production of the Built Environment: Architects, Architecture and the Post-modern City." *Progress in Human Geography* 11.3: 354–78.

Kramer, Hilton. 2004. "Marc Quinn Sculpture Meets Shock Standard for Limbless Nudes." *New York Observer* (January 25): www.observer.com/node/48701 (accessed July 26, 2008).

Lacan, Jacques. 1966. *Écrits*. Paris: Seuil.

Lacayo, Richard. 1990. "Talented Toiletmouth." *Time*, June 4, 48.

Levin, Kim. 2004. "Marc Quinn, a 'Sensation' Artist, Returns with the Toughest, Most Problematic Show Around." *Village Voice* (January 13): www.villagevoice.com/2004-01-13/art/lost-and-found/ (accessed July 26, 2008).

Lifchez, Raymond. 1987. *Rethinking Architecture: Design Students and Physically Disabled People*. Berkeley: University of California Press.

Lindgren, Laura, ed. 2007. *Mütter Museum: Historic Medical Photographs.* New York: Blast Books.

Lyall, Sarah. 2005. "Disability on Pedestal in London." *International Herald Tribune* (October 8): www.iht.com/articles/2005/10/07/news/statue.php (accessed July 26, 2008).

Marks, Deborah. 1999. *Disability: Controversial Debates and Psychosocial Perspectives.* London: Routledge.

Martin, Emily. 2006. "Moods and Representations of Social Inequality." *Gender, Race, Class, and Health: Intersectional Approaches.* Ed. Amy J. Schulz and Leith Mullings. San Francisco: Jossey-Bass, 60–88.

Mauss, Marcel. 1950. "Les Techniques du corps." *Sociologie et anthropologie.* Paris: PUF, 365–86.

McFadden, Robert D. 1999. "Disputed Madonna Painting in Brooklyn Show Is Defaced." *New York Times,* December 17, A1.

Merleau-Ponty, Maurice. 2002. *Phenomenology of Perception.* Trans. Colin Smith. 1962; New York: Routledge.

Middleman, Raoul. 2000. "An American Sensibility." *Harper's,* July, 18–20.

Miller, J. Hillis. 1992. *Illustration.* Cambridge: Harvard University Press.

Miller, J. Hillis. 2001. "Paul de Man as Allergen." *Material Events: Paul de Man and the Afterlife of Theory.* Ed. Tom Cohen, Barbara Cohen, J. Hillis Miller, and Andrzej Warminski. Minneapolis: University of Minnesota Press, 183–204.

Millett, Ann. 2008. "Sculpting Body Ideals: *Alison Lapper Pregnant* and the Public Display of Disability." *Disability Studies Quarterly* 28.3: np.

Mitchell, W. J. T. 2001. "Offending Images." *Unsettling "Sensation": Arts-Policy Lessons from the Brooklyn Museum of Art Controversy.* Ed. Lawrence Rothfield. New Brunswick, NJ: Rutgers University Press, 115–33.

Mosse, George L. 1991. "Beauty without Sensuality / The Exhibition *Entartete Kunst.*" *"Degenerate Art": The Fate of the Avant-Garde in Nazi Germany.* Ed. Stephanie Barron. New York: Los Angeles County Museum of Art and Harry N. Abrams, 25–31.

Mumford, Lewis. 1983. *The Culture of Cities.* New York: Harcourt, Brace and World.

"A Nazi Treasure Trove." 2007. *The Independent* (October 8): findarticles.com/p/articles/mi_qn4158/is_20071008/ai_n21037552 (accessed July 26, 2008).

Nead, Lynda. 1992. *The Female Nude: Art, Obscenity, and Sexuality.* New York: Routledge.

Newman, Heather. 1998. "So Much to Tear Down; Why Target Heidelberg?" *Detroit Free Press,* September 18, 13A.

Nochlin, Linda. 2001. *The Body in Pieces: The Fragment as a Metaphor of Modernity.* London: Thames & Hudson.

Nussbaum, Martha C. 2006. *Frontiers of Justice: Disability, Nationality, Species Membership.* Cambridge: Harvard University Press.

O'Neill, Brian. 2007. "Statue of Limitations." *The Guardian* (May 17): www.guardian.co.uk/commentisfree/2007/may/17/statueoflimitations (accessed July 7, 2008).

Ortner, Sherry B. 1994. "Theory in Anthropology since the Sixties." *Culture/Power/History.* Ed. Nicholas B. Dirks, Geoff Eley, and Sherry B. Ortner. Princeton, NJ: Princeton University Press, 372–411.

O'Toole, Corbett Joan. 2004. "The Sexist Inheritance of the Disability Movement."

Gendering Disability. Ed. Bonnie G. Smith and Beth Hutchison. New Brunswick, NJ: Rutgers University Press, 294–300.

Pernick, Martin. 1997. "Defining the Defective: Eugenics, Aesthetics, and Mass Culture in Early-Twentieth-Century America." *The Body and Physical Difference: Discourses of Disability.* Ed. David T. Mitchell and Sharon L. Snyder. Ann Arbor: University of Michigan Press, 89–110.

Petzold v. Borman's, Inc. 2000. Michigan Court of Appeals, No. 211567, July 18: www.securitymanagement.com/library/Petzold.html.

Poe, Edgar Allan. 1978. *Collected Works.* Ed. Thomas Ollive Mabbott. 3 vols. Cambridge: Harvard University Press.

Poore, Carol. 2008. *Disability in Twentieth-Century German Culture.* Ann Arbor: University of Michigan Press.

Poulet, Georges, 1972. "Criticism and the Experience of Interiority." *The Structuralist Controversy: The Languages of Criticism and the Sciences of Man.* Ed. Richard Macksey and Eugenio Donato. 1970; Baltimore: Johns Hopkins University Press, 56–88.

Quinn, Marc. 2004. *The Complete Marbles.* New York: Mary Boone Gallery.

Rayman, Graham, and Sean Gardiner. 1999. "Painting Smeared, 72-Year-Old Activist Charged." *Newsday,* December 17, A3.

Reynolds, Nigel. 2004. "Disabled Mother Wins Battle of Trafalgar Square." *Sidney Morning Herald* (March 18): www.smh.com.au/articles/2004/03/17/1079199293170.html?from=storyrhs (accessed July 26, 2008).

Rothfield, Lawrence, ed. 2001. *Unsettling "Sensation": Arts-Policy Lessons from the Brooklyn Museum of Art Controversy.* New Brunswick, NJ: Rutgers University Press.

Sagoff, Mark. 1978. "On Restoring and Reproducing Art." *Journal of Philosophy* 75.9: 453–70.

Sartre, Jean-Paul. 1991. *The Psychology of Imagination.* New York: Citadel Press.

Sax, Bejamin, and Dieter Kuntz, eds. 1992. *Inside Hitler's Germany: A Documentary History of Life in the Third Reich.* Lexington, Mass: D.C. Heath.

Schor, Naomi. 1989. *Reading in Detail: Aesthetics and the Feminine.* 1987; New York: Routledge.

Sensation: Young British Artists from the Saatchi Collection. 1999. London: Royal Academy of the Arts.

Shklovsky, Victor. 1965. "Art as Technique." *Russian Formalist Criticism: Four Essays.* Ed. Lee T. Lemon and Marion J. Reis. Lincoln: University of Nebraska Press, 3–24.

Siebers, Tobin. 1998a. "Kant and the Politics of Beauty," *Philosophy and Literature* 22.1: 31–50.

Siebers, Tobin. 1998b. *The Subject and Other Subjects.* Ann Arbor: University of Michigan Press.

Siebers, Tobin. 2000a. "Hitler and the Tyranny of the Aesthetic." *Philosophy and Literature* 24.1: 96–110.

Siebers, Tobin. 2000b. "The New Art." *The Body Aesthetic: From Fine Art to Body Modification.* Ed. Tobin Siebers. Ann Arbor: University of Michigan Press, 217–41.

Siebers, Tobin. 2006. "Disability Aesthetics." *Journal for Cultural and Religious Theory* 7.2: 63–73.

Siebers, Tobin. 2008a. "Disability Aesthetics and the Body Beautiful." *Alter: European*

Journal of Disability Research, Revue européenne de recherche sur le handicap 2:329–36.

Siebers, Tobin. 2008b. *Disability Theory.* Ann Arbor: University of Michigan Press.

Siebers, Tobin. 2009. "In the Name of Pain." *Against Health: Has Health Become the New Morality?* Ed. Anna Kirkland and Jonathan Metzl. New York: New York University Press, forthcoming.

Silvers, Anita. 2000. "From the Crooked Timber of Humanity, Beautiful Things Can Be Made." *Beauty Matters.* Ed. Peg Zeglin Brand. Bloomington: Indiana University Press, 197–221.

Snyder, Sharon L., and David T. Mitchell. 2006. *Cultural Locations of Disability.* Chicago: University of Chicago Press.

"Special Report." 1989. *Newsweek,* December 25, 18–19.

Stiller, Jerome. 1984. "The Role of Personality in Attitudes toward Those with Physical Disabilities." *Current Topics in Rehabilitation Psychology.* Orlando, FL: Grune and Stratton, 1–26.

Suhr, Jim. 2000. "Michigan Appellate Court Hears Case of Fired Tourette Sufferer." *Ann Arbor News,* May 3, B6.

Sullivan, Louis. 1979. *Kindergarten Chats and Other Writings.* New York: Dover.

Talbott, Strobe. 1989. "Defiance." *Time,* June 19, 10–11.

Tarde, Gabriel. 1969. "The Public and the Crowd." *On Communication and Social Influence: Selected Papers.* Ed. Terry N. Clark. Chicago: University of Chicago Press, 277–94.

Taylor, Brandon. 1989. "Picking Up the Pieces." *Art News* 88, February, 43–45.

Teunissen, John J., and Evelyn J. Hinz. 1974. "The Attack on the *Pietà*: An Archetypal Analysis." *Journal of Aesthetics and Art Criticism* 33:43–50.

Thomson, Rosemarie Garland. 1997. *Extraordinary Bodies: Figuring Physical Disability in American Culture and Literature.* New York: Columbia University Press.

Turner, Victor. 1967. *The Forest of Symbols: Aspects of Ndembu Ritual.* Ithaca, NY: Cornell University Press.

Tyjewski, Carolyn. 2003. "Hybrid Matters: The Mixing of Identity, the Law and Politics." *Politics and Culture* 3: aspen.conncoll.edu/politicsandculture/page.cfm?key=240 (accessed August 3, 2004).

Vincent, Norah. 1998. "Disability Chic: Yet Another Academic Fad." *New York Press,* February 11–17, 40–41.

Warhol, Andy. 1988. *Death and Disasters.* Houston: Houston Fine Art Press.

Whitfield, Jenenne. 2000–2001. "Thoughts on Tyree Guyton's Heidelberg Project." *Southern Quarterly* 39.1–2: 187–96.

Will, George. 2001. "Minimalize Offensive Art to Invisibility." *Ann Arbor News,* February 22, A11.

Wimsatt, W. K., and Monroe C. Beardsley. 1954. "The Intentional Fallacy." In W. K. Wimsatt. *The Verbal Icon.* Lexington: University of Kentucky Press, 3–18.

Winckelmann, Johann J. 1991. *Réflexions sur l'imitation des oeuvres grecques en peinture et en sculpture.* Trans. Marianne Charrière. Paris: Jacquiline Chambon.

Wu, Cynthia. 2004. "'The Mystery of Their Union': Cross-Cultural Legacies of the Original Siamese Twins." Ph.D. dissertation, University of Michigan.

Yolles, Sandra. 1989. "Junk Magic." "Vasari Diary." *ARTnews,* October, 27.

Žižek, Slavoj. 1989. *The Sublime Object of Ideology.* London: Verso.

Acknowledgments

I thank for their comments and criticisms audiences at the American Comparative Literature Annual Convention, the University of Antwerp, the University of California at Berkeley, the University of California at Los Angeles, the University of Colorado at Boulder, Cornell University, Emory University, the University of Illinois at Chicago, the Martin-Gropius-Bau in Berlin, the University of Michigan, the Mid-Atlantic Popular Culture/ American Culture Association Annual Conference, the Ohio State University, Pennsylvania State University, and the Society for Disability Studies. Some parts of this book have appeared previously in *Cultural Critique, Journal for Cultural and Religious Theory, Michigan Quarterly Review,* and *Publication of the Modern Language Association.* I am grateful for the right to reprint the materials, all of which have been substantially revised. I also express my gratitude for the permissions, given by the many artists, museums, and other organizations, to reproduce works of art. Every effort has been made to obtain copyright permission and in the rare instances where permission is not recorded, fair use has been applied. Generous support from the Department of English Language and Literature and the Office of the Vice President for Research at the University of Michigan helped to defray the cost of including illustrations.

I express special gratitude to LeAnn Fields for encouraging me to publish this book and for her support of my work over the years. Anne Waldschmidt originally conceived of the idea for the German cousin from which this book spins off. I salute you. I thank Shannon Winston for helping with permissions. Visits by and correspondence with friends brightened my days while I was working on the manuscript. I thank for

giving me the gift of their time Leslie Atzmon and Michael Schoenfeldt, Timothy Brennan and Keya Ganguly, Carine Chatet, Susan Cohen, Lois Cooper and George Marcus, Nancy and Tom Egerer, Maria and Richard Emerique, Angela Dillard and Alan Wald, Claudine Farrand and Daniel Moerman, Marci and Stephen Feinberg, Rosemarie Garland-Thomson, Michael Gill, Alvia Golden and Carroll Smith-Rosenberg, John Gutoskey and Peter Sparling, Jean Hébrard and Martha Jones, Daniel Herwitz and Lucia Saks, Mette Hjort and Paisley Livingston, Chris and Lloyd Holdwick, Erika Hupperts, Eunjung Kim, Ann Laboda, David Schoffner, and Debra Stevens, Joanne Leonard, David Mitchell and Sharon Snyder, Satya Mohanty, Kristine Mulhorn, Mary and Richard Price, Yopie Prins, Joy Pritchett, Penny Romlein, Maggie Seats, Nancy and Scott Shaw, Sidonie Smith, John Su, Gretchen Suhrer, Steven and Margaret VandeHey, Martha Vicinus, Maggie Villa, John Whittier-Ferguson, James Winn, Daniela Wittmann, Cynthia Wu, Patricia Yaeger, and Marie Ymonet.

I am grateful for the attention and many favors of my dear friends Linda Gregerson and Steven Mullaney, David Halperin, Bernard and Marlyn Hupperts, John Kotarski and Theresa Tinkle, Alan Levy and Susan Pollans, Brenda Marshall and Valerie Traub, Randall Tessier, and Lynn Tindall.

I thank my doctors Bruce Redman, David Miller, Michael Simoff, and Gregory Graziano for keeping me alive. I wish you continued success. Catherine Susan, my physical therapist, deserves my enormous gratitude.

Thank you Karen and Rob and Jane for your love, support, and advice and for visiting me from that faraway land, California.

Finally, I thank Claire and Pierce, whose love sustains me in these difficult times. I love you. And then there is Jill, the love of my life. God only knows what I'd be without you.

Credits

Index